DRAWING WITH COLOR

Studying the techniques of the old masters for working methods and a personal style.

by GASPARE DE FIORE

Translated from Italian
by Joachim Neugroschel

AND IMAGINATION

The Drawing Course, Volume Three

WATSON-GUPTILL PUBLICATIONS/New York

Copyright © 1983 by Gruppo Editoriale Fabbri, S.p.A.,
Milano

Published 1983 in Italy by Gruppo Editoriale Fabbri
S.p.A., Milano

First published 1985 in the United States and Canada
by Watson-Guptill Publications, a division of Billboard
Publications, Inc., 1515 Broadway, New York, N.Y.
10036.

Library of Congress Catalog
Card Number: 85–040403

ISBN 0-8230-1454-1

Manufactured in Italy

First Printing, 1985

Printed in Italy by Gruppo Editoriale Fabbri S.p.A., Milan.

Introduction

I am convinced that while drawing cannot be taught, it *can* be learned because in a way drawing comes naturally to us and only needs to be brought out and refined. In a way, the image of something seen or imagined is a drawing formed in our heads and only needs method and materials to transfer it to paper.

But drawing is more than this, too. Precisely because it can express both reality and fantasy, drawing is an expression of our rapport between the world outside us and our inner selves. And so, if we can understand drawing beyond its value as a pretty picture—that is, see it as a means of recognizing and participating in the world around us—then we will find this world of drawing on the pages of our albums, the sketches on our walls, and in the thousands of images that surround us daily.

We are always drawing. The moment we trace a line to paper, our participation in drawing is direct. But we also draw indirectly when we interpret a series of lines by mentally adding form, light and shadow, and color to it as we look. Thus the white spaces—the blank parts—are as important as the filled ones to the viewer, and we can participate in drawings deeply as a part of life just as we do in poetry, music, dance, painting, and sculpture, interpreting the images of the real world and creating new ones from our imagination.

Thus the world of drawing belongs not only to the great artists, but also to the rest of us who draw what we see in reality or our minds, or who use it daily to solve practical problems. It belongs to writers like Victor Hugo, who enriched his novels with his own charming images; and to film directors like Federico Fellini, who jotted down ideas for lighting, costumes, and scenery for his films on hundreds of colored sheets of paper and hung them around his studio. The world of drawing is also the world of adventure in the comic strips of our daily newspapers and in animated cartoons on television, and includes everything from blueprints for cars

and motorcycles, furniture and buildings…to designing the colors and shapes of a jigsaw puzzle, a deck of cards, record album, or a film poster.

But how can we find the right kind of drawing to express ourselves? How can we learn how to draw? I think there's no more productive and exciting way to learn than by reading the words, advice, experiences, and teachings of the masters, past and present; seeing what they have written about drawing and problems they've encountered, hear them analyzing their work, revisiting them, and discovering in their drawings the manner, methods, and tools they have used.

This book is an invitation to look at the drawings of the masters as though we were looking over their shoulders as they drew, watching them as they traced a line down the page, looking at their models and how they interpreted them, seeing them first sketch an idea and then develop it. What we really would like to do is try to understand those drawings without relying on theory but by letting the artist speak and explain for himself the history, reasoning, meaning, and development of a project from its birth as an idea to the last stroke of pencil on paper.

Every time we can see a work with the eyes of the artist and understand the creative process behind it, we face the problems he faced and prepare ourselves to resolve them as he has. With this in mind, I have chosen a few drawings from the many in the history of art and I have imagined being able to ask the artists about each drawing and through a sort of imaginary interview—or lesson—to get each one to tell his motivation, his aesthetic and technical problems, his artistic solutions and his inventions.

We will do this by interpreting— each drawing and composition carefully and critically so that we can go beyond our own interpretations of the work to unravel the threads of the artistic process to reach the artist himself.

Gaspare de Fiore

The Drawing Course Series

The drawing course is developed through five volumes on the basic phases of drawing, with a sixth volume on drawing materials. The course provides a rich, as well as practical and enjoyable framework for the teaching of drawing. In each section, the ideas, teachings, experiences, and works of the great masters, analyzed through different stages of their development, are used to illustrate the basic techniques taught in the course.

The lessons are developed through a method that individualizes the diverse procedures of drawing without losing the synthesis of the vision and actual portrayal of the subject. At the same time that the lesson teaches the need for scientific and objective' procedures, it also emphasizes each person's personality and interpretation.

The course focuses on the techniques of drawing, from the moment of "seeing" to the interpretation of color. The final volume gives specific information about materials, such as the various kinds of pencils and crayons available, and how to use them. Other volumes describe the various types of drawings—from sketches to technical drawings, culminating in an introduction to painting.

This is the third volume in the series. The entire six-volume course is described below:

VOLUME ONE
LEARNING TO SEE AND DRAW

Learning to See

The course begins by stressing the need to learn to see. Observing in order to portray an object, the definition of form and chiaroscuro, the analysis of form and color, images of reality and images of ideas all represent fundamental steps in learning to draw, phases which are picked up and developed throughout the course in their most diverse applications.

Drawing From Life

We learn to know the world around us better through drawing, and present it in a personal way. Drawing from real objects, notes from travels (in a sketch book that we will take with us when we go out to help us see and remember), anatomy studies, and perspective of objects and backgrounds that interest us will all be covered, using the drawings of the masters as a laboratory of experience and technique.

Seeing Shape

The first lesson in the learning process is the analysis and representation of form. As we read about shape, we will discover the geometric structures that are the key to the construction or basis for the drawing, along with the relationship of the various elements and the search for balance and proportion. We'll see that even when a shape is represented by a single line, that line can suggest emotion, sensation, light and shadow.

VOLUME TWO
COMPOSING AND SHADING YOUR DRAWINGS

Chiaroscuro

A line can suggest light and shadow but it is chiaroscuro that interprets and expresses it fully through the wise use of black and white, reflections and tinted shadows, thereby creating a third dimension of volume and depth.

Developing the Drawing

A drawing begins with a sketch of the initial idea or impression; then the search begins for the right arrangement, point of view, develop-

ment of foreground and background and its position on the paper. Chosen with awareness, this series of elements will contribute to the synthesis of the composition.

Composing with Geometry

Composition, which is the basic structure of drawing, finds harmony and balance in the discipline of geometry, even in free sketching. An axial composition is based on one of the axes or on two perpendicular axes. It can also be diagonal, triangular, square, circular or something even more complex such as mixed where geometric figures vary or are superimposed on each other.

VOLUME THREE
DRAWING WITH COLOR AND IMAGINATION
The Theory of Color

Drawing is seeing and interpreting the world around us, a world in color. Light is color; all colors are created from the three primaries, red, blue and yellow. Besides the abstraction and stimulus of a black and white drawing, color theory is developed in order to understand and portray new compositions and spatiality.

Color and Personality

Beyond objective color theory there is the world of color in each of us, full of contrasts, variations, harmonies, and subjective agreement for the portrayal of ideas and impressions. Color thus becomes a means of self-expression.

Quick Sketches

Sketching is the first step in a drawing; notes are born from ideas or observations, whether real or from fantasy, made up or actually seen. In the sketchbook, images and impressions multiply that can become drawings themselves or parts of another project.

A few lines on a page sometimes say more than a complicated drawing. More than other drawings they succeed in expressing personality and feeling and developing our fantasy.

VOLUME FOUR
DRAWING TO COMMUNICATE
Getting Practical Ideas on Paper

Fantasy drawing is inventive drawing that can be applied to daily life, in fashion, decoration, jewelry, household objects, furnishings. In drawing, we can freely express our fantasies clarifying ideas that can then be carried out.

Drawing as a Language

Drawing is communication. With lines on paper we can speak even to those whose language we don't know. We can draw to explain something, to show how something is made, to recall an event, to play and even to dream. One needs only a line to suggest something to enrich and complete the imagination.

Illustrating Stories and Ideas

In mass media, drawing plays a protagonist's role, working hand in hand with texts, even substituting for them at times, and competing with photographs. There are scientific drawings, humorous ones, such as caricature and political satire, illustrations in books and magazines, and the still young field of comics and animated cartoons. But even with this wide range, there are fixed rules on which every drawing is based.

Diagramming Objects in Space

The methods of geometric representation give us rules for drawing three-dimensional objects. The concept behind each method, however, is unique: The drawing, as a projection on a surface (paper) seen from a single point of view.

With perspective, an actual point of view is projected, while orthogonal projects such as maps and diagrams are infinite. In each case the geometric drawing is a fundamental tool for the representation of architecture, objects, machines and land.

VOLUME FIVE
PRACTICAL AND FINE ARTS DRAWING
Designing to Catch the Eye

This section looks at the vast world of graphics as used in designing books, covers, signs, publicity and brochures as well as in the industrial world where it becomes a blueprint for the production of models and products.

Preliminary Sketches

A drawing starts with the preliminary sketch; it is also the basis of paintings, sculpture, architecture, scene paintings and engravings. It is the link between the idea and the finished work, letting us understand the beginnings and history of the process of invention and its realization.

Turning Drawings Into Paintings

In the long process toward the discovery of drawing, color is often brought into play. Now that we know something about drawing, we can turn to the fascinating world of painting where color triumphs, with a greater awareness and consciousness, enriching our images, visions, and ideas with color.

VOLUME SIX
WORKING WITH DRAWING MATERIALS

Drawing materials (crayons, pastels, pencils, etc.) and how to use them.

CONTENTS

THE THEORY OF COLOR

Color is light. The world that we see going past our eyes during the day is nothing but a reduction, brought about by the action of our brain, of the variations in the colors of daylight.

The colors of the spectrum, which Newton discovered by letting a ray of sunlight pass through a prism, are evident whenever we see sunbeams crossing through the water drops of a rainbow or a soap bubble or dispersed on the reflections of the wings of a dragon fly.

What is color made up of?

Color is made up of a pigment. However, the color of the pigment is actually the color of the light that it reflects. In fact, whenever we call an object yellow, green, red, or blue, we are really saying that the light reflected by this object is yellow, green, red, or blue, because the pigments are able to absorb certain light-wave lengths and reflect others.

The eye gathers the color sensations, which are then transmitted to the brain. The brain decodes them, perceiving the color. How this process works is still a mystery.

Winston Churchill, the great British statesman, loved to work with watercolors. Although his paintings were not exceptional, his remarks about colors are interesting: "When I go to heaven, I will ask for a richer palette than the one I had on earth. I expect that orange and vermilion will be the darkest and dullest hues, and that there will be a whole array of new and marvelous colors to delight the eye."

Hans Hartung: T. 1935-1. 142 x 186 cm. Unknown collection.

Applied Theories of Color

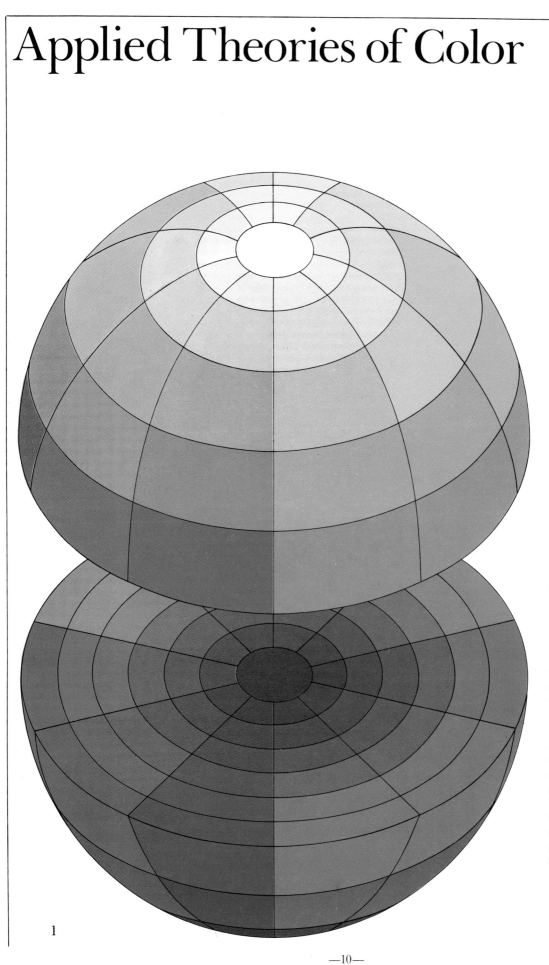

1. The color sphere by the American artist A.H. Munsell is based on Goethe's color system: the vertical light-dark axis with gray at its mid-point, and degrees of saturation represented by concentric circles beginning at the equator and moving to the center.

2. The choice of colors is important for appreciating volume and depth. Cold colors (blue, green) have a "regressive" effect, that is, they seem to move away, while an equal zone of hot color (red, yellow) seems to move forward.

3. The sense of depth aroused by color also depends on the saturation of the hues. The outline of "Leonardo da Vinci's man," in intense red, seems to emerge from a closer plane in relation to a non-saturated surrounding area in the same color.

1

The Sphere of Colors

Johannes Itten (1887-1967), a Swiss painter who taught at the Bauhaus, reconstructed the chromatic sphere intended by the scholar Philipp Otto Runge to indicate a complete arrangement of the general system of colors.

Why the sphere? Because a representation on a two-dimensional surface cannot fully and simultaneously render all the characteristics of colors, the laws of complementaries, the interrelations of the various colors, and their relationship with black and white. On the other hand, all the relationships can be visualized by a representation based on the three directions, which in a sphere develop along the central axis, the meridians, and parallels (i.e., the circles passing through the poles and the parallel circumferences with diverse diameters).

A similar experience guided the American artist A. H. Munsell in the construction of a chromatic spherical space.

On the surface of a sphere, draw nine equidistant parallel lines. This will create ten zones. Next, perpendicular to these lines, draw ten equidistant meridians. In the ten sectors of the horizontal bands created by the parallel lines, put the colors of the chromatic disc based on red, blue, yellow, and the intermediate colors red-orange, red, violet, blue, blue-green, green, yellow-green, yellow, yellow-orange, orange). In the polar zones (i.e., the circles created by the smaller parallels at the top and bottom) of the sphere's axis, put white and black, one at each end, then mix the disc colors with black or white in such a way that the bands between the North Pole and the equatorial zone contain the two gradually lightened tones of the principal colors (the ten indicated by the horizontal strips). The two bands between the South Pole and the equatorial zone contain the five gradually darkened tones of the same colors. Each segment (corresponding to the ten principal and intermediate colors of the parallel bands) will thus have a series of ten color ranges, which, starting with white (North Pole) and ending with black (South Pole),

2

3

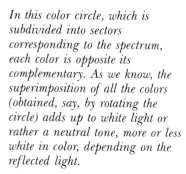

In this color circle, which is subdivided into sectors corresponding to the spectrum, each color is opposite its complementary. As we know, the superimposition of all the colors (obtained, say, by rotating the circle) adds up to white light or rather a neutral tone, more or less white in color, depending on the reflected light.

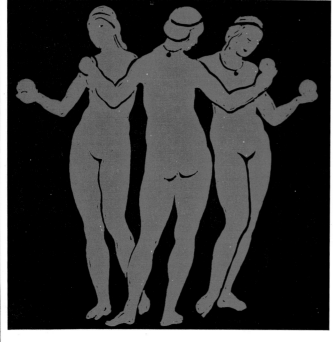

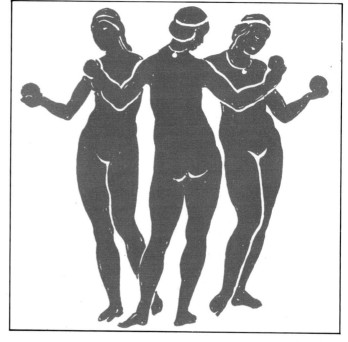

Fundamental to the perception of colors is contrast. In these diagrams of Raphael's Three Graces *(red against black and red against white), the red color, its tone and intensity* identical in both cases, seems lighter against a dark background and darker against a light background.

grow darker and darker. Yellow, the lightest color, will have very slight gradations of the pure color (i.e., the two segments toward white); its darker gradations (i.e., the two segments nearest black) will be greatest. Violet, the darkest color, will have the most differentiated gradations toward white and the least differentiated toward black.

Thus, around the two poles—white and black—we will have ten rings, made up of ten colors, always the same (those of the horizontal bands). However, two of them, around the white pole, will have lightened tones and two, around the black pole, will have darkened tones.

By "opening" the sphere in an imaginary projection on a plane, we will have a chromatic star, with the white pole at its center and the parts of the black pole at the extreme tips.

Now try to picture the sphere from one side and then from the opposite side. You will thus have two views. One has at its center the segments of yellow and yellow-green; and the other, at its center, the opposite segments, that is, violet and blue. If we examine only the equatorial zone, we will see that this zone is made up of six pure colors: from left to right, orange-red, red, violet, blue, blue-green, green.

Slice the globe with a horizontal plane at the level of the equator and view it from above. At the center, in the smallest circle, you will have a neutral zone, which involves only the two concentric circles nearest the core while leaving the pure colors of the outer circle unchanged. The range of grays develops between the white and the black poles along the vertical axis of the sphere. "Neutral gray," at the center of the equatorial section, constitutes an intermediate value.

Finally, imagine cutting the sphere in half with a vertical plane.

In this case, observing the equatorial band, you will see the succession of thirteen colors, with the two complements, while the remaining eleven are gradually neutralized or grayed as they move from one side to the other. From left to right, these are: orange and its progressively grayer hues, across the core to the gray hues of green, ending with pure green.

In the horizontal sections, as we have noted, we see the full range of increasingly darker hues; while in the vertical section, we see the gradation of tones of a single color from light to dark.

Using the sphere of colors, Munsell managed to represent:
1. The pure colors, on the equatorial bands (at the midpoint of the sphere);
2. their nuances from white to black, on the surface of the sphere, in the various strips;
3. the mixtures (deriving from pairs of complements) on the horizontal sections;
4. the gradations of the pairs of complementaries toward light and toward dark, in the vertical sections.

What is the practical use of the chromatic sphere?

Imagine trying to pinpoint the intermediate tones between two complementary colors, for instance, blue and orange (= red + yellow). With the sphere we can find it by simply following three directions:
1. We can follow the meridians along the band running from white to black (in the two poles), above and below.
2. We can follow the equatorial strip, from right to left.
3. We can follow the diameter of the sphere.

Taking the first direction, along the meridian, we have dark blue, black, and dark orange. If we move along the equator, we have violet, red, and orange on the left and green and yellow on the right. Finally, by following the diameter, from orange to blue, we have the mixtures of orange and blue with gray.

As we see, the chromatic sphere can offer in a single spatial image all the possible combinations of pure color tones and their variations from light to dark.

Above all, in a single three-dimensional representation, we can unite and therefore vary constantly and immediately the characteristics of a color: hue (yellow, orange-red, violet, blue, green, and intermediate combinations), brightness or value (light or dark), and chromatic saturation (the amount or intensity of a color).

Goethe and the Theory of Color

The first real theory of color was presented by Moses Harris, an engraver and entomologist, in his *Natural System of Colors* (1776). Here, he published the first color circle, indicating the three primary colors—red, yellow, and blue—as vertices of an equilateral triangle; and the three secondary colors, i.e., combinations—orange, green, and purple (as vertices of an upside-down equilateral triangle). Harris placed two intermediate colors between every pair of a primary and a secondary color; e.g., orange-red and red-orange between red and orange. He thus obtained a circle divided into eighteen bands, each corresponding to a tone. Every band is sub-divided into ten strips, from as many concentric circles corresponding to the intensity of the color, which increases toward the inside.

Johann Wolfgang von Goethe, who had already shown his interest in drawing in *Voyage to Italy*, was passionate about colors. He spent twenty years studying them. In 1810, he published *The Theory of Colors*, a weighty volume, which, despite its inaccuracies, was felt by the author to be his most important work. Why was Goethe so interested in colors?

As a poet, novelist, and also philosopher fascinated by the mysteries of life and death (just think of his *Faust*), Goethe observered and studied the world around him. (This was one of the reasons why he wanted to master the profound medium of drawing) and could not help but be fascinated by the mystery of color.

He was interested in the contrast between the split-second persistence of the fleeting image of a color and the lasting image of a pigment: between the "physiological" color and the "chemical" color. Between the two, Goethe placed the "physical" colors, those we see reflected in mirrors or through window panes or from the sides of prisms.

For Goethe, Newton, who had decomposed a light ray by making it pass through a prism, was focusing on only one of three possible color types, the physical type—a limited view, according to

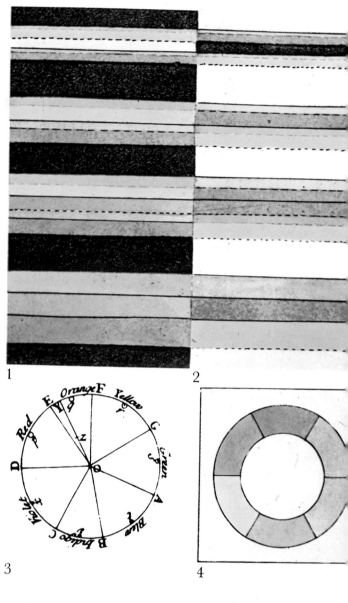

1. *Newton's spectrum*
2. *Goethe's spectrum*

3. *Newton's color wheel*
4. *Goethe's color wheel*

Goethe added several watercolors to his Theory of Colors. *This watercolor confronts Goethe's color wheel with Newton's and two different sets of prismatic colors (i.e. colors that appear on a strip of paper when it is viewed through a prism); the first, a strip of white paper against a black background (equal to Newton's spectrum), the second, a black strip against a white background.*

Goethe. The German poet maintained that colors have to be studied as they appear in the splendor of the outside world, as components of the white light that reaches the eye with different wave lengths.

Yellow is the first color that appears when white is darkened, just as blue is the first to appear when black is lightened.

Between these two colors come the successive pairs characterized by opposing qualities: more/less, hot/cold, active/passive.

Thus, after yellow and blue, there are two other pairs of important colors: red and green, orange and violet. If orange is reddened, and if violet becomes blue-violet, the resulting blend of red is called "purple" red by Goethe. In his circle of colors, it is placed at the opposite pole of green, which results from a blend of the initial colors, blue and yellow.

Goethe's color wheel is thus made up of six colors: yellow, orange, red, violet, blue, and green.

It is different from Newton's wheel. Here, "proportional to the seven notes of the scale or intervals of the eight/nines," Newton's colors are arranged as follows: yellow, green, blue, indigo, violet, red, orange.

Finally, we have to recall the mystical character of Goethe's color interpretation, which was close to that of his friend Philipp Otto Runge. According to Runge, the three primary colors are linked to the Holy Trinity: blue for the Father, red for the Son, and yellow for the Holy Ghost.

Yellow and blue, which seem to confirm that color is born from the interaction between light and dark, are joined by red, for the minimum palette used by a painter.

The solid sphere reconstructed by Itten is based on the six colors in Goethe's system: red, violet, blue, green, yellow, orange.

Goethe's triangle.
Goethe constructed his color triangle divided into nine triangles on three strips. The basic colors at the vertices are yellow, red, and blue. On the left, the "brilliant" colors; on the right, the "serious" colors. Thus we have: in the top vertex, red; in the three triangles of the median band, orange, violet, and blue-purple; in the five triangles of the lowest strip, yellow, light yellow, purple, green, and blue.

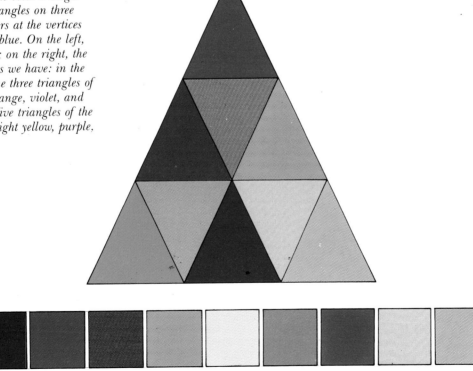

"The first colors that struck me were a bright, vivid green, white, black, carmine, and ochre. These impressions go back to the time when I was three years old. I saw these colors on different objects that passed before my eyes—and I was drawn by the liveliness of the colors themselves. Sometimes they spiraled out from thin branches.

In the first strip [ring] only the outer membrane of the bark was removed, and then also the lower membrane. These strips became tricolored horses for me: a brown layer (suffocating—I didn't like it and I gladly exchanged it for a different color); a green layer (my favorite, which, even when faded, retained a certain charm); and finally,

a bare, white layer, like ivory, the very heart of the branch. It was extraordinarily fragrant, and I felt like licking it, but when I did lick it, it was so bitter....
My memories of Italy are ruined by two dark impressions. The first: I am with my mother in a black carriage crossing a bridge over muddy-yellow

Delaunay's "Disc"

Among the painters fascinated by colors, Wassily Kandinsky was certainly one of the earliest. In his paintings, he captured the colors that had impressed him when he was three years old. And he also found color in musical notes, linking scarlet and blue to the sounds of trumpets and flutes. Kandinsky went even further, painting and writing, above all experimenting, in order to understand the psychological relationship between form and color. "It is the inner desire of the subject to determine the form unexpectedly ... the divorce between the artistic sphere and nature became sharper and shaper within me, until I finally considered each as distinct within itself, an entirely separate entity."

In 1912, Kandinsky got to know a young French painter, Robert Delaunay, who experimented with the theories of colors by doing paintings in which light decomposed into prismatic colors. Spurred on by his discoveries about the transparency of color, which may be likened to "musical notes," Delaunay, in quest of something "constructive," something no longer fragmented or lacerated, painted his *Windows*. This is how he define them:

"Colored sentences, enlivening the surface of the canvas in cadenced measures, which gallop along in movements of colored masses. Color, here, is practically an end in itself." The French poet Apollinaire, fascinated by Delaunay's work, invented the term "Orphism" for Delaunay's way of conceiving and rendering color—a method of transfusing warm blood into the cold, rigorous monotony of Cubism.

This experiment led to what Delaunay called the road to the "real central problem of painting": the "disk, the first non-objective painting." (Actu-

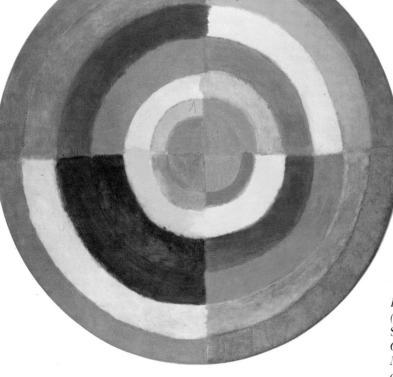

Robert Delaunay (1885-1942): First Simultaneous Disk, *1912. Oil on canvas, 143 cm. Meriden, U.S.A. Private collection.*

water. They are taking me to a children's home in Florence. The second: I am going down steps that lead to black, opaque water. A long, black boat with a terrible black box in the middle is floating on the water. We are about to board a nocturnal gondola....All in all, a single picture remained from that voyage, and I painted it in Munich, on the basis of the memories I had brought back. The title of the painting is *The Old City*. It's very sunny, and the rooftops are colored in bright red, the most vivid that I could create.
(Wassily Kandinsky: *The Painter's Text*, 1918)

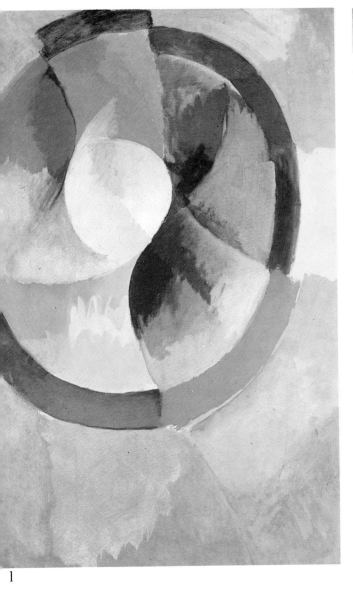

Robert Delaunay: Circular Forms, *1912-13.* Oil on canvas. *100 x 68.5 cm. Paris, M.N.A.M. Centre National d'Art et Culture Georges Pompidou*
2. Wassily Kandinsky: Red and Blue. *1913. Watercolor. 360 x 400 mm. Neuilly-sur-Seine, Kandinsky Collection.*

1

2

ally, Kandinsky and the Abstractionists had already discovered that new non-objective reality in their paintings.)

Why did Delaunay use the term *disk?*

He wanted to freely express the language and meaning of colors, with a chiefly and uniquely visual effect. Delaunay himself says that he composed his disk with "superimposed red and blue gradations," placing two quarters of slightly different reds and two quarters of slightly different blues at the center, which produced barely perceptible vibrations.

"Always sinuous in a circular form, there were other contrasts, always superimposed upon one another [in one quarter of the disk, around the red, at the center, violet, blue, purple, white, ochre, and violet again] always simultaneous in regard to the painting as a whole, that is, the totality of its colors...I could well cry out: 'I've found it! Eureka!'"

A Drawing a Day

Many of Vincent van Gogh's sketches were done with indications of the colors of the objects. These were rapid notes, in which the painter fixed the shapes (not only of objects—cups, jugs, lemons— but also landscape elements—skies, clouds, waves, and grass). He used a reed pen to make his nervous strokes. Then, in large letters, he wrote out the names of the colors in the appropriate places. It seems he had neither the time nor the means to note the values. Back in his studio, van Gogh employed these sketches to recapture on canvas the fascination, the harmonies, the contrasts of the colors that had impressed him. As a true painter, he could not do without color nota-

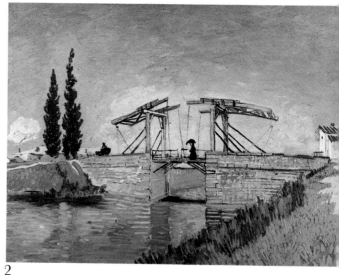

1

1. V. van Gogh: The Bridge at Langlois, *Drawing in a letter to E. Bernard. Amsterdam, National Vincent van Gogh Museum.*

2

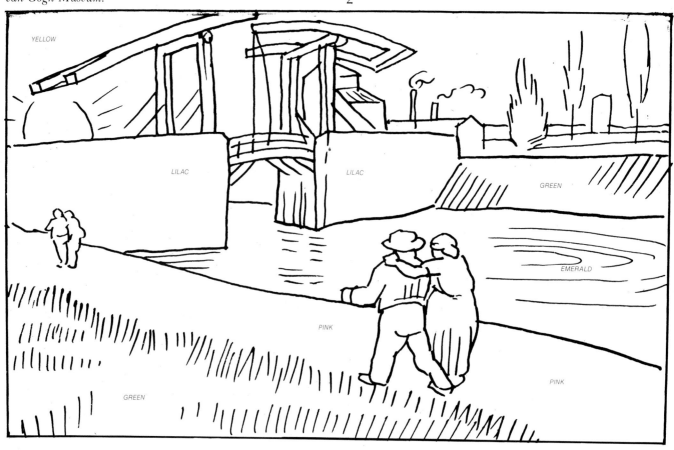

2. Vincent van Gogh: The Bridge at Langlois, *1888. Canvas, 49.5 x 64 cm. Cologne, Wallraf-Richartz Museum.*
3. Vincent van Gogh: Boats at Saintes-Maries. *Sketch.*

Amsterdam, National V. van Gogh Museum.
4. Vincent van Gogh. Boats at Saintes-Maries. *1888. Canvas, 64 x 81 cm Amsterdam, National V. van Gogh Museum.*

tions, even though he only wrote their names in his sketches.

In some still lifes, he indicated the colors of the cups, the pitcher, the lemons, the background. And when a color appeared in various nuances, he wrote: "yellow 1...yellow 2....yellow 3."

In his sketch of the bridge (1), he did not fail to "remember" the two embracing figures on the "pink" shore.... In the sea sketch (3), in which the sea is the true protagonist (the strip of sky fills barely one-tenth of the paper), the white sails slice through the tones of blue, blue violet, blue green, green....Try to copy Van Gogh's sketches on paper and color them according to his indications.

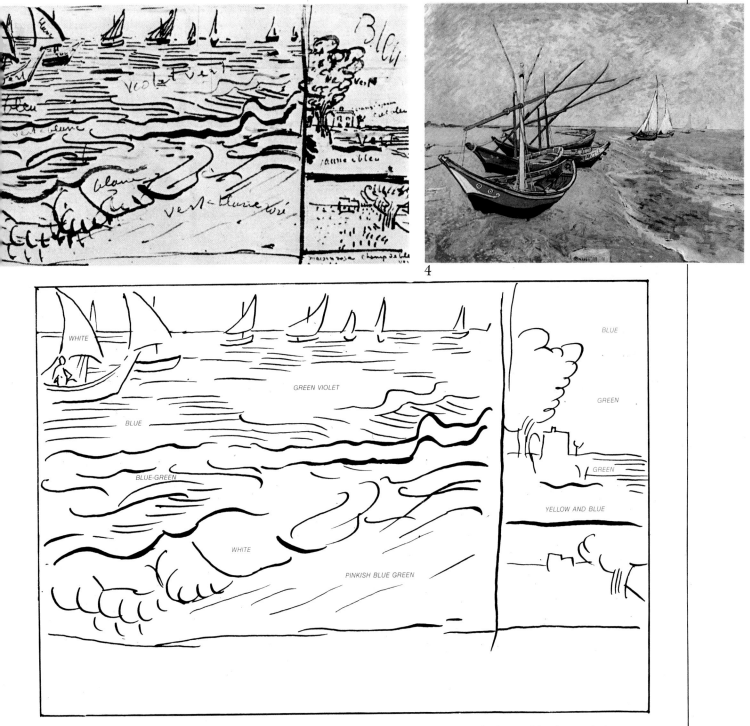

To make the exercise easier, that is, to indicate the colors used by van Gogh in his paintings (even if not for the same subject), we have reproduced two of his famous works. The shades used in these paintings can also be used for coloring the diagrammed copies of the van Gogh sketches.

—19—

The Colors of Prehistoric Cave Drawings

When we say that the world we live in is a world of images, and indeed colored images, we must not forget that man used color even in his earliest efforts at painting.

The famous Altamira caves in northern Spain were discovered in 1879 by the daughter of the archeologist M. de Santuola, who was in charge of the cave excavations. On the walls and ceilings, we find the typical subjects of paleolithic art: bisons, horses, stags—in color. According to the theory of "hunting magic," the ancient cavemen painted these pictures of animals in order to ensure success in their hunts. However, this theory does not suffice to explain why the cavemen rendered only these animals and not plants or landscapes or the sun and the moon. Nor does it explain why the depictions of human beings are so crude and child-like in contrast with the refined drawings of animals.

In order to render these animals, the cave painters chose certain areas in which the rock had bumps and bulges that fostered the illusion of representational volume.

The pigments they used were: red, ochre yellow, and manganese. And in some of the oldest paintings, they also used the mud from the cave floors. In Altamira, the artists already employed calcite crystals for highlights, as well as other, darker pigments to obtain an effect of relief with expert chiaroscuro.

We cannot help but admire the talents of these earliest color masters, who succeeded in adapting the animal shapes to the reliefs in the rock, enriching the shadow colors, rendering movement, and even showing the perspective of the legs and hoofs.

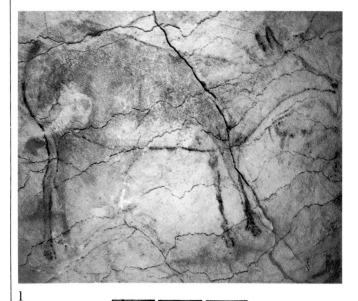

1

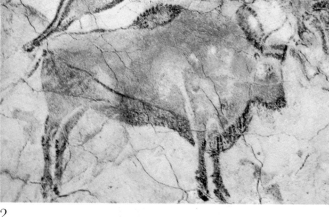

2

Caves at Altamira (Santander):
1. Stag, painted on ceiling. 2.25 m.
The lines astound us with their elegance and lightness. Equally careful and expressive is the color with its sure sense of chiaroscuro.

2. Bisons. Manganese black and ochre. 1.95 m.
The image of the bison is over six feet long. The head is treated in a painterly fashion with careful shadings that render not only the volume but also the character and even details in the hide.

Basic Colors

This is how Newton describes the discovery of the spectrum of his *Optics:* "In a very dark room, in a round hole about one third of an inch wide, in a window shutter, I placed a glass prism in such a way that the ray of sunlight entering through this hole was reflected upward on the opposite wall; and there it created a colored image of the sun."

Newton had observed that when light falls upon a transparent object, most of the rays are bent or refracted through the object. (We all have seen that when a stick is immersed in water, it seems to bend at the surface of the water.)

The explanation is simple. Light is composed of a certain number of waves; each wave has a different length and frequency (i.e., vibration speed). Therefore, each wave that penetrates the prism is refracted at a different angle. In his experiment, Newton noted that red light, which has the highest wave length and the lowest frequency, has the greatest refraction. On the other hand, violet light, which has the shortest wave length and the highest frequency, has the smallest refraction.

However, the refracted waves are not colored. If they are to appear colored, the spectrum has to be directed to a surface. The wave lengths, reflected from this surface, will then create the sensation of colors.

Newton applied the term "primary" to the colors of the spectrum. He found that by mixing them, one obtains "white" light. White light can also be achieved by blending just two or three primary components. For instance, a "white" light appears if you superimpose blue and yellow light, greenish-blue and red light, or green-red and blue light.

The characteristics of brightness and intensity are heightened when pairs of complementary colors are juxtaposed and placed side by side.

To Understand Colors Better
These examples of works in
color offer fundamental lessons
and practical advice for drawing
in color. At the end of the
commentary on each work, we
have summed up this
information under the heading:
Experience.

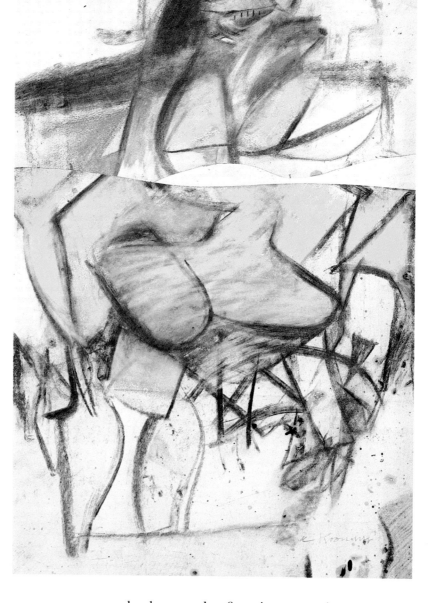

*Willem de Kooning (1904), Woman.
Pastel on pasted papers, 762 x 559
mm. New York M. Knoedler & Co.,
Inc. Collection Mr. and Mrs. Lee V.
Eastman*

*The expressive power of this drawing
(or rather, collage) is certainly only
in part to the open mind of the artist,
who has cut the paper into three
sections, but pasted only the upper and
lower ones together, eliminating the
middle. The overall effect derives also
from the color. The yellow, heightened
only partially by the touches of orange
and blue, becomes opaque and strangely
obtuse where it is used side by side with
and blended into the black of the
charcoal.*

The Experience
*The freedom to manipulate the
drawing, the proximity of charcoal and
pastel, the expressive meaning of the
yellow, a detail of the yellow muddied
by the black.*

Yellow

Yellow is the color of light. It is also the most
luminous color, becoming even brighter when it
passes from orange-yellow, through orange, to
orange-red. Red is thus the limit of yellow; while
orange, at the center of the yellow-to-red pro-
gression, is the most intense synthesis of light and
matter.

The transformation of matter into light is rep-
resented by a special tone of yellow: yellow gold.
This hue was employed widely by early artists. For
them, it not only symbolized spiritual light as in
the golden aureoles of saints; it also served to
wipe out all materiality and all confines of space
and time in Byzantine domes and in the gold
backgrounds of ancient mosaics.

Yellow, as the brightest color, also symbolizes
both material and spiritual clarity, as well as
intelligence and knowledge. If yellow is
darkened, it implies ignorance, falseness, be-
trayal. Indeed, yellow immediately loses its
brightness and its character if it is darkened by
gray, black, or violet.

As usual, if you want to understand the rela-
tionships and reciprocal values between yellow
and other colors, the best way is to experiment.
Place the colors next to and over one another
using colors that cover, such as tempera, on
colored paper or suitably prepared backgrounds.

—22—

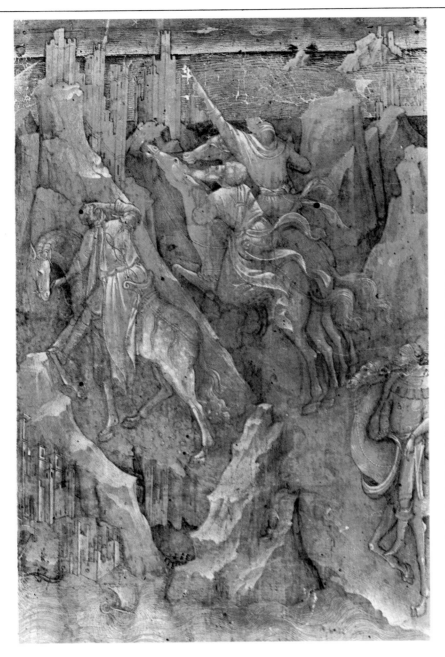

Lorenzo Monaco (Piero di Giovanni, so-called; 1370-c.1425): The Ride of the Three Magi, *c. 1420. Black ink, white lead, blue, green, and yellow tempera on parchment, 257 x 181 mm. West Berlin, Staatliche Musuen*
The drawing commands instant attention because of the orange tone of the figures and the landscape. The almost monochrome color is made particularly bright and powerful by the adjacent strips of blue sky and green sea. However, the unity and effectiveness of the rendering are due to the unity of tone in the overall image. The drawing plays entirely on the red-orange nuances; the illusion of a relief is created by illuminating the "raised" areas with "white light," while the shadowy areas are darkened by brown tones.

The Experience
The choice of a single color in an unreal tone, warm and suggestive; the expert use of white highlights; the heightening of the orange by a juxtaposition of green and blue.

Orange

In its various shades, orange is a blend of red and yellow. It is therefore as bright and lively as these two colors are. It is also one of the so-called warm colors, inspiring action and cheeriness.

The warmth of orange depends on how much yellow is added to the blend. However, it requires a sufficient amount of red in order to preserve its qualities. While yellow provides light and cheer, red ignites the tone, supplying heat and life. Aside from orange, we have yellow-orange and red-orange. These are tertiary colors in the chromatic circle of twelve colors (three basic colors; three compound or secondary colors; and six tertiary colors between pure yellow and orange

and between orange and pure red). In the chromatic circle, the opposite of orange is blue, which, is its complement.

Red-orange is denser, but opaque, even resplendent at times, with an inner color, like fire. For this reason, it stands for the fire of passion (while red symbolizes spiritual life), and also the world of demons and war.

Orange is a solar color—remember Renoir's fields of ripe grain, Guttuso's brilliant oranges against emerald leaves, the artificial light of taverns in Van Gogh's nocturnal visions.

Red

Red, more than any other color, is linked to the concept of activity and passion. While a bull may be excited more by the waving of a cloth than by its color, tradition nevertheless associates red with excitement and incitement.

In his *Theory of Colors*, Goethe describes red as arousing an "active, animated, enterprising" behavior. At the same time, he sees red as being very dignified and serious, because he feels that it combines all the other colors. And given its dignity and drama, red is also the color of ecclesiastical officialdom. royalty. The purple of the king's mantle becomes red in a cardinal's garb, symbolizing the unity of worldly and spiritual power.

Pure red is the symbol of spiritual love.

As a symbol of passion, linked to the planet Mars, red-orange implies the world of war and hell. The traditional use of red in military uniforms was supposed to inspire the soldiers (and perhaps camouflage the blood). Thus, the red flag is the symbol of revolution.

Red becomes most ignited, most violent, on black. Thus, the most conspicuous insignia, the colored signs that strike us most effectively, are in red printed on black.

Finally, it is very curious that the gamut of meanings for red changes completely when this color moves toward pink. It then will become delicate and harmonious, as well as a symbol of femininity.

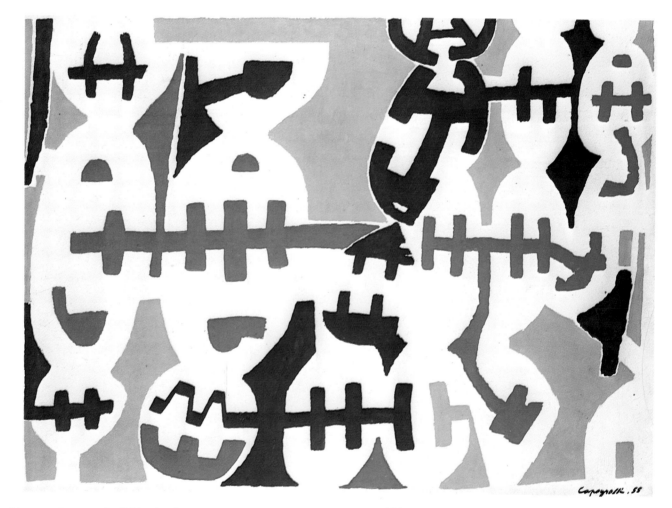

Giuseppe Capogrossi (1900): Surface 114. *1955. Milan, Galleria del Naviglio*
Capogrossi's works contain an idea of order and spatial balance in the composition of shapes and colors. The colors are usually white, black, and red and always flat and pure. The space is always painted as a surface, with no other meaning than itself. "I first had to use natural images, similes and similitudes taken from outer reality. Then, I tried to express, directly and autonomously, the meaning of the

space within me, which I realized by carrying out the actions of my life."

The Experience *The invention of a particular autonomous space, brought out by an original "form"; the importance of the juxtaposition of the colors and the different values of a black or colored "shape" against a colored or black background.*

Violet

Violet is a blend of blue and red. But it is hard to find its exact tone, which should be neither too red nor too blue.

In the color circle, violet is at the opposite pole from yellow, its complementary. And if yellow symbolizes light and knowledge, violet represents the unconscious, darkness, and mystery. In general, it is tied to the notion of sadness. But sometimes it can be reassuring, depending on the adjacent colors with which it contrasts. However, if it veers toward purple, in large amounts, then it inspires fear. Violet is the color of transgression as well as sadness. In ecclesiastic symbology, violet is the color of the sacred vestments of the priests on the days when they evoke the Passion of Christ.

"When red is influenced by blue, it acquires an intolerable presence," writes Goethe in his *Theory of Colors.*

But we should not forget that with the mixing of two colors as diverse and contrasting as blue and red, the significance of the resulting color varies with the amount and prevalence of either blue or red. Pure violet suggests darkness and sublimity; blue-violet, solitude and isolation; red-violet, strength and spiritual love.

Violet thus seems able to confirm a great variety of expressive values and meanings. The warm and light colors represent the luminous side of life, the splendor and color of light. The cold and dark colors evoke the shadowy and negative side, the mystery and sadness of the dark.

Richard Wilson (1714-1782): Landscape, Monte Carlo. *Black pencil, and stump, white highlights on lilac paper, 283 x 419 mm. San Marino, California, Henry E. Huntington Library and Art Gallery*

In this painting, we are struck by the both colorist and luminous unity of tone, achieved by the use of a single color, or rather by rendering diverse tones of violet with the stump, black pencil, and the white on lilac paper.

The Experience
The possibilities of monochrome drawing, either with diverse nuances of a color on white paper, or with white and black pencils creating different nuances of the paper color; the characteristic layout of a traditional landscape: horizon halfway up, background details in precise, subtle strokes, foreground on one side, in shadow.

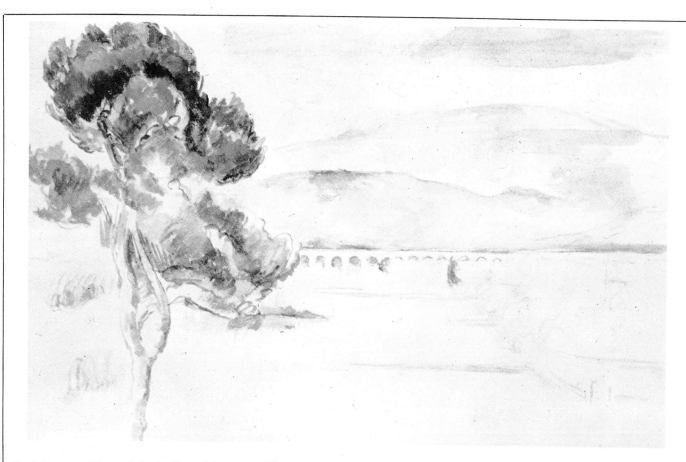

Paul Cézanne: View of the Valley of the Arc with Railroad Viaduct, *c. 1885. Gray pencil and colored tinting on cream-colored paper, 470 x 290 mm. Vienna, Albertina*

This landscape takes up a theme that Cézanne frequently repeated. The composition is extremely simple. It is based on the vertical of the pine in the foreground, left, and the horizontal of the viaduct line, which slices the drawing in half. However, it is really the tints that make this watercolor a fascinating view, transforming the subject into an extraordinary event: the blue of the large pine with the barely indicated spots of green, the blues of the viaduct arches, hills, and sky, and the color of the paper, which suggests the vastness of the valley.

The Experience
The basics of composition; the use of blue tones, which submerge the landscape elements in the atmosphere, making the distant objects seem far away; the importance of white, of the non-drawn areas, which give free rein to the viewer's imagination.

Blue

If yellow is associated with the mind and red with the heart, blue is associated with the spirit.

Recalling the vastness of the sky and the sea, blue inspires reflection. Even though it is considered a cold color, it has an inner nobility, a tenacious strength, a tranquility and freshness that virtually make up for its negative meanings, i.e., sadness, depression, solitude.

The association of blue with the sky, with depth and immensity, makes it symbolize faith (the robe of the Madonna is blue). For the Chinese, it indicates immortality; for the ancient Romans, Jupiter. For all nations, it symbolizes the supernatural, the transcendent. Consequently, in interior decorating blue seems to have a calming effect, which makes it an especially favorite color for decorating bedrooms.

In drawing and painting, blue is used to express the depth of the atmosphere, as well as mystery. Cézanne, for instance, recommends using blue in a landscape in order to "move mountains back in the space." Picasso, in .turn, garbed the mystery and intrinsic sadness of life in the nuances of his blue period. He painted blue jugglers, vagabonds isolated by blue tones—blue-violet, blue-green, blue-gray—in a destructive atmosphere of proverty and suffering. He also showed tender mothers clutching babies to their breasts—reminiscent of the Madonna.

Blue used in these ways seems to acquire new richness of meaning—melancholy and contemplation. The "blue" meanings make blue (as Picasso writes) "a color that seems to be the best in the world ... the color of colors. ..."

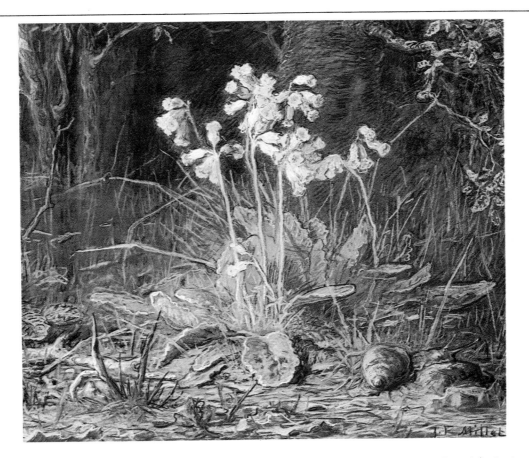

Francois Millet: Primroses, *1868. Pastel, 400 x 478 mm. Boston, Museum of Fine Arts*
Brown tones are used for the background and the earth, on which we see a snail in the same color. The splendor of the yellow and the soft, luminous greens of the primroses stand out against these browns. Brown, yellow, and green are the three colors making up this original woodscape. But the most interesting features are the adjacency of the tones and the prominence of the bright, vivid green of the leaves, grass, and stalks against the brown shadow of the background. The green, a cool color, emphasized by brief strokes of yellow and white, stands out against the warm tones of brown, while remaining immersed in the forest atmosphere.
The Experience: Unity of background tones and unity of primrose tones, in the proximity of yellow, green, and white; a loving delight in details; fusion and synthesis of the final result through the use of a green superimposed on the brown tones, with a contrast of hot and cold, light and shadow.

Green

Green is one of the complementary colors that result from a blend of primary colors, the union of blue and yellow. Aside from the tones we can pinpoint in the chromatic disk (green-blue, green, green-yellow), it has further tones: bottle green, emerald-green, and olive-green. All of these nuances are characterized by different luminosities, and they are frequently linked to the colors of nature—the emerald or the olive leaf, for example.

Because of its wealth of variations, green, in practice, comes not only from mixing blue and yellow. (Incidentally, this blend varies, depending on whether we use, say, chrome yellow, Prussian blue, ultramarine, and so on.) Prepared greens are also available commercially.

Green is one of the so-called cold colors, combining, of course, the qualities of blue and yellow. It is bright, but also restful. It inspires relaxation and meditation—but not sadness, thanks to the vivacity of yellow. While blue recalls the line and the vast hue of the ocean horizon, green evokes the wide stretches of fields with tender or lively colors, heated by the yellows of sunlight, and often brought out by the tones of its complementary color, red.

Green and brown are the colors most often found in landscape art throughout the ages. Their always harmonious relationship is linked to the dark hue of the sky, often with thanks to the presence of blue, which renders the atmosphere.

One Drawing, Eight Colors

Duilio Cambellotti's lithograph has been reproduced here in various colors in order to show diverse examples and to suggest multiple interpretations based on each color.

Obviously, not all hues lend themselves to a reproduction of this lithograph, which shows four women around a fire inside a hut on the plain surrounding Rome. Which color or colors can best depict the subject or most effectively capture the theme and atmosphere of the lithograph?

For each variation hue, it would be interesting to find the meaning that the different color

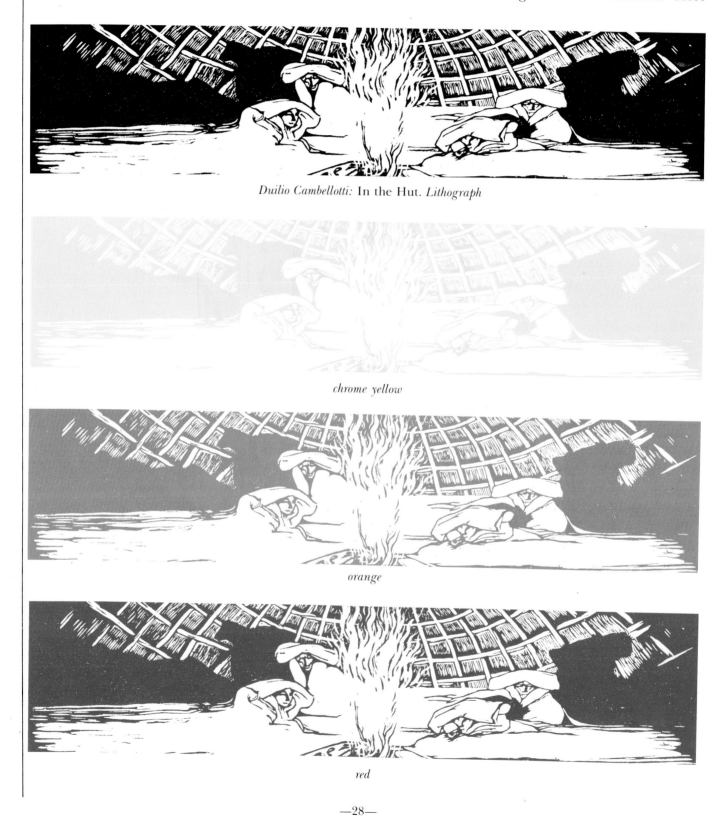

Duilio Cambellotti: In the Hut. *Lithograph*

chrome yellow

orange

red

brings to the scene: The meaning is obviously tied to the tone, but it is also determined by the effect that this tone has upon an individual viewer. If colors do, indeed, have precise significances, each of us nevertheless has a personal relationship to the world of colors, which, even without the overall picture of influence and suggestion (known, and even codified) depends on an individual's color sensitivity. Thus, the warm colors seem more suitable for rendering an interior, while cool colors tend toward abstraction. On the other hand, black and sepia appear more open to interpretation.

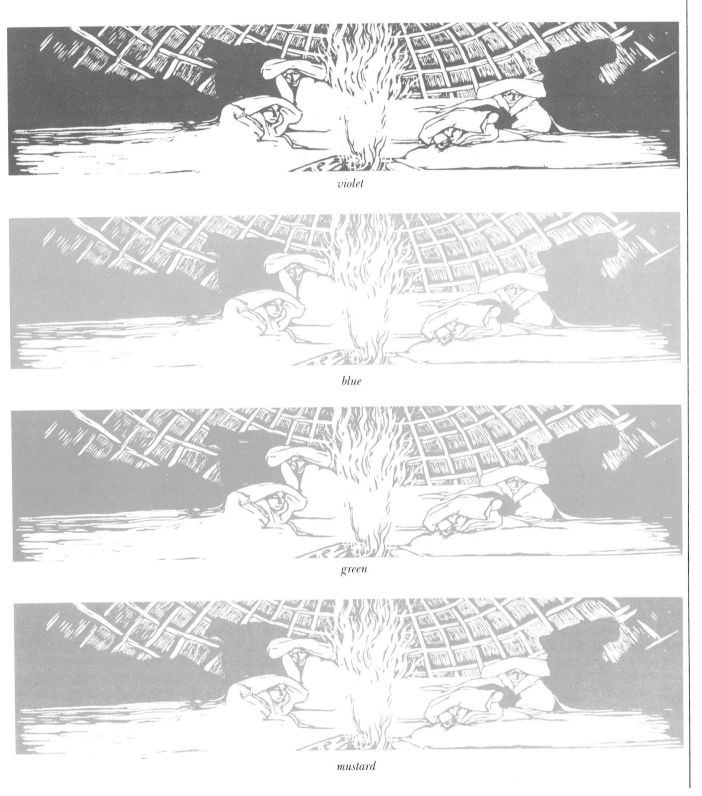

violet

blue

green

mustard

A Drawing a Day:
A Female Portrait, Four Colors

The proposed drawing shows a female face characterized by the ample space of the hat (which unites with the tree branches on the right), the chiaroscuro of the tones in the shadows, and the chiaroscuro in the fusion of the landscape outline with the foreground figure.

The same subject is "seen" and realized in black, in yellow, in red, and in blue, with equal attention to the shadings of the colors, the gradations of the tones, and the monochromatic result. Nevertheless, each color is able to suggest light,

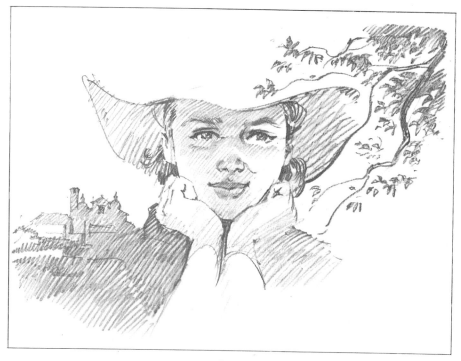

black

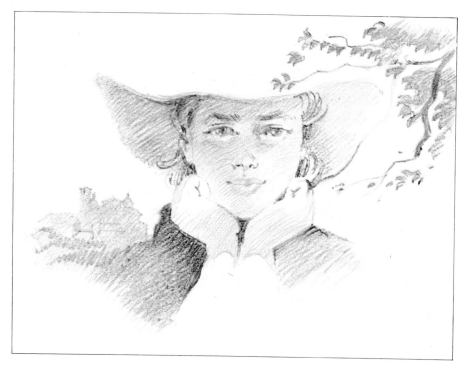

yellow

volume, depth.

Gazing at these four examples with their four different hues for the same subject, we cannot help asking which color is preferable and why.

Granted, a great deal depends on the individual observer's color sensibilities; he may personally prefer a given color and certain nuances and variations. Likewise, the three basic colors used along with black (leaving the actual enrichment of the "color" up to the viewers imagination) bring diverse characteristics to the three drawings. Yellow makes the drawing more abstract; red, more vivacious; blue, more real by immersing it in the atmosphere.

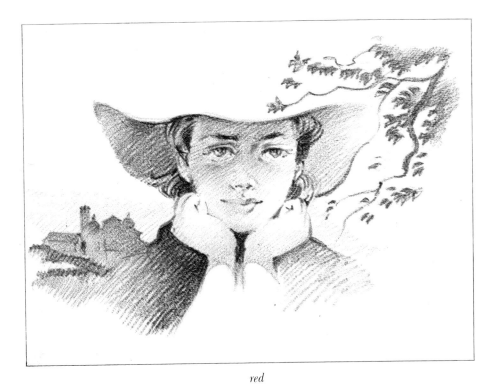

red

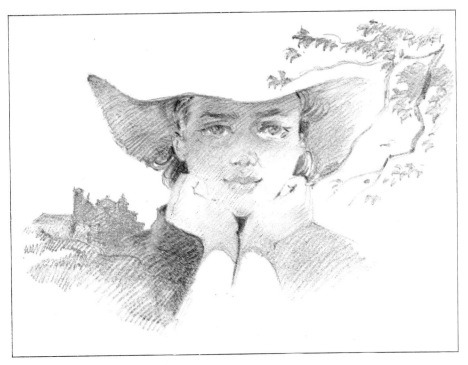

blue

Finding the Colors

The surrounding world that we see every day is a colored world. Yet we are so used to these colors that we frequently do not really *see* them.

The easiest and most immediate color exercise is the following one. Find the colors, especially in drawings and paintings in which the artist had tried to recreate the colored reality that he has managed to *see*. Leaf through the pages of this drawing course and observe the many colored drawings reproduced here. Select those that interest you most from a chromatic viewpoint and *find* the colors. How?

1) Pinpoint the chief tone that you feel characterizes the entire work and constitutes the predominant color.
2) Seek out any pure colors (red, yellow, blue) in the various elements of the drawing and establish their inter-relationships.
3) Find the intermediate colors (not only green, violet, or orange, but also the tertiary colors, which are variations of these three); and then establish the primary colors making them up.
4) Indicate the presence of white and black, i.e., the two non-colors, which, mixed with the colors, determine the values.

The reproduced drawing points out how we can do the exercise. The diagram indicates the found colors and notes the tones on the edge of forms. An analysis can be more or less deep and varies with each drawing and its artist's palette.

In Dupré's drawing, the most conspicuous tone, and apparently the fundamental one, is gray-blue. The colors employed are gray, blue, white, green, and ochre in various and different blends that are enriched by the suggestive grain of the paper, especially in the rendering of the clouds.

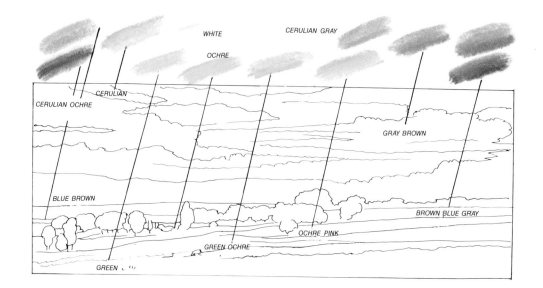

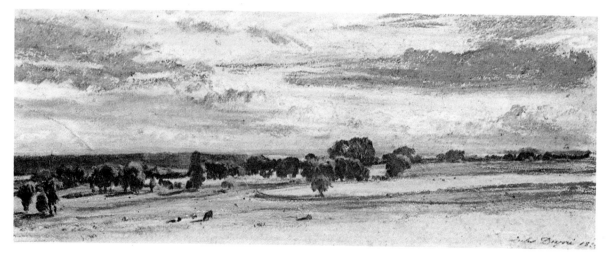

Jules Depré (1811-1889): The Plain. *Pastel. 150 x 400 mm. Paris, Louvre, Cabinet des Dessins*

Reality and Color

It is impossible to imagine a world without color. After all, colors are light; and light, in all its variations, marks the rhythm of our lives from the wan light of dawn to the pitch-blackness of night. One of the most thrilling natural spectacles is the rainbow in the sky—a splendid aureola of the colors that science has classified in the spectrum. And children can also find rainbows to marvel at in the reflections of dragonflies or in the transparency of soap bubbles.

Just as sound transmits a sense of color in words, so too color gives form a spiritualized musicality that intensifies it and transforms it, submerging it in light. And if we picture a lively, cheerful, active world, we cannot help thinking of a colored world.

Is it easier to draw the shape, the outline of an object, a figure, a landscape, or is it easier to depict its colors?

This is a hard question to answer. In a logical process of drawing, it may be preferable to render the form and then the color. However, the effects of the colors are essential for artists or anyone for that matter who is interested in the spectacle of reality and wishes to depict it.

These effects can be verified by visual perception and for this we need analyses and theories. It is certain, however, that the most profound and meaningful secrets of colors reside in the depths of our sensibilities. If you can express yourself fully with a pencil and colors, then you don't need chromatic laws and theories. On the other hand, if you fail to see and interpret the world around you and within you, then you have to know these laws and theories, you have to try to understand them and study them.

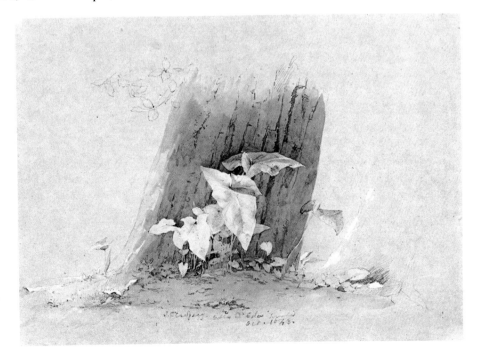

Jasper Francis Cropsey (1823-1900): Plants at the Foot of a Tree, *1848. Pencil and wash, 285 x 397 mm. Boston, Museum of Fine Arts, Collection M. and M. Karolik Nature has always fascinated artists who find themes here for depicting their landscapes. In Cropsey's watercolor, the frail leaves, illuminated by an "aquarium" light, symbolize life and hope at the trunk; yet the delicate colors speak an incisive language.*

The Landscape

Among the many artistic themes, landscape is one of the highest and most characteristic expressions of the poetics of civilization, that is, of the way in which we both see and approach nature.

The Middle Ages, until Giotto, had a symbolic vision of nature. The Renaissance then developed an interpretation based on realistic perspective. Artists produced "fantasy" landscapes (Polidoro da Caravaggio, Salvator Rosa) and ideal landscapes (Giorgione, Titian); then heroic landscapes (Carracci, Poussin) and naturalistic ones (Corot, Courbet, Constable, Cozens, and the Impres-

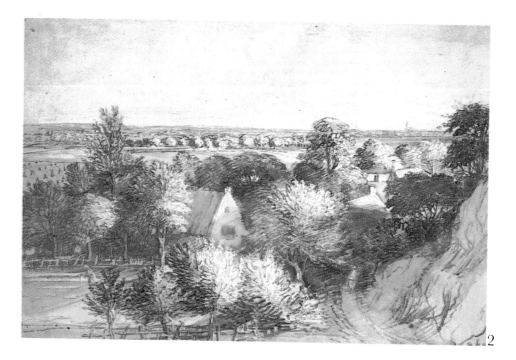

1

Jan Bruegel the Elder: Stormy Sea. *Pen and brush with black and blue ink, 195 x 232 mm. Berlin, Staatliche Museen, Kupferstichkabinett*

2

Philips de Koninck: Landscape with Houses Among Trees. *Pen and brown ink, brown and gray watercolor, white highlights, 250 x 290 mm. Leningrad, Hermitage*

sionists). Indeed, the Impressionists turned the Renaissance landscape vision inside out with their rendering of light. Next, the Divisionists, Cubists, Futurists, and Surrealists, in their oneiric-symbolic and abstract quest, opened the way for the non-figurative trends of modern art. The landscape seemed to disappear once and for all, at least as an image of nature.

Today, the modern age and its artists, in seeking themselves and a new relationship with the surrounding world and with nature, are returning to landscape as an expression of the personality and the desire for freedom and infinity.

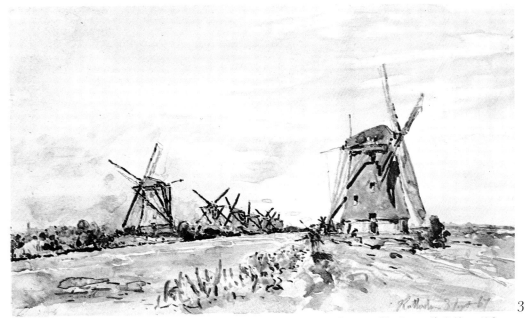

Johann Barthold Jongkind (1819-1891): Windmills. Watercolor over black pencil. 263 x 450 mm. Cambridge, Mass., Harvard University, Fogg Art Museum, Grenville L. Winthrop Legacy.

1. This is an extraordinary drawing, with few strokes and only two colors, it manages effectively to render the stormy waves, the force of the wind, and the agitated figures struggling against the wind. The pen and brush strokes of brown ink achieve a particular tone and fascination on the pink paper.
The blue used thinned-down in a pale wash effect, and the contrast with the pink makes it transparent and forceful. The entire scene, with its strange rose-blue light, evokes the gold of sunset as well as something unreal at a specific moment of a stormy day, which we are invited to witness.

The Experience
A rather high horizon, as if the scene were being viewed from a dune. Although only two colors were used—blue and brown—the pink of the paper alters the transparent blue, giving it an original tone, and causes the brown spots and tones to attain a particular value.

2. De Koninck was a pupil of Rembrandt's. Taking up his master's themes, he composes his panoramic view with foreground houses under trees and a distant background of trees and buildings; the landscape is seen from an elevated viewpoint. The artist uses only a few tones, gray and brown ink with a bit of white lead applied with a pen and a brush; however, the effect is that of a sunny and colorful landscape.
This extraordinary result is due to the closeness of various tones of ochre, brown, dark gray, and white, and especially the interrelationship of all the tones of the panorama and the whitish tone of the sky. This drawing is practically a monochrome; but the brown ink, masterfully gradated in various tonalities, is an interesting example of the possibilities of juxtaposing these variations.

The Experience
A high horizon, with the strip of terrain prevailing against the strip of sky within the rectangle of the paper; shadowy horizontal foreground with houses and trees; almost monochrome drawing, with brown and gray intensified by white.

3. This drawing, a typical example of Jongkind's art, shows his love of light dominating the subject matter, even the line of windmills along the canal bank. The horizon is traditionally very low: the ground fills only one fifth of the space, the other four fifths are covered by the sky in blue brushstrokes. And the blue brings out the shapes of the mills, canals, and grassy fields. The watercolor is simple; in its mastery it suggests the artist's experience: first, the azure of the sky and the canal; then, the green of the earth; finally, the green-blue of the windmills. The harder-edged strokes of the shadows and the windmill blades along the far bank stand out against the wash-like color of the rest of the painting.

The Experience
A low horizon with the sky predominating; two basic colors, green and blue and a blue-green blend, plus a few essential strokes for the shadow lines; color spots on a pencil sketch.

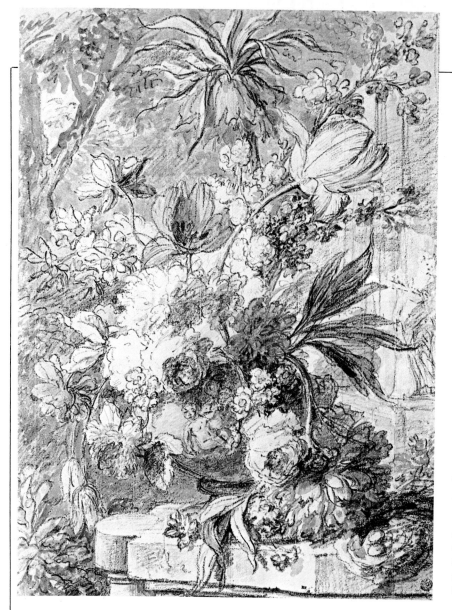

Jan van Huysun (1682-1749): Vase of
Flowers. *Charcoal and watercolor, 475 x
356 mm. Paris, Louvre, Cabinet des Dessins*

*A still life outdoors: the invention and artifice
of the flowers in the vase (tulips, amaryllis,
roses, etc.) is emphasized by the contrast with
the background trees and decorated
architecture. The trunk and foliage are treated
naturalistically, with large transparent
brushstrokes. The flowers and the bronze vase
decorated with relief patterns are drawn in
charcoal and painted in watercolor with
chiaroscuro effects brought out by charcoal
shading. The diagram reveals the directional
lines of the composition and the areas of
yellow and red.*

The Experience
*The composition is based on wide curving
lines in the flower stalks and the vase; soft
colors with a few yellows, the green of the
leaves, and two red spots; yellowish
background giving depth and unity to the
scene.*

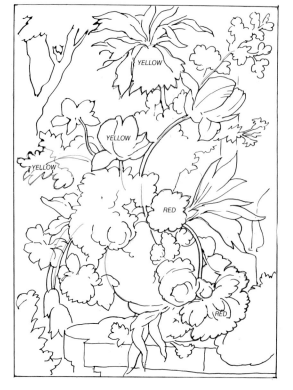

The Still Life

Still life refers to a static, silent, motionless nature
as opposed to a living model. Nothing moves in
the still life—unlike the pictures of figures or
other animate beings.

Although the earliest still lifes date back to
Greek and Roman painting, it was not until late
Mannerism, during the sixteenth century, that
the still life became a distinct genre. The interest
in examples of Antiquity, the search for and
curiosity about naturalism, the desire to go
against the rhetoric of historical painting all came
together in still lifes of flowers, fruit, fish, game,
crockery, and musical instruments.

From Bruegel the Elder to Caravaggio (who
painted the famous *Fruit Basket)*, Chardin, and
finally Delacroix, Courbet, Cézanne, and Picasso,
the still lifes multiplied, always expressing an inti-
mate, sometimes interior, often symbolic world.

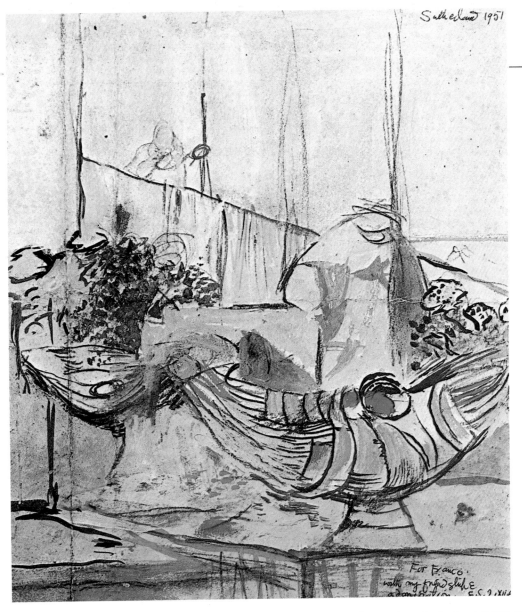

Sutherland 1951

For Franco.
with my friendship
admiration. C.S. 9.XII.

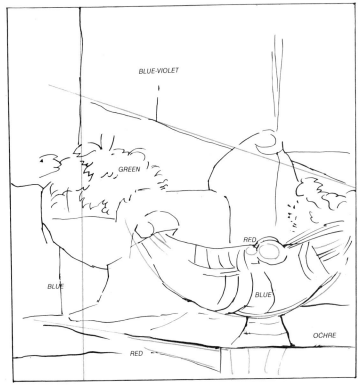

BLUE-VIOLET

GREEN

RED

BLUE

BLUE

OCHRE

RED

Graham Sutherland (1903-1980): Composition. 1951, tempera and pastel. Milan, Collection Franco Russoli

A still life by a British painter who seems to be reseeing *Matisse, though in a very different key. The highly agile composition is stressed by the curves of the bowl and harmonized by the blues and greens; these colors are brought out by a few areas of red—the whole immersed in light. When interviewed by Giorgio Soavi, Sutherland expounded on his ideas: "To explain why I feel impelled to paint a given object is as impossible as explaining why I am attracted to certain persons, but one reason is the way light becomes a transforming element. When it falls upon an object it transforms it into something else. Then there is also a psychological side. Light gives a sense of tranquility and allows the mind to move.... There are things like shadows edged by light, purely beautiful decorative forms...which create a mysterious, a virtually transcendental atmosphere, transfiguring the shapes you see before you."*
The diagram reveals the main lines of the composition and the red spots and brushstrokes.

The Experience
Mixed media, pastels and tempera, with subtle strokes for the outlines; soft colors, blue, violet, and ochre, with red spots and lines.

The Perception of Colors

We have already studied the workings of the human eye. The light coming from the seen object strikes the eye and is refracted by the cornea. The light then enters the ocular chamber, i.e., the inside of the eyeball, and passes through the pupil (the small hole at the center of the colored iris). The amount of light that enters the eye is regulated by the iris, which contracts for stronger light and dilates for weaker light. The pupil is black because most of the light entering the eye is absorbed.

Finally there is the crystalline lens: its curvature is modified by the ciliary muscle so that it may focus correctly on the images of the outer world, which are actually projected upside down.

Within the eye, the retina, which is .4 mm thick, is made up of 120 million rods and six million cones. The most sensitive area of the retina is the fovea centralis at its center; its job is to furnish a precise vision. It is made of about one hundred thousand cones that are sensitive to red and to green. Each cone and each rod contains molecules of a pigment, the rhodopsin, which absorbs the light entering the eye; this light subdivides into its components, releasing a chemical transmitter. This sparks the highly complex process of the transmission of electrical messages from the rods to the brain. At the same time, special biochemical mechanisms regenerate the molecules of the "divided" rhodopsin, restoring them to their original sensitivity to light and thus enabling them to recommence the vision process.

The cones also possess pigments similar to the rhodopsin of the rods and are capable of going through analogous processes of whitening and regeneration and, therefore, getting the cells of the cone to produce electrical reactions to light.

There are three types of cones, characterized

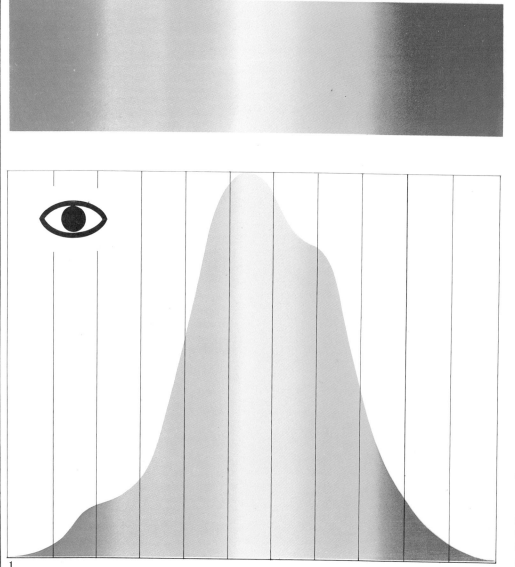

1

1. The wave lengths of the visible spectrum range from around 400 to 700 nanometers, but the sensitivity of the eye to color varies greatly within the arc of this interval. At the extremes of the spectrum, ocular sensitivity is very weak, but it rapidly intensifies with green and yellow.

2. If the illumination is very weak, colors are not easily distinguished, and ocular sensibility shifts toward blue, which seems brighter than red. We can observe this phenomenon by gazing at this illustration first in light, then in darker surroundings after several seconds of adjustment.

by three types of visual pigments highly similar to the rhodopsin. These pigments, illuminated by light, regenerate more rapidly. They are sensitive to three different intervals of the spectrum, conventionally known as: red, blue, and green. They have a wide range of absorption, between four hundred and seven nanometers (a nanometer, nm., equals one billionth of a meter).

An object is called white if it reflects and diffuses the white light of the sun and the diffuse light of bright clouds on a bright day. White light contains a zone of radiation that goes from the extreme red ray to the extreme violet ray (infrared and ultraviolet).

The retina has a predominance of "red" and "yellow" cones, which produce the sensation of yellow. There are few cones sensitive to blue light; and most of them are absent from the fovea centralis, the central part of the retina. On the other hand, the rods are sensitive chiefly to green-blue light.

Thus, during the day, when the cones are active, the eye is sensitive mainly to yellow light. At sunset, when the eyesight gradually shifts from the cones to the rods, its sensitivity to the spectrum likewise changes. The more vivid the light, the greater the number of illuminated rhodopsin molecules, and the weaker the electrical activity of the receptors. Oddly enough, it is darkness and not light which generates the electrical signals transmitted to the nerve cells of the retina. This peculiarity is explained by the fact that the human eye is called upon more frequently to distinguish dark objects against bright backdrops than vice versa (for instance, printed words on white pages). In light, therefore, the consumption of energy needed to produce electricity is less.

2

A Drawing a Day: The Landscape

The examples presented here illustrate two different views of a single landscape: one done with colored pencils and one in black and white.

When you deal with the problem of drawing a landscape for the first time, one of the most difficult aspects is deciding on which part of the landscape you want to render. Your choice can be guided by various factors, for instance the presence of an element in the foreground, the importance of a precise theme, the succession of different grounds, the significance of the horizon, or the space of a sky animated by clouds.

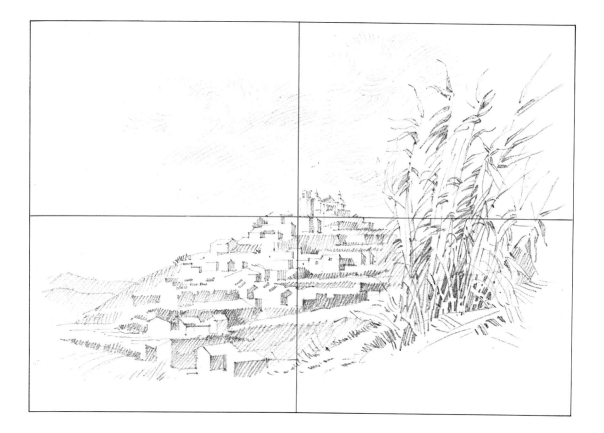

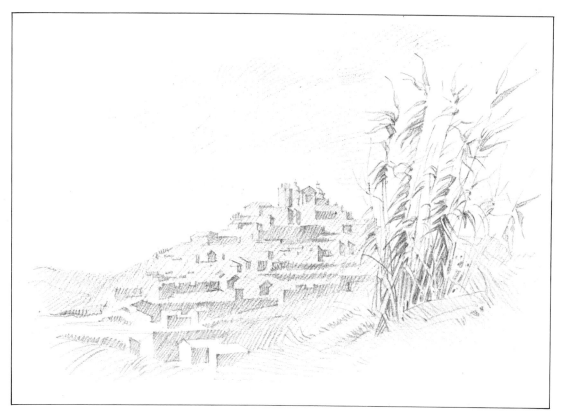

The individual artist's sensitivity and direction must therefore emphasize a particular element in order to suggest one subject area rather than another. In any case, the cross frame (which isolates a framed "space," and thereby positions the various landscape elements within the rectangle of the paper) and the two mutually perpendicular axes (acting as references for the shapes and proportions of the various elements) become valuable instruments for the artists.

These two examples of the landscape barely differ from one another; yet they suggest different viewpoints of the same subject, with two different views.

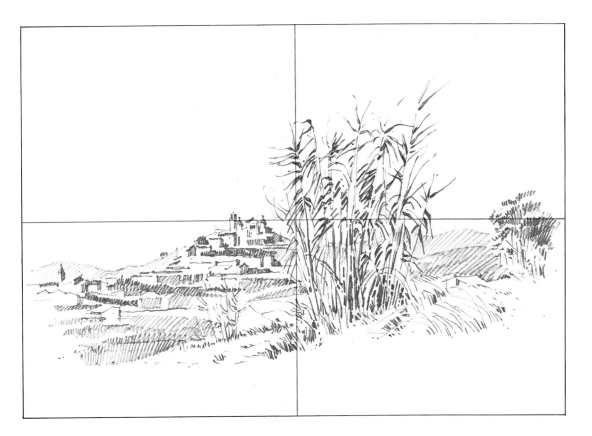

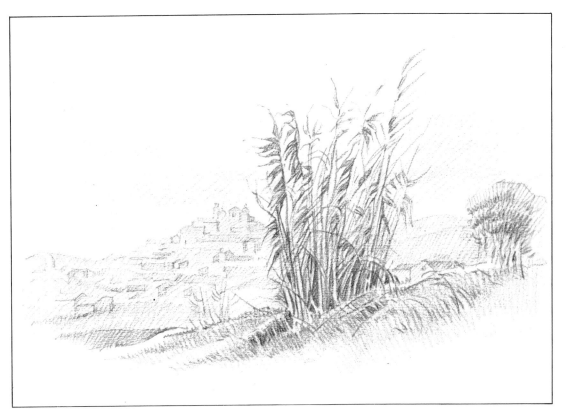

A Drawing a Day: Still Life with Peaches

A still life is a useful exercise that any of us can prepare by selecting the objects we prefer—fruit, flowers, fish, or game.

You have to select a subject area for a landscape (a process that, as we have seen, is not always as easy or as available as it would seem to be). On the other hand, for a still life, the artist arranges the objects—the flowers and fruit, the fish and birds—in terms of what he or she feels is effective and meaningful.

In the present example, the subject is made up of fish, lobsters, and a lemon. These items were selected not only because of their shapes, but also, and primarily, because of their colors and the

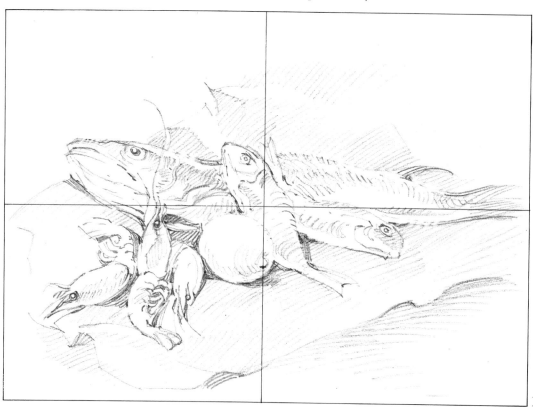

1

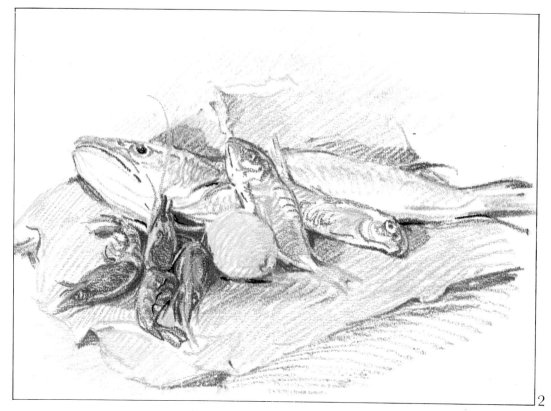

2

possibility of numerous arrangements. This exercise is thus based on the relationships between the reds, the orange, and the yellow in contrast to the gray, green-blue, and the brown tones of the background. Diagrams 1 and 3 illustrate the first phase of the procedure: defining the shapes by defining the proportions and inter-relationships. All this is facilitated by the use of the crossframe and hence by the references to the horizontal and vertical axes.

Drawings 2 and 4, however, suggest the final version, one of many possibilities, depending on the individual artist's personality.

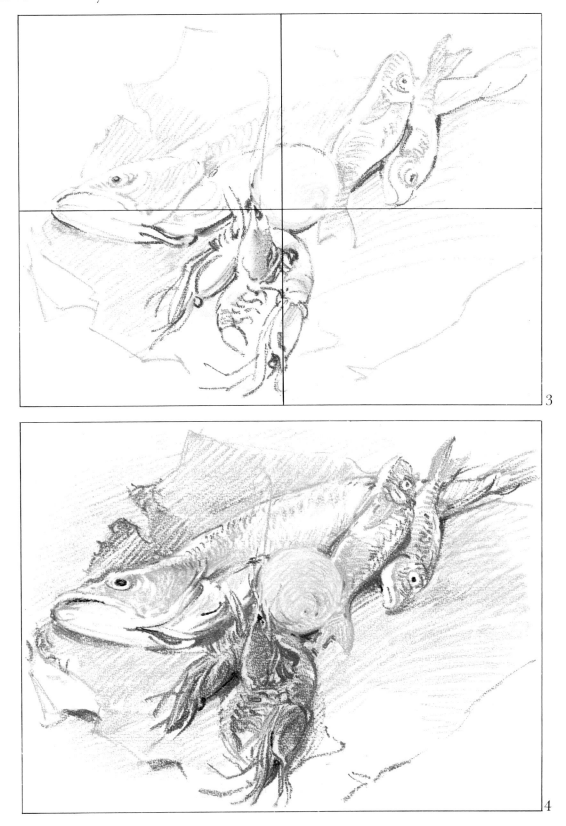

3

4

Painted Facades

One characteristic of the historical city centers in Italy are the painted facades. These facades are decorated not only with colors, but with an ornamental apparatus that combines fountains, cornices, balconies, balusters, and pilasters. So many of these minor and even major Italian centers (just think of Rome, whose historical center is crammed with painted facades) are adorned with figurative as well as architectural motifs.

On the one hand, even the most ancient builders used local material—a logical choice, of course—thus adapting their constructions to their environment in a natural way. On the other hand, the individual *homo faber* tried to make at least some of his buildings, the most important, stand out by means of colors. The Greek and Roman temples were colored, as were their Oriental counterparts, and even those of the ancient Maya, in Mexico. The Byzantine basilisks were resplendent with colors, gold, and mosaics. It was only Romanesque architecture that allowed the splendor of color inside; the gold of the mosaics was supposed to "annul" the walls in a quest for infinity, bestowing an image of the outside on the colors of the stone, the bricks, and the marble.

Color has remained on the facades of houses not only for decorative reasons. In a series of row houses, the color distinguishes each single unit, each residential strip. This differentiation gave a distinctive character to Italian seaside towns, which could be seen from far away by returning sailors.

In the facades of major Italian palazzi, a decoration made up of columns, cornices, fountains, and pilasters, may not be possible on certain streets or squares, because the view would not show them off. Instead, a painted decoration, a "fake" architecture, merely drawn, although in correct perspective, lends prestige and importance to a building. Sometimes, the facade becomes a veritable standard, a painted background for the perspective of the street or square.

In modern buildings, the colors of facades are those of the construction materials, which are left exposed. Next to the gray of concrete, we find the red of bricks or the blue of the window panes. One special feature is the vast glass front, which reflects clouds and surrounding structures.

Hans Holbein the Younger: Sketch for the Façade of a Ballroom. *Pen and ink, watercolor, 571 x 339 mm. Berlin, Staatliche Museen Preussischer Kulturbesitz, Kupferstichkabinett*

The Palette

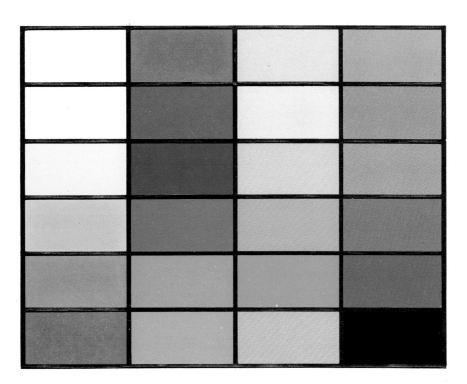

A painter's palette reveals his or her personality more effectively than any other tool. The palette can consist of only three colors, the basic ones, or a series of hues arranged according to how useful and convenient the artist considers them. This diagram suggests a possible arrangement.

A palette is not just an oval or rectangular board that the painter holds by inserting his thumb in the hole, and arranges his oils or watercolors on. The word *palette* also refers to the range of his colors, his predilections and modulations in the overall effect of his painting. Ultimately, *palette* signifies the colors that characterize a painter's art.

The beginner with watercolors ought to know the reasoning behind his palette, his choice of colors and their disposition. Not even an expert painter can respond immediately and thoroughly to the seemingly simple question of which colors are necessary for his work. Makers and sellers of paints and pigments can mention the names of the more complicated colors: "English green, madder red, chrome yellow." Some will parade their learning by recalling ancient terms that sound even more bizarre, such as lapis lazuli, and so on.

Yet the only colors that exist in nature are those that arise from the breakdown of light: red, orange, yellow, green, blue, and violet. The infinite variations that we see in the surrounding world are modulated solely on these colors. Nor can we imitate or recreate them on our palettes without pigments. However, even if we use the most intense color materials, we cannot obtain darker or lighter variations without the help of white and black. That is why we also need these "achromatic hues" (i.e. colorless colors) along with the six basic colors.

Once you have chosen your colors, you have to ask what would be the best arrangement of pigments on the palette. The easiest and most logical

answer would be the order indicated by the solar spectrum.

White and black can be placed at two extremes: white at the beginning, black at the end.

White is used if the artist employs covering paints, e.g., tempera or oils; for watercolors, the white is present in the paper itself. Oil and tempera painters use large amounts of white in order to lighten their other colors; they place it on their palettes between yellow and green, which are the least contrasting colors and which also mark the division between the so-called hot and cold colors.

How do the six basic colors plus black and white suffice to render the hues of nature and the imagination? Michael-Eugène Chevreul, a famous chemist of the early nineteenth century, put out *Chromatic Chart.* In it he demonstrated practically that with the six colors plus black and white we can obtain as many as fourteen thousand gradations of color. He left open the possibility of inventing

Georges Rouault (1871-1958): At the Mirror, *1906. Watercolor, 720 x 550 mm. Paris, Musée d'Art Moderne. Centre National d'Art and Culture Georges Pompidou.*

As always in Rouault, the stroke and the color are intimately connected. There is no attempt at verisimilitude, but rather a social critique that the entire scene, the composition, and the colors blurt out in all their absurdity. The flesh tone is strangely bluish, brought out by the blue of the stockings, the colored background of the wall, and the pink couch. The mirror reflects the woman's face frontally; she is made up like a clown. The hues acquire strength and transparency from the thick outlines, which underscore the contours, as in a stained glass window.

The Experience
The compositional freedom goes hand in hand with the color freedom, the powerful contrasts of hues are stressed by the thick contours; the formal effort becomes an open social polemic in a new and dramatic reality.

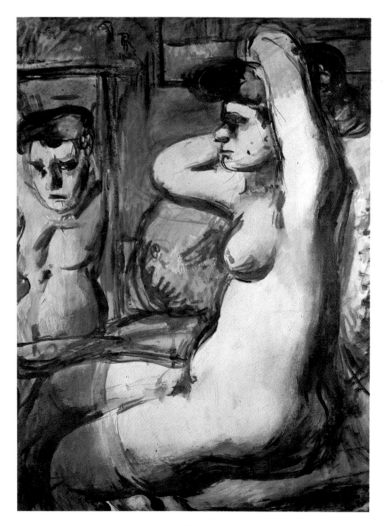

Edgar Degas: Studies of Classical Ballerinas. *Pastel, 720 x 700 mm. New York, private collection*

A study for the painting Waiting to Go On Stage, *one of Degas' many studies of ballerinas, whose figurative world fascinated him. This drawing stands out mainly because of the extraordinary interweaving of forms, a complex composition of four superimposed figures in a perspective that clusters them together. When we look at the drawing closely, we realize that the apparently casual movement is expressed in a perfect equilibrium with utmost attention and refinement. The composition is echoed by the colors: the pink and light blue tones of the female bodies glow within the dark-pastel outlines, like a stained-glass window.*

The Experience
A way of seeing and depicting movement beyond the three dimensions; an ability to see and interpret colors beyond reality, enclosing them in outlines.

others depending on individual demands and sensibilities.

Given this unbelievable panoply of colors, we nevertheless find many painters with an opposite theory and practice. Trying to keep their palettes as simple as possible, these artists use only the three primary colors, yellow, red, and blue. With an arduous deployment of energy, they mix and blend, ultimately obtaining the hues that can be bought ready-made.

There are other problems connected with the artist's palette. For instance, if he uses oil colors (more about them later), he has to deal with the layers of pigment that build up under the brushstrokes. If he uses watercolors, he has to cope with the solution and blending of the pigments on the palette or in the wells, the choice between cakes and tubes, between thin and thick brushes, round and flat ones. ...

These problems can be resolved only in the course of direct experience.

Blending the Colors on the Palette

How do we get the color mixtures, the many hues that we see around us and that we certainly cannot buy in art supply shops? The range of colors for the beginning watercolorist is necessarily limited, because it is impossible to find all existing colors commercially. We must therefore obtain nuances by blending the ten or fifteen pigments that we squeeze out of tubes.

Our research is based on our ability to analyze the component tones of the colors we wish to produce and our knowledge of the pigments making up each hue.

We know that blending red and yellow produces orange, blue and yellow green, red and blue violet; but obviously these are not the sole combinations. Indeed, the number is infinite; therefore, it is essential to experiment with the colors. Only your personal experience will lead to a thorough knowledge of how to use your own palette.

1) You can start with an assortment of pigments in the six basic colors of the spectrum: yellow, orange, red, green, blue, and violet.. By blending them all together, you obtain a dark maroon, almost brown. If you combine equal parts of opposite colors (yellow and violet); red and green; orange and blue), you obtain a series of warm, neutral hues.

You can lighten these colors by adding white and a touch of yellow.

If you want to darken them, you reach for black. However, the addition of black makes a

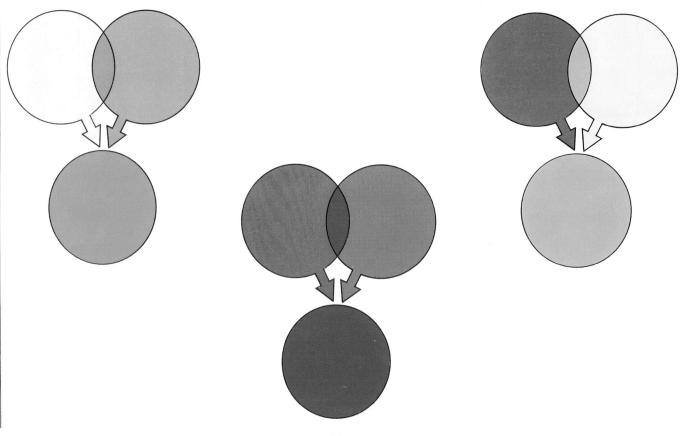

color grayish and muddy, depriving it of nuance and luster.

2) You may be able to add a bit of black to darken red, blue, or green, even blend in a darker version of the same color. However, you cannot do the same for yellow, which tends to look green with the addition of black.

3) If you combine yellow and black, varying the proportions, you can obtain a vast range of greens. (There is no need to mention that green is a fusion of blue and yellow, varying with the predominance of either color.)

4) Aside from the mixing of primary colors, instructive results may be obtained by blending equal parts of neighboring colors in the spectrum: yellow and red, red and violet, blue and green, green and yellow. If, however, we vary the amounts of each color, we achieve numerous variations in tone, which we can increase with a touch of white.

5) When using oils, we can achieve a pastel effect by adding a bit of color to the basic white.

6) You can obtain "cream" colors by blending white—a large amount of white—with yellow and red, with or without a touch of black.

7) Grays can be achieved by fusing white (in a proprotion of at least three to one) with black. We can obtain warmer grays by adding a touch of red; and richer grays by blending in, say, red, green, or yellow in varying proportions.

8) Often, a touch of black adds more brilliance to a color.

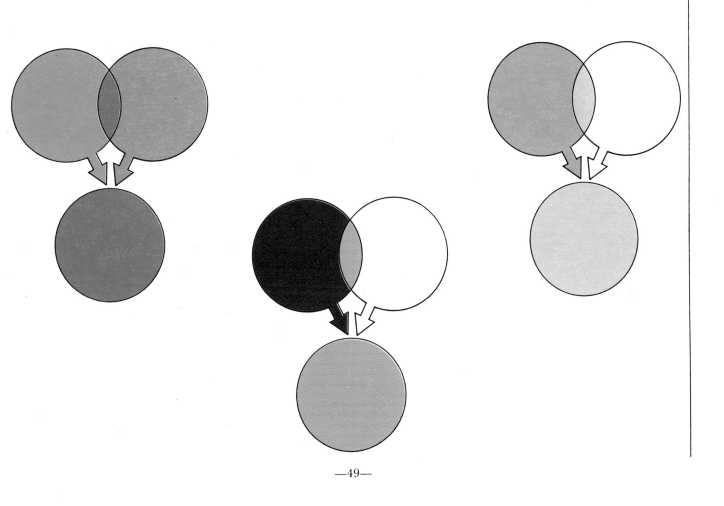

Seurat's Palette

One may logically assume that Seurat succeeded in rendering an infinite number of effects with the chiaroscuro of his black-and-white drawings, concealing them and suggesting them in the grain of rough paper with the Conté crayon. He was virtually a theorist of colors.

In order to have a clear notion of how both primary and complementary colors function, Seurat drew a disk on which he arranged the colors of the rainbow, with the various intermediate tones: blue, ultramarine, artifical ultramarine, green, violet, purple, purple-red carmine, red, vermilion, red-lead, orange, orange-yellow, yellow, yellow-green, green-yellow, green, emerald-green, green-blue, blue-greenish, blue-green, blue-azure, azure, light azure, and finally the initial blue. Then he added white to these colors, obtaining a range of values that runs from "shaded" white to pure white. The first colors were arranged around the center of the disk, moving away they gradually became lighter in tone, ultimately forming an outer ring of pure white. In this way, Seurat had a disk on which he could easily pinpoint the "complementary" of each color. Above all, he used this disk for scientifically applying his theories to his paintings.

How did Seurat paint?

His work was based on the principles of the simultaneous contrast of colors, and his palette was methodically prepared to this end.

Seurat used the so-called local color, i.e., the color of the illuminated object. He "achromatized" it with luminous brushstrokes. These correspond to colored light that is entirely reflected or else first absorbed and then reflected and, to light reflected by surrounding objects and to complementary colors.

In order to render such a combination of colors, to represent this complex interpenetration of all the colors and their shades under given light conditions, Seurat was not satisfied with the traditional blending of colors on the palette. He decided to use the process of optical blending that occurs in the observing eye: the colors are placed separately on the canvas and then melted together by the eye. Seurat applied the pigments with light dotting strokes, uniting on a miniscule surface area a huge number and variety of tones and colors, each corresponding to one of the components of the apparent color of the object.

Seurat aimed at achieving a luminosity and intensity superior to any blending on the palette. His works gave birth to Pointillism, a technique that interprets colors with an array of dots, points, and tiny strokes of component colors.

To some extent, the problem of Seurat's art and Impressionism in general seemed to be as follows: these painters had to establish the proper distance from which the observer could correctly perceive the blended effects. Pissarro tried to fix this distance at three times the length of the diagonal of the canvas. In practice it was up to the viewer to find the proper distance and focus on the dots in such a way as to reconstruct the hue intended.

However, the creation of an optical blending is not the only lesson we can learn from Seurat. The experiments of neo-Impressionism contributed fundamentally to the artistic use of color. More than anything, Seurat reminds us of the importance of the method, the need to organize and rationalize the chromatic experiments which sometimes seem to be guided purely by instinct.

This diagram illustrates the arrangement of colors on Seurat's palette; the upper row contains the colors he used; the center row contains those same colors mixed with white, which is indicated in the bottom row.

Ogden Rood's diagram, which was meant to illustrate the science of colors for artists, supplies a scale of tones blended from six hues; other tables indicate the tones produced by blending colored light in different ways. In order to blend colored light, Rood applies "a certain number of spots in two colors next to one another...blended by the eye at a certain distance. He thus experimented with a concept that, as we know, was basic to Impressionism.

Georges Seurat: Le Bec du Hoc, Grandcamp *(detail). 1885. London, By courtesy of the Trustees of The Tate Gallery*

The Impressionist painters achieved secondary or tertiary colors, as we know, by applying tiny adjacent strokes and dots of pure color; sometimes they even juxtaposed black dots to create effects of gray and to evoke shadowy areas, added dots of blue, violet, and black.

"I find it hard to understand why so much store is set by the word *research* in modern painting. As far as I'm concerned, research in painting means nothing. Finding is what counts. No one would care to follow a man who keeps his eyes glued to the ground and spends his entire life looking for the wallet that someone may have dropped.

If a man finds something—anything— even if that was not his intention, he will at least excite our curiosity if not our admiration. I have been accused of committing many sins; however, the falsest accusation is that the spirit of research is the chief objective of my work. When I paint, I try to show what I have found, not what I am looking

for. In art, intentions are not enough, and, as we say in Spain, love must be proved with deeds, not protestations. What counts is what one does, not what one intends to do. Everyone knows that art is not truth. Art is a lie that makes us realize the truth, or at least the truth that we are given to understand. The artist must know how to convince

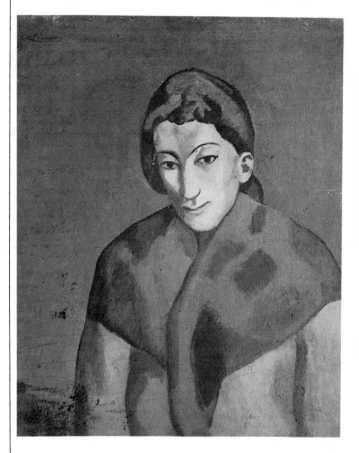

Picasso: Woman with Blue Shawl, *1902. Painting. Private collection.*

The two diagrams show the blue areas (the blue is mixed even into the wan tone of the face): hair and shawl (darker), garment and background (barely lighter).

One Hundred and One Colors

Picasso didn't like to give advice. But when he did give advice, especially toward the end of his life, he would amuse himself by ironically demanding the opposite of advice: the freedom to express oneself at will.

However, one of the things that Picasso believed in most firmly and one of the few pieces of advice he was willing to give was a simple and practical suggestion for anyone starting to draw in color. A beginner, said Picasso, should look at his subject, the reality he wants to reproduce, through a filter that virtually lets only one color through with all its more or less light, more or less luminous tones. This color depends on what the artist is trying to express. Paintings would thus become monochromatic, based on earth tones, reds, greens,

blues, and their hues. At the same time, they would preserve the unity and essence of a vision and its synthetic depiction.

As we know (and this is not unimportant), many great artists, even great colorists such as Titian, turned to practically monochromatic works during the final years of their lives.

We can therefore follow Picasso's advice with confidence. Or, if you do not care to give up the pleasure of color, the delight of applying the hues you see around you, then you can interpret a subject in two ways. First, pinpoint all its colors. Next, reduce the depiction to the chief colors, either the dominant ones, or the single color you find most expressive.

The point is to *see* colors, that is, to see them with the mind's eye, or the "third eye," as Picasso called it.

others of the truth of his lies. If his work merely shows that he has sought and sought a method of making his lies come true, then he has achieved nothing. The idea of seeking has often led painting astray, and the artist has gotten lost in arduous cerebral efforts. This may very well be the greatest mistake in modern art. The spirit of seeking has corrupted those who have failed to fully understand all the positive and conclusive elements of modern art, inveigling them into painting the invisible, hence the unpaintable. These people speak of naturalism and modern painting as opposites.

I would like to meet the man who has actually seen a natural work of art. Since nature and art are two entirely different realities, they cannot be the same thing. By means of art, we express our conception of what nature is not.

(From statements made by Pablo Picasso to Marius de Zayas, Spain, 1923)

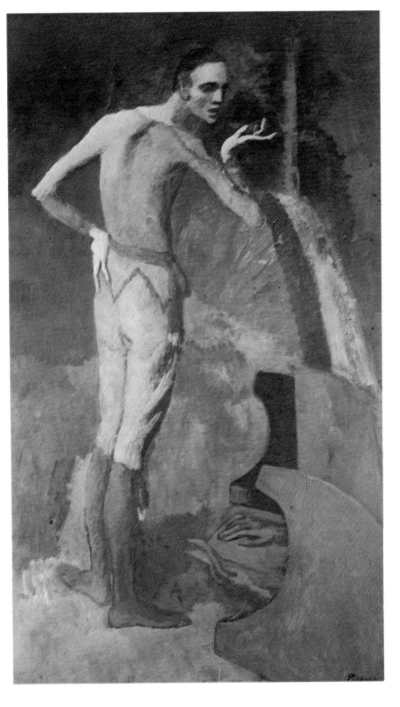

Picasso: The Actor, *1904/1905. Painting. New York, Metropolitan Museum of Art, gift of Thelma Chrysler Foy. The diagrams show the pink and the blue areas: against the neutral background (enlivened by the prompter's red cape), we see the expert interplay of the two darkened contrasting colors.*

A Drawing a Day: A Basket of Oranges

These two drawings are examples of a still life done twice: each time with colored pastels, but on different paper, white and then brown. They demonstrate a method of working and the palette, i.e., the colors used.

Diagram 1 reveals the compositional process. The red-pencil sketch shows the first phase of the drawing: the choice of a framework, in other words, the definition of the subject matter and the layout of the drawing within the rectangle of the paper. To make our job easier, we have once again used a crossframe. By establishing the horizontal and vertical axes, this tool facilitates the positioning of the compositional elements within the space of the drawing.

The sketch, which precedes the color drawing here, is not always necessary. We could simply begin with the colored pastels, using the different

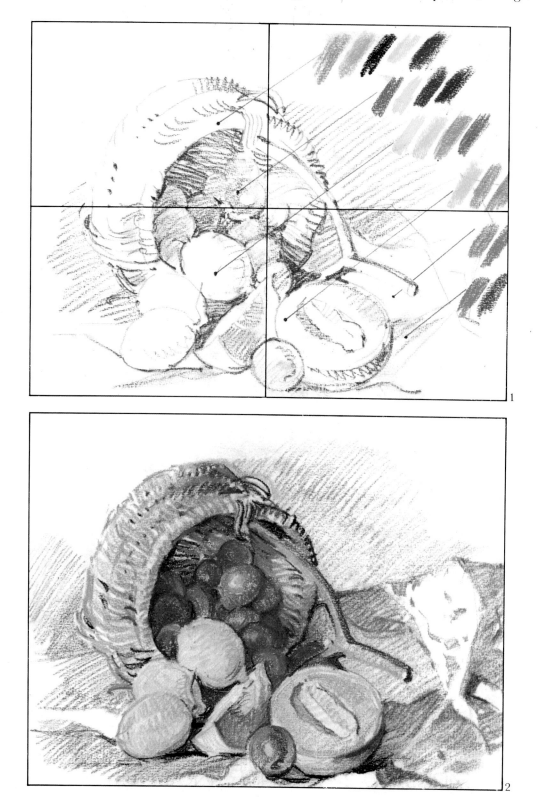

colors to indicate the outlines and main shadows. However, for a beginner, it is better to define the shapes before applying the colors.

In the same diagram, we have indicated the palette. This suggests that we must *see* before we draw, even when doing a preliminary drawing. We must, in particular, see the colors and pinpoint the hues that are in the subject and that we intend to apply to the paper. Next to the various elements, we have applied a few short color strokes. As we know,

the richness of pastel resides in its blending ability. We can interweave and superimpose several colors, thereby modifying the basic shades and defining their saturation and value.

The same procedure was followed in diagram 3 for drawing 4. This time, however, we used pastels on *colored* paper.

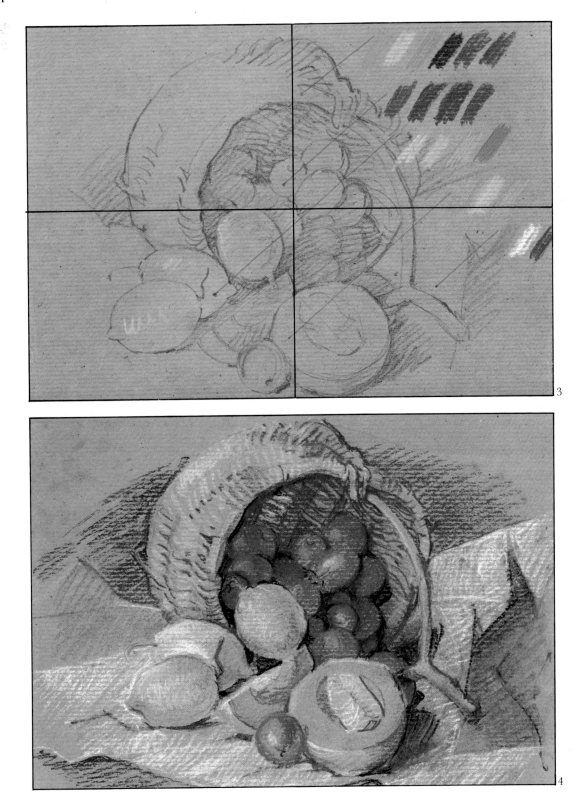

3

4

Coloring Agents and Colors

Just what are colors concretely? Types of matter that, when applied to a material, permeate and color it.

Long ago, a few kinds of dye were available: cochineal, sepia (from a cuttlefish), purple (from a whelk). Cochineals are insects of various species; the most useful for manufacturing dyes are the red cochineal and the lake cochineal.

Carmine was first extracted from cochineals that were dried in the sun and then mixed with other materials. The lake cochineal in India lives on certain species of fig trees. It causes resin to ooze from the trunk. This resin, known as lake, was widely used in manufacturing dye stuffs.

We can therefore say that there are two categories of colors: pigments and dyes.

1) The colors adhering to a surface tinge it by means of superimposition: mineral colors (formed from metallic oxides or salts) mixed with oil produce so-called oil paints; blended with water, gum, or paste, they produce watercolors; combined with gypsum, talcum, or clay, they produce pastels.
2) Dyes, on the other hand, penetrate the material they are applied to, color it, and are then fixed by means of mordants or strikers.
 There are two kinds of dyes:
 a) Natural dyes, obtained from plants and, although rarely, from animals.

b) Synthetic dyes, generally organic and constituting the bulk of commercially available coloring agents.

In earliest times, men used to paint their bodies white or in brilliant colors. Their goal was not only practical (embellishment, protection against insects, or to inspire fear in enemies), but also mystical. Red, for instance, was viewed as a symbol of war, love, and life, and many ancient groups covered the skeletons of their dead with red ochre. The Egyptians painted their mummies red, following a liturgy that described red as the color of the gods and of the children of the Sun. In Egyptian papyruses, titles and initials were drawn in red, just as Christian liturgical books today are printed in red and black.

The Egyptians obtained their most brilliant colors from precious stones. Many tints that have survived the centuries were made of powdered glass, lapis lazuli, or artificial ultramarine. Furthermore, colors could be accentuated by means of firing, which brought out the hue of certain natural earths.

In sum, we must say that color, or rather the use of color, appeared with the earliest human and was instantly applied to artworks. Plinius writes: "Using only four colors, the great painters Apelles, Aeschiones, Melanthius, and Nicomachus created immortal works, which were judged to be as rich as the wealth of an entire city. These artists used only white, ochre, red, and black."

pencil *watercolor* *chalk* *ink*

The Dimensions of Color

tone

luminosity

saturation

Newton, breaking down "white" light into its constituent wave lengths, arranged the colors of the spectrum in a circle running from red to violet. However, colors form a much more complicated totality. Every hue or color—red, orange, yellow, green, blue, violet, and all the intermediary shades—reddish orange and greenish blue for example—can be lighter or darker, more or less intense or opaque.

The strength or abundance of a color is generally indicated by the term *saturation*. A color is more or less saturated depending on how much of a hue it contains; it is more or less light depending on how much gray it contains.

We may therefore conclude that colors have three dimensions: hue, value, and saturation.

1) The hue or tone is the characteristic of an individual color, identifying it as red, orange, yellow, green, blue, violet (the colors of the spectrum) or the intermediates (yellow-green and blue-green next to green; orange-yellow and orange-red next to orange; and blue-violet and red-violet next to violet); plus purple (a tone between red and violet, not present in the spectrum).

2) The value or brightness refers to the amount of light apparently emitted by the color, or rather the colored surface, and is commonly indicated by such adjectives as "clear" or "brilliant."

3) The *saturation* or intensity defines the proportional presence of a hue.

When we use the term *chroma* in regard to saturation, we are referring more to the proportion than the amount of the color present. If the saturation value of a color is zero (in other words, it is not a specific tint), then the color is called achromatic. Examples are: black, gray, white.

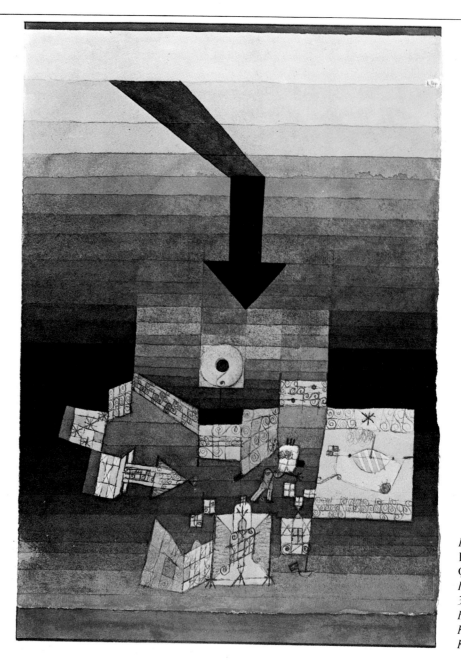

Paul Klee: The Place in Question, *1922. Ink and watercolor, 327 x 230 mm. Berne, Kunstmuseum, Paul Klee Stiftung*

Thus, if we view, say, two orange objects, we can note that they have the same hue (neither is more red or more yellow than the other) and the same value (neither looks lighter or darker than the other). But we may say that they are unequal in saturation if either seems more orange, that is, of a more strongly orange color.

Every color can be defined and classified in terms of the various combinations of these three different parameters. And since there are thousands of diverse combinations of hue, value, and saturation, there are likewise thousands of colors that we can see around us.

A drawing that is also penmanship, a strange union of image and words, in a gradual succession of tones and strokes.
The enigmatic meaning is in the gradation from yellow to brown, in strips of various widths. These gradually darken toward the center (the initial tone brought out by a thin brown line), reigniting in the lower part of the drawing. Against tones of orange (from orange yellow to orange red) and brown (from brown to brownish black), we see, above, the crooked black arrow, a threat and a symbol, and, below, at the center, the mosaic of an innocent place, a target and destination. Klee's art is based on allusions and hieroglyphs as well as on expert combinations of color variations.

The Experience
A patient arrangement of colors on which the salient episodes of the narrative are drawn; a virtuoso use of color and line, intimately linked.

The Apparent Dimensions

We know that color influences our perception of size and dimension. There is one feature of color that distorts our vision of nature and that manages to alter the effect of the environments created by man. Colors such as blue, gray, green (in general, the cool colors) tend to make objects look further away; and vice versa, the contrasting colors tend to make figures jut out.

Thus, when the builders of Gothic cathedrals wanted to make the vaults of their enormous constructions virtually "move away," they painted them blue, to recall the color of the sky. Blue seems to move away and open up, so that these naves look higher and vaster.

The same blue was preferred for the same reason by the makers of stained-glass windows, which enclose, or rather open up, the walls of cathedrals.

And blue has the same function in aerial perspective from Leonardo Da Vinci to Cézanne: it evokes depth and distance, just as the blue filter of the atmosphere modifies colors in proportion to their distance. There is an atmospheric diffusion effect that has made us used to associating distance with azure-blue: hills and mountains, whether green or brown, look bluish in the distance; and faraway objects lose their colors before losing their shapes.

Beyond artificial mimicry (like military camouflage), which follows natural mimicry (think of the function of colors in animal life), man has always studied the effects of color when designing en-

The Rainbow and the Circle: linear and logical arrangements of color. I would like to try and tell you something useful about colors. I am not only going by my own experiences, I have also light-heartedly taken over ideas from other people, both scientists and laymen, in order to transmit them to you. To name but a few, let me recall Goethe, Philipp Otto Runge, whose Chromatic Sphere was published in 1810, Delacroix, and Kandinsky *(The Mind in Art)*. The first part of my task consists in constructing an ideal box of colors, in which the colors are arranged in a well-established order—a kind of tool-kit, if you will.

Nature offers us a huge abundance of chromatic stimuli: the vegetable world, the animal kingdom, mineralogy, the ensemble of things known as a landscape; everything gives us material to think about for hours and be grateful for....Here too, however, our creative ability helps us to overcome the deficiency of the phenomenon, allowing us at least to achieve a synthesis of the perfection characteristic of the beyond. We should not assume that when it manifests itself

Three equal rectangles; We see a red and a green rectangle in the first one; four smaller red and four smaller green rectangles in the second rectangle; and an equal number of even smaller green and red rectangles in the third rectangle. If we now look at the first large rectangle from a distance of six feet, we can still distinguish the red part and the green part. And we can distinguish the two colors when we look at the second rectangle

from the same distance. But, when we look at the third large rectangle, it will look brown, and we can no longer tell the greens and the reds apart. The reflected light rays of the different colors blend when they reach our retina. And this is the principle exploited by the Impressionists when they made small adjacent strokes of component colors in order to obtain a specific compound color.

vironments and garments, decorations and banners. After all, we know that colors can change an apparent distance, as well as size, shape, and perspective, or weight and motion. Our everyday experiences in looking around, living in a colored world, can be made more specific if we study the dimensions of color.

1) Take two equal-sized cubes, one painted black and one white. The black one looks more solid and homogenous because the tone emphasizes the shape.

2) Paint two contiguous sides of the white cube red, and you achieve an effect of distortion. This effect is accentuated if you paint each face of the cube a different color, because it disrupts the unity of the shapes.

3) Open up the cube by removing one face and paint the inside in different colors. The inner space will seem to change, always with different results. The same thing happens when we paint the walls of a room white or blue or cover them with wallpaper containing horizontal or vertical stripes.

As we know, vivid colors seem to create tension and aggressiveness, and soft or delicate colors tend to produce the opposite effect.

Color also influences our perception of time. An experiment conducted at a British university demonstrated that a meeting held in a brightly painted room seemed to take less time than a meeting held for the same length of time in a room painted in dim colors.

Finally, there is one aspect of color that is of great interest to painters. This feature is linked to the colored surface and to its relationship with other colors.

I am referring to the different results we achieve when we place a small red or yellow spot on a large green surface or a small green spot on a large red or yellow surface. It is not enough to study and to get to know the relationships among colors, among complementaries, the harmonies,

only in part or as in an imperfect semblance that it is without imperfections; our artistic instinct must therefore help us to find the form of that perfect existence. What does the insufficiency of the rainbow phenomenon consist of?...In the rainbow we perceived a series of colors, to wit seven, which we call: red-violet, red, orange, yellow, green, blue, blue-violet; and the number seven seemed good in general.

In music too, there are seven notes, we said, as if to confirm that....But the essential problem is that in a rainbow the colors appear in a linear arrangement...here, color dots proceed in a parallel fashion, tracing out lines: a yellow dot next to a green one, a green dot next to a yellow one, and so on....This linear depiction of the surface actually...has a medium character, an average character and not an active one. A red or blue or yellow line may arouse an impression of a surface, but it nevertheless remains a line. (from *Theory of Form and Figuration* by Paul Klee)

the cold or hot colors. We also have to familiarize ourselves with the dimensions of colors and the relationships between their dimensions. A certain secret was well-known to the Impressionist painters: In their optical blending of colors, they were well aware of the proportions required of one hue in relation to another in order to construct a specific tone, as well as to suggest light and shadow on the given color, or rather, on the same blend of colors. To better understand their method, just do the following: Between and over brush strokes, add dots of bright colors, yellow or orange, or dark colors, blue or violet, in order to modify the result for the desired effect.

1. The perception of the green color varies from the first example to the second, depending on whether the green is a brushstroke against a background or the background of a brush stroke.
2. The dimensions of orange (hue, luminosity, saturation) vary with the quantitative ratio.

1

2

Shapes and Colors

Itten, a Bauhaus painter and teacher, studied the relationships between shapes and colors and found the same expressive values in the three basic colors—yellow, red, and blue—as in the three fundamental shapes—triangle, square, and circle.

The triangle, says Itten, emerges from the intersection of two horizontal and two vertical lines, with three acute and aggressive angles. The circumference of the triangle thus involves the shapes based on diagonals, including the rhombus, the trapezium, and the irregular triangles, of course; the color that corresponds to the triangle is yellow, the color of thought.

The square comes from the intersection of a horizontal and a vertical pair of equidistant lines. It is a symbol of rigor, measure, completeness. Its circumference involves shapes enclosed by orthogonal (mutually perpendicular) lines, and thus the rectangle in its various manifestations. The color corresponding to the square is red, the color of matter.

The circle comes from the rotation of a point around a center at a constant distance; this sense of steady dynamics makes the circle the symbol of the uniform motion of the mind. The circum-

The dimensional values of colors vary with simultaneous modifications in conformity with the shapes and the relationships between the colors of the shapes and the backgrounds.

ference of the circle involves every other curvilinear shape, such as the ellipse, the oval, and the parabola. The color that corresponds to the circle and its circumscribed infinity is transparent blue, the symbol of the motion of the mind.

Itten goes even further when he sees geometric figures as corresponding to the secondary colors. Thus, for orange, he selects the trapeze (logically, the contamination between the square and the triangle, and hence between red and yellow); for green, the spherical triangle (since yellow and blue correspond to the triangle and the circle); for violet, the eclipse (red and blue correspond to the square and the circle).

Itten therefore concludes: "When the expression of a shape coincides with the expression of a color, their effects accumulate. In a painting based essentially on color, the shapes ought to emerge from the color, while in a painting based essentially on shapes, the color ought to be constructed according to the shapes."

These theories greatly influenced the abstract painters, especially Mondrian, who constructed his compositions in terms of precise mathematical proportions and exact ratios based chiefly on the golden ratio (1:1.61) between square and rectangular shapes in white or pure colors.

Correspondence between the meanings of colors and the geometric shapes.

While a still a boy, I watched the transformation that materials underwent with these tools, and I ventured to imitate it in order to achieve the same result, hoping (somewhat presumptuously given my age) to do better. This procedure, which I practiced while still a mere child and which helped me in later years, soon brought me mastery of various media: clay modeling to make terra-cottas, working in wax to make models for casting, molding plaster while it is soft and then redoing it when it is hard; smoothing and polishing cast bronze with a file and touching it up with a chisel. I saw my father even more frequently; as a quasi-artistic craftsman, he designed oranmental decorations for ceilings, walls, and furniture. I kept up with his work and avidly observed the rapid procedure, which made the designs fairly spring from his hands, making it all look so easy. Seduced by this seeming ease, I tried to emulate him. But the difficulty of achieving the

Not coincidentally, Itten also declared: "The knowledge of the laws of artistic creation should free us from uncertainty and hesitation." These same laws and theoretical principles formed the basis of his teachings at the Bauhaus and his pictorial compositions.

A Design for a Stained Glass Window: Duilio Cambellotti: *The Crows*

If we study this black-and-white drawing, Duilio Cambelotti's design for a stained glass window, we can offer two hypotheses for the application of color as suggestions for a color exercise.

In a biographical note, Duilio Cambellotti writes about his love of trees: "I felt a great desire to be outdoors, a desire for the open air, the sun, the countryside. As a result, I alternately worked and went on country outings, hiking far from Rome and finding remote and unfamiliar places unfrequented by other people. I virtually discovered new worlds. ... My impressions during these georgic phases helped to shape and are still

perfection that came so readily to him irritated me and forced me to go over and over my work, tenaciously and patiently. Imitating his work unconsciously, I associated a certain elementary notion of art with manual and graphic effort, a notion that flowed forth from my father's work: a small ornamental wonder. In this way, …I acquired a new technique—graphics: a graphics not limited to copying shape and light; not independent graphics, but, rather, contingent on the immediate goal of gathering a shape around an elementary or elevated thought. This exercise of, so to speak, intellectual (evocative) graphics eventually enabled me to use graphics to capture on paper not only things outside my eyes, but also things and images that surged up from within me. (From Duilio Cambellotti's Autobiographical Notes

shaping my art: I observed the trees, the animals, the men of the spade and the furrow, and they all nourished my soul, feeding visions and dreams that were then translated into graphic and plastic form" and then into this design for a stained glass window with its splendor or lines and light.

The tree is the central element in Cambellotti's artistic conception. His love of nature is also confirmed by the stylized "spike," which, at a certain point, joins the initials in his signature. When he designed furniture, he was also thinking of a tree, trying to recreate the nature and com-position of a trunk in the modified wood. Thus, a bookcase he designed was made up of a central element flanked by lateral elements, which grow thinner and thinner, more and more detached from the earth, virtually as ramifications of a central trunk.

However, Duilio Cambellotti is also a stage de-signer. The tree trunk is the leitmotif in many of his sets for D'Annunzio's *The Ship*. The construction of the boat becomes a pretext for illustrating the metamorphosis of the wood from the trunk to the vessel, man's possession of the earth and sea.

A Drawing A Day:
The Peasants of Bruegel the Elder

Pieter Bruegel the Elder was a prolific draftsman, who loved walking through the countryside with a pad of paper to capture pictures of landscapes and peasants. His drawings reveal his concern with shapes, behavior, and detail; but he did not use color. Subsequently he transferred these images to his paintings. In order to remember the colors, he used a precise and orderly calligraphy to indicate the hues next to the figures of men and women. His notes thus allow us to imagine what these peasants looked like. He drew the

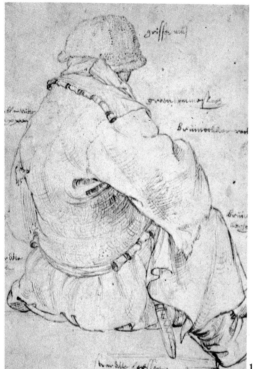

1

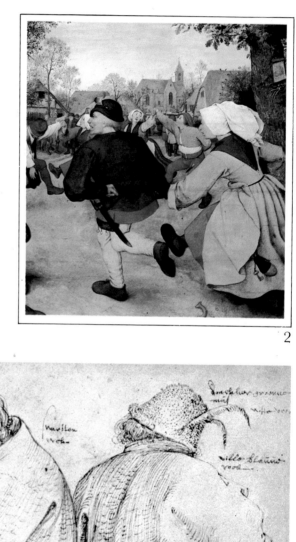

2

1. Pieter Bruegel the Elder: Peasant Woman Sitting. *Pen and brown ink on black pencil, 138 x 99 mm. Berlin, Staatliche Museen, Kupferstichkabinett*

2. Pieter Bruegel the Elder: Peasant Dance *(detail). 1565-66. Vienna, Kunsthistorisches Museum.*

3. Pieter Bruegel the Elder: Studies of Three Peasants. *Pen and brown ink on black pencil, 157 x 200 mm. Berlin, Staatliche Museen, Kupferstichkabinett*

3

figures with a black pencil, sometimes a red one, going over them in brown ink, which he also frequently used to write out the names of the colors.

Bruegel emphasized that these figures were drawn from life—although, of course, "life" is then transformed by the artist's sensibility and the colors of his personality. The phrase "from life" shows how important it is to look at reality, even the most humble reality, whether from an artistic or from a theoretical viewpoint. Ultimately, we must consider the creativity rather than the acumen of the witness.

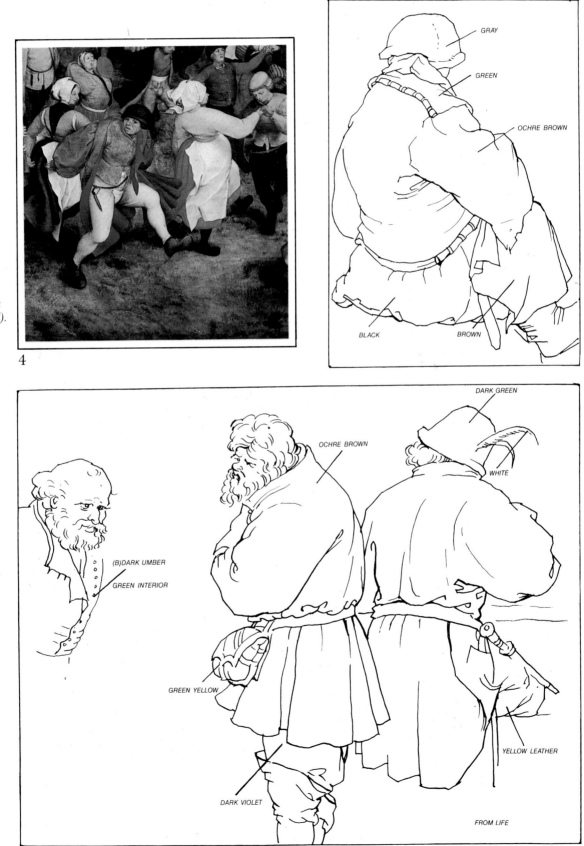

4. Pieter Bruegel the Elder Wedding Dance Outdoors *(detail). 1566. Detroit, Institute of Arts*

4

The Windows of Gothic Cathedrals

We are familiar with the stained glass windows in the vast surfaces between the pilasters of Gothic cathedrals. These polychrome windows are not merely an architectural element capable of modifying the dimensions of the space by annulling the walls and transforming them into light. The windows are also a message that can be understood by all people. And because of its luminosity, this message becomes even more penetrating than that of the frescoes narrating the sacred history on the walls of basilicas.

The effect of stained glass windows in cathedrals emerges from a contrast between the reds and blues and between the reds and greens, that is, between cool and warm colors. The light thus has a particular character: it is almost a cosmic light, radiating energy upon burning matter.

Naturally, aside from the colors, there are also the figures. They are organized in compositions that take up paleo-Christian and Byzantine motifs, constituting a true prayer.

The window as a whole sums up its message chiefly in the colors when these colors are ignited by the sun as it shines through the glass, varying in the course of the day, turning into light, a symbol and a means of ascending to God.

Stained glass window of the Cathedral of Chartres. Twelfth century.

THE PERSONALITY OF COLOR

The meaning of a color, the definition of the characteristics of tone, brightness, and intensity, are not autonomous values. They depend on a complex series of elements.

The theory of color, the analysis of chromatic disks, the study of contrasts form the necessary basis not only for those who wish to deal rationally with the problem of color, but also for those who would like to refine their chromatic sensitivity. Nevertheless, neither the knowledge nor the practice of the theory of color is enough to produce an aesthetic effect. And they certainly cannot solve the problem of interpreting color beyond the personality of the individual artist.

As we know, the artist's personality is crucial: he has to find his "own drawing." And the artist's personality is even more intrinsic to the interpretation of colors and the definition of "his own color." Color training can refine and heighten a chromatic personality and sensibility, which are instinctive in all of us.

Thus, color and personality are closely bound in the execution of a colored drawing. The colors can only be the expression of the artist's personality, which, however, has been trained and refined by the theory of colors.

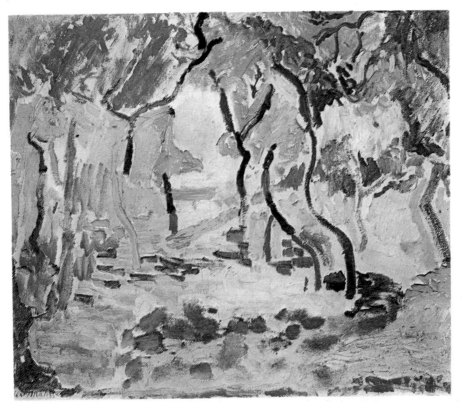

Matisse's study uses all the colors of his palette in a single composition. The primary and secondary colors are placed side-by-side in a precise and methodical experiment.

Henri Matisse: Study for Joie de Vivre. *Oil on canvas, 530 x 465 mm. Copenhagen, Statens Museum for Kunst*

Contrasts

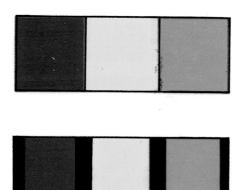

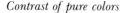

Contrast of pure colors

Contrast of pairs of complementary colors

Pure Colors and Complementary Colors

The value of colors is influenced and modified by many factors. One of the most important is the contrast, or more simply the relationship between an object and its surroundings. The contrast between pure colors is the simplest and most immediate kind; it results from the juxtaposition of red, yellow, and/or blue. But in order to create this contrast, we have to use intense and sharply separated hues, with an even more decisive and obvious chromatic effect when red and blue are separated by yellow rather than being used side by side.

The primary colors can be contrasted even more effectively if we separate them with black lines. These lines pull apart their mutual influence and radiation, giving each color its true value. The relationships between the colors can be greatly modified and nuanced in infinite variations if we gradate their brightness and saturation by blending the hues with white or black.

The violent effect of the relationship between the three pure colors is mellowed by a contrast with or among secondary colors—green, orange, or purple. The effect is further softened by a contrast with or among tertiary colors, which, in the chromatic disk, are: green-yellow, yellow-orange, red-orange, red-violet, blue-violet, and blue-green.

Furthermore, every color (particularly the pure ones) acquires a different value, hence is perceived differently by the human eye, depending on whether it is juxtaposed against a white or a black ground.

White seems to tone down the strength and brightness of a juxtaposed color, making it appear darker. Black, on the other hand, intensifies the color's brightness, making it more brilliant. Just think of signals or road signs that exploit the effect of yellow or red against a black background.

The contrast between pure colors leads to the contrast between pairs of complementaries, each pair being made up of the three basic colors.

The combination of two complementary colors gives us, as we know, a neutral gray tint. Thus, the contrast between complementaries is characterized by two features: juxtaposed or adjacent colors produce a higher degree of brightness; but if blended, they form a gray tone. The experience is particularly interesting when, as we have pointed out, the human eye spontaneously tries to integrate each color with its complementary and, upon not finding it, creates it, representing it in the successive image, according to what is defined as a contrast of simultaneity.

Thus, a square of gray color looks grayish violet against a yellow background, greenish gray against a red background, and yellowish gray against a blue background. In each case, gray

assumes a shade that is complementary to the color it is next to. Two colors are said to be harmonious if blending them produces a neutral gray tone (the eye requires the totality of colors, the sum of blue, red, and yellow, finding its equilibrium in this). Hence, the contrast of pure colors and complementary colors underlies the harmony of colors in a harmonious composition.

However, each pair of complementary colors has specific qualities and characteristics.

1) The relationship between blue and orange seems to indicate the two extremes of the contrast between cold and hot.

2) The relationship between yellow and violet emphasizes the powerful chiaroscuro contrast between maximum brightness and opaqueness of blue mixed into red.

3) The relationship between red and green accentuates their degrees of brilliance with respect to each other.

What practical use is knowing the contrasts of pure colors and complementary colors?

In the works of the great masters, we often find pure or complementary colors, which the artists contrast in order, as we have said, to produce a particular immediate effect. Sometimes, we also find secondary and tertiary colors, which, with the affinity of the two contrasting colors, produce shades of a gradual passage between them.

Furthermore, many painters obtain their luminous grays by blending complementaries. These grays seem to "contain color," precisely because they are produced by the superimposition of a bright color and its complementary. On the other hand, the Impressionists, as we know, obtained gray either by juxtaposing complementary colors with small brushstrokes, or by juxtaposing small dots of black and dots of color, thus blendiing the gray within the visual process itself.

1. This checkerboard, which can be subdivided into sixteen or more squares, serves as the basis for exercises in composition using complementary colors with the addition of black and white. Obviously the greatest contrast occurs when the squares of complementary colors are contiguous with one another.

2. The color gray emerges from the mixing of black and white, from the superimposition of all the colors, and, as demonstrated here, from the union of pairs of complementary colors.

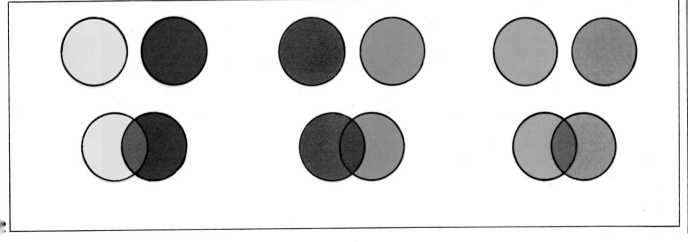

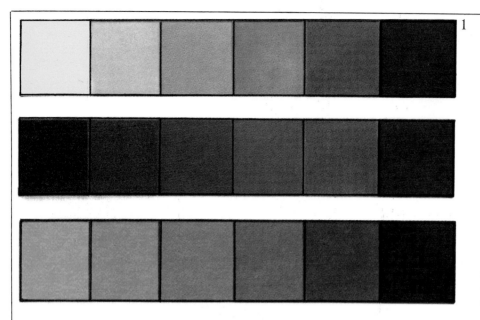

1

1. This diagram illustrates the gradual passage of a color to gray: little by little, more and more gray is added to the initial hue.

2. This diagram illustrates the relationship between brightness and quantity in pure and complementary colors.

Relationships of Quantity and Quality

We have often spoken of contrasts and adjacencies of colors, as well as juxtapositions of colored spots and shapes. However, we have not as yet asked whether there also exists a relationship of quantity, that is, whether the sizes of the colored shapes themselves also influence the relationship between their colors.

We should realize that chromatic effect is due not only to the intensity of a color—the value of its brightness—but also to the size of the colored field. In other words, is there such a thing as a relationship or contrast of quality, in addition to a relationship or contrast of quantity?

How do we measure the brightness or luminosity of a color?

The brightness scale can be obtained if we place the colors of the spectrum (yellow, orange, red, violet, blue, and green) against a neutral gray background.

According to Goethe, the scale of values, from maximum to minimum brightness, runs as follows: yellow, orange, red, violet, blue, green. And since Goethe gives yellow the value of 9, orange 8, red and green 6, blue 4, and violet 3, we can use these figures to determine the value of each pair of complementaries; for example, the ratio of yellow to violet = 9:3, and hence a brightness value of 3; orange to blue = 8:4, hence a value of 2; and red to green = 6:6, hence a value of 1.

Thus we have a simple method of translating brightness values into harmonious quantity values.

If we have two surfaces, a yellow one and violet one, the violet surface has to be three times the

2

size of the yellow surface in order to balance the latter's brightness. A blue surface, similarly, has to be twice the size of an orange surface in order to balance its brightness. And a red and a green surface have to be of equal size in order to achieve a balance of luminosity.

All this, as we have said, is crucial to abstract compositions, in which the sizes of surfaces correspond precisely to the color brightness in a pre-

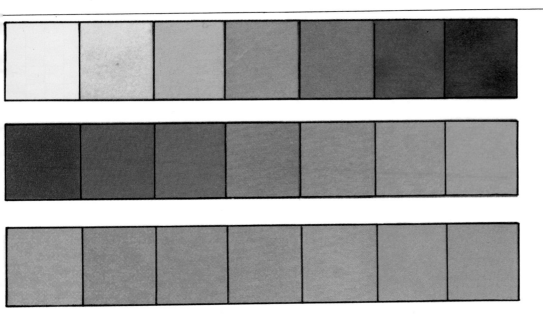

cise reckoning of balances. This calculation is emphasized by black outlines around the surfaces. Furthermore, this situation is fundamental to every composition in painting.

However, this quest for compositional balance is not as simple as it might appear at first sight. We cannot really preestablish in absolute terms the value of a colored shape. Even if we know its dimensions and color, this value is contingent not only on the chromatic intensity, but also on the contrast with the other colors in the composition.

We have spoken about chromatic intensity; and when we speak about contrast of quality, we are referring not only to the degree of brightness, but to the degree of intensity or saturation of a color.

The contrast of quality is the contrast between intense, luminous colors and dim, dark colors. Pure colors can lose some of their brightness when they are darkened. How can we modify pure colors in this sense? By blending in white, black, or their complementaries.

1) When we blend a pure color with white, we achieve a cooler tone. This variation will differ from color to color, and the result can be fully appreciated only in a direct experience. Think of violet. When lightened with white, it acquires rosy tones that modify its chromatic effect.

2) A tiny touch of black livens up any color except yellow. A slightly larger amount of black dims any color, mixing yellow greenish, pushing red toward violet, and darkening blue.

3) Finally, when we mix a pure color with its complementary, we obtain nuances of gray, which vary with the prevalence of the basic color—yellow, red, or blue.

These diagrams show the variation of a color mixed with more and more of its complementary until it finally turns into that complementary. Thus, in the first square of the first series, we have pure yellow; in the second square, yellow with a little violet; in the third, yellow with more violet; in the fourth, a blend that is neutral or gray; in the fifth, gray with a dominating violet; in the sixth, more violet; and finally, in the seventh, total violet.

Georges Rouault: The Parade, *1907. Watercolor and pastel, 105 x 65 cm. Basel, Kunstmuseum.*
In order to grasp the nature and character of Rouault's paintings, (he was Moreau's favorite pupil), it is useful to know what he was once told by his teacher: "In those of you who are poor, our art must be solidly rooted because you are crossing a desert without food or baggage. I am especially afraid for those who, like you, can only affirm their own particular vision...I see you with your entire nature, your fierceness, your love of rare material, your essential qualities. You love a grave and sober art that is essentially religious, and everything you do will be marked by that."

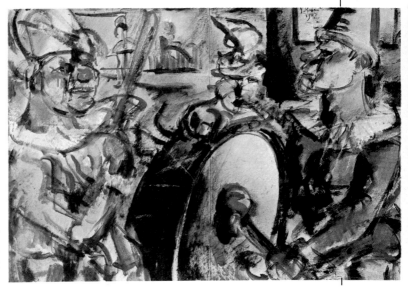

Effect of Cold or Hot, Shadow or Light

It may seem odd to speak of temperature sensation when we are dealing with the visual perception of colors. However, in calling a hue cold or hot, we are not only using a metaphor, referring to materials or symbols that the given hue might indicate (blue = water; red = fire), we are also talking about real sensations. Our sensitivity to cold or heat increases or diminishes in environments painted, respectively, red-orange or green-blue. Nor is it surprising to learn that red and orange activate the circulation of the blood while green and blue slow it down.

Furthermore, as we know, cold hues such as yellow, green, or blue are preferable in an environment that is meant to be restful; while red, more than any other color, arouses and prepares us for action, and is therefore the most useful color for an environment meant for activity.

The greatest contrast of chiaroscuro is between yellow (the lightest and most luminous color) and violet (the most opaque). Hence the poles of contrast between cold and hot are red-orange and green-blue, which are opposites on the chromatic circle.

Thus, on the one hand, we have the so-called hot colors: yellow, yellow-orange, orange, red-orange, red, and red-violet. And on the other hand, we have the so-called cold colors: yellow, yellow-green, green, green-blue, blue, blue-violet, violet.

But, as usual, it is not the objective values that count, but rather the values of the various colors in relation to colder or hotter tones. Thus, a yellow can appear cold or hot depending on whether it is next to a red or a blue. The relationship between hot and cold is connected to a series of other meanings, which refer to other conditions and situations such as distance, illumination, transparency.

What I mean is that, as we have seen, the so-called cold colors tend to make objects look farther away, and the hot colors tend to make them look closer. The cold colors are more effec-

1

2

1. Contrast of hot and cold colors.

2. The first strip illustrates the passage from yellow to cooler and cooler colors (which arouse a sense of cold because the adjacent colors are warmer). The second series shows the variations of hot tones, again starting with yellow.

tive in rendering shadow, and the hot colors are more effective in rendering light. In this way, we can also describe the cold colors as being more transparent than the hot colors.

All this is intrinsic to a practical use of colors. Recalling Leonardo Da Vinci's "thick air," and noting the stages of the atmosphere, we employ cold colors, greens and blues, to treat the planes that we want to have farther away, while we apply hot colors, ochres and reds, to objects in the foreground.

The difference between a shadowed subject and a sunny subject is made more obvious if we use the blue and violet tones of shadow for the former and the yellow and orange tones of light for the latter. The chromatic effect is heightened if these subjects and their colors are contrasted.

Linked to these concepts are the experiences of the transparency of bluish colors in contrast to the opacity of reddish colors. It follows that the contrast of cold and hot is tied to the chiaroscuro effect, which underlies a black-and-white draw-ing. The range of grays, between the two poles of white and black, finds an infinite number of suggestions and illusions rendered in paintings of color tones. This contrast seems to include all the others: between close and far, light and shadow, transparent and opaque.

All this seems to confirm that when we use colors, even in a composition based only on one of the fundamental contrasts, we must never lose sight of all the relationships that exist between colors, depending on their meanings and values.

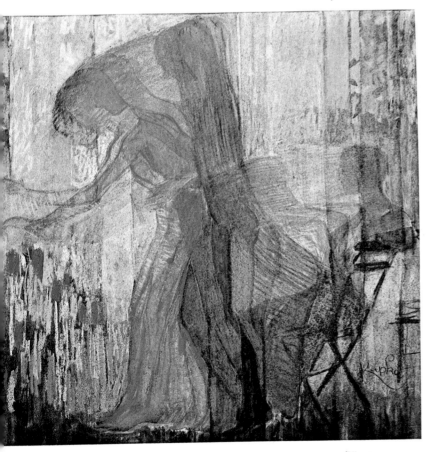

Frantisek Kupka (1871–1957): Woman Picking Flowers. Pastel. 430 × 475 mm. Musee National d'Art Moderne, Centre National d'Art et Culture G. Pompidou, Paris. (Gift of Mme. Kupka, 1963).

The depiction of motion in the female figure leaning forward is emphasized by tonal variations that follow the color spectrum, accentuating the dark and light blues of the central vertical outline.

The hues, from yellow-pink to greenish, stand out against the background, which is shaded on the basis of ochre.

The experience
A both Cubist and Futurist conception to render the fourth dimension, recalling the lesson of Art Nouveau in the definition of the energy lines: an expert technique that succeeds in melting and transforming the pastel colors from one shade into another.

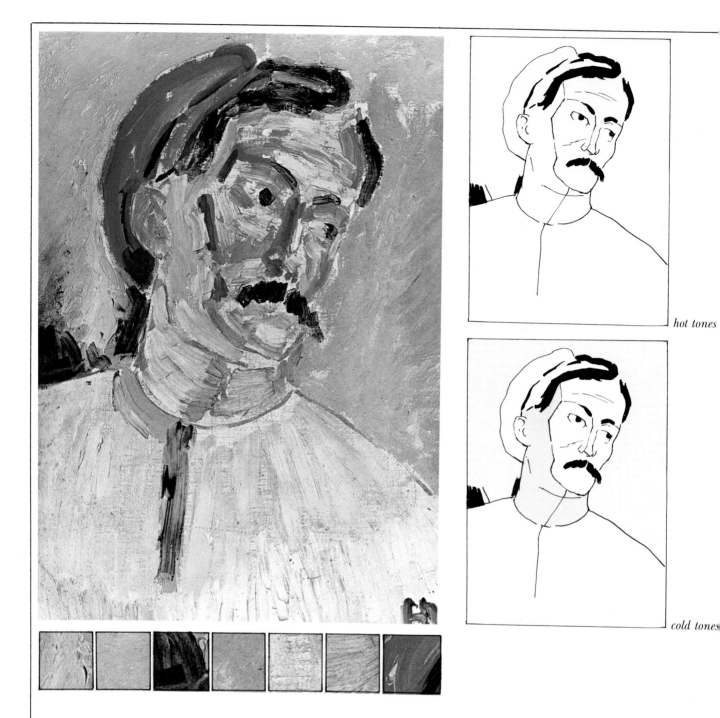

hot tones

cold tones

Henri Matisse: Portrait of André Derain, 1905. Oil on canvas, 280 x 380 mm. London, by courtesy of the Trustees of the Tate Gallery

Matisse's portrait of Derain is based on a precise and obvious relationship of colors. We have a hot-cold contrast between the yellows and reds of the face and the blue-greens of the background. In the face, separated by a violet line along the yellow, red, and orange, wide brushstrokes of green-white fill the cheek and the neck. We also see pairs of complementary hues: red/green and orange/blue. The extraordinary symphony of cold and hot colors, pure and complementary ones in the head is based on the yellow of the blouse; the yellow is heightened by the green tone.

This is not just a portrait, but an affirmation of Matisse's theories: "Construction by means of colored surfaces. A quest for color intensity. Unimportance of the subject. Reaction against the diffusion of the local color in the light. The light is not omitted but expressed in a harmony of intensely colored surfaces."

k tone

ow tone

Renato Guttuso: Bust of a Drinking Woman, *1961.*
Pen and India ink with watercolors on white paper, 470
x 335 mm. Milan, private collection.

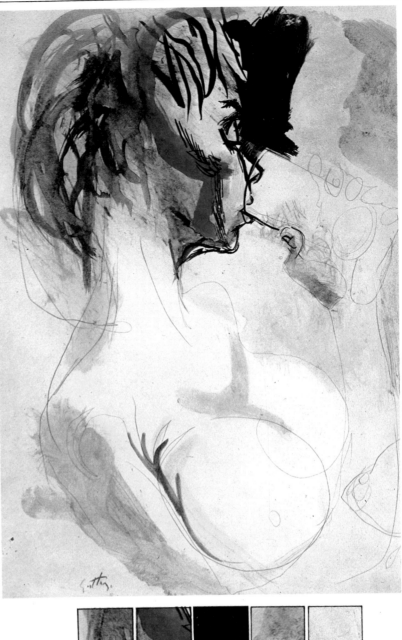

Among Guttuso's many drawings, this one is characterized chiefly
by the deliberate contrast in the colors of the face. The drawing is
all harmony and delicacy. A very thin pen stroke indicates the
shoulders, the large breasts, the hand holding the glass, the
slender, graceful neck. A more decisive sensitive line brings out
the profile, the lowered lid, the half-closed lips, and several locks
of hair on the forehead. The background is barely indicated by
blue-gray watercolors, which further emphasize the delicate flesh
tones of the body. Then, we see several unexpected spots in three
colors: the yellow in the hair, the red question mark of the cheek,
the black in the background, which makes the figure stand out. In
this portrait, the tones in the figure are juxtaposed with those in
the background, finding a leitmotif in the red stroke of the cheek.
We also have to underscore the adjacency of the basic colors:
yellow, red, and black.
Try to cover one of these colors, each in turn, and see how
different the result is each time.

A Drawing a Day: Adjacencies and Contrasts

These four drawings exemplify the use of pure and complementary colors placed adjacent to or juxtaposed with one another. The effects of contrast are more or less obvious.

As we see, these four impressions of a car graveyard on the outskirts of a big city were done with pen and ink. They are therefore characterized by strong, bright, intense colors, since a pen and ink usually cannot render nuances and chiaroscuro (except by means of gradated hatching).

Each drawing has three planes. The foreground is indicated by an auto on the right side of the paper. The middle ground is made up of the other abandoned cars. And, finally, the background is the panorama of the city outskirts with buildings and industrial structures.

In drawing no. 1, the foreground is treated

with burned ochre (terra-cotta), while the middle ground is rendered with a gray retouched with blue and violet strokes. The background is all gray, while the ground is treated with various greens.

Drawing no. 2 is based practically on two colors: the gray of the background and the automobile heap, and the red of the foreground, which is further emphasized by the green of the terrain.

Drawing no. 3, in contrast, uses yellow for both the background and the middle ground, burned ochre for the middle ground and the foreground, with bluish violet touches in the foreground.

In Drawing no. 4, the contrast is deliberately accentuated with the orange of the right hand car, the blue of the autos in the middle ground, and the gray of the background.

3

4

The Colors of Signs

The entire world around us is colored, and most of the colors we see are selected and created by human beings. Granted, the colors of nature—the blue of the sky, the tones of hills and mountains, the green of forests and meadows, the splendor of flowers—are the framework of our lives. However, the colors of cities, streets, houses, furniture, clothing, and so on are chosen by us to surround and condition us.

As we have already discussed, some colors are preferred by certain people and rejected by others. Colors can calm us or stimulate us, they can arouse memories of childhood or unpleasant associations. For Jung, colors were potent symbols; for Lüscher, another theorist of color psychology, a preference for a certain color indicates a specific kind of personality.

In this variety of preferences (just think of fashion colors and the infinite combinations used by single individuals) and reactions, there are nevertheless several tones that civilization has taken on as symbols and that it uses, in contrasts and combinations, for its messages. Of major importance here is contrast, which renders signals more obvious. The signs and emblems, in the colored panorama of towns and countrysides, can be brought out and seen only if they are made obvious by that chromatic effect.

Thus, as we know, traffic signs have different shapes and different color contrasts, so they may be easily seen in different kinds of light. Red is the color of crosses indicating first aid. Red, yellow, and green are used in traffic lights. And advertising signs and posters likewise use contrasts of color quality and contrasts of pure or complementary colors.

The theory of contrasts is useful for everyone when first dealing with the problems of colors to depict objects, people, or landscapes. And it is fundamental for anyone interested in advertising and graphics in general.

This area overlaps with the problems of Gestalt psychology and the psychology of shapes. It is based, above all, on the knowledgeable use and proportional use of colors as seen and studied in their relationships and contrasts between quality and quantity.

Combinations of Colors

The tree is a favorite subject of Duilio Cambellotti. Here, it is also a pretext for an expert interrelationship of complementary colors: the blue-violet of the fronds and the shade on the trunk; the ochre-orange of the branches and the background.

The Experience
The layout with the twisted branches is cut by the shape of the foliage; it is extraordinarily dynamic and creative. There are really only two colors: ochre and violet. Next to one another, juxtaposed, and blended, they suggest the chromatic variations of the olive leaves, the character of the trunk, and the light and shadow.

Duilio Cambellotti: Olive Trees, *ca. 1920. Rome, Cambellotti Collection.*

To speak of colors, pure and complementary, primary and secondary, remains academic if we do not deal with combinations of colors. As we know, a specific color is not as important as the relationship, contrast, and combination of colors. There are highly specific contrasts, such as those of simultaneity, which are due to the fact that the human eye requires the entire color spectrum and hence always looks for the complementary of any color it sees. And then there are the contrasts between hot and cold, near and far, and so on.

These are not the only relationships, however. In order to deal with colors in an aware way, we have to know the processes of modifying them. In this way, we can familiarize ourselves with the infinite possibilities of colors, practicing all the combinations.

We have already experimented with some of these combinations, for instance, by adding complementary colors to pure colors in order to obtain the given complementary colors, or adding gray in order to obtain gray.

We have also examined Goethe's isosceles triangle, which is subdivided into smaller triangles: at the vertices of the overall triangle, we have the red, yellow, and blue sub-triangles, while the other sub-triangles are in the secondary or tertiary colors.

If we then construct a similar triangle, with the secondary colors—green, orange, and violet—in

its vertices, the internal triangles will show the further shades of these colors.

By utilizing these experiences, we can create a series of color combinations organized in a square checkerboard.

One of many examples of this diagram could be a square subdivided into thirty-six smaller squares, with six horizontal and six vertical strips.

We then put the colors of the spectrum across the first horizontal strip: yellow, orange, red, violet, blue, green. Then, in the bottom horizontal strip, we put the complementary color of each of those colors: violet, blue, green, yellow, orange, and red.

In the first vertical column, we gradually blend violet into yellow until we achieve pure violet at the bottom. That is, the progressive addition of the complementary to the basic color will change the yellow into its complementary color—violet.

We perform the same process in each of the other five columns.

Ultimately, for every color, we will have a range of shades, which gradually become grayer and grayer toward the central zone (we know that the blend of two complementary colors produces a gray). Gradually losing the initial tone, the squares, after becoming neutral or gray, turn into the specific complementary.

This is one of many learning methods to help us understand colors in their possible blends, mixtures, and combinations, beyond mere adjacency and juxtaposition.

And there are many other approaches as well. Here are some more examples and exercises.

Observe the great works of the color masters. In a colored drawing or painting, try to pinpoint the color tones and isolate them on one or more strips of squares (one square for each color) in the order in which the colors appear. The strip(s) can be either horizontal or vertical. In other words, by using a sort of checkerboard, you are repeating the chromatic composition of the examined artwork. Try to analyze Redon's *Portrait of Violette Heymann.* You can appreciate its peaceful fascination, the diagonal composition that separates the group of flowers from the female figure. Make up an initial row of squares for the colors gray, pink, blue, and yellow. Then, in a strip underneath, line up the colors blue, light brown, green, and the pale green of the girl's frock. Naturally, instead of using

two rows of four squares, we could just as easily use a checkerboard of four by four, or even five by five squares, with a more subtle indication of the tones and nuances.

We can repeat this experiment with a real-life view. Before starting to draw, carefully observe the colors of nature. Then, using a checkerboard, or simply a series of strips, indicate the colors that you can distinguish. Place them next to or over or under each other. In this way, you will have something like a personal archive of color combinations. This will come in handy for recognizing colors in real life, refining your chromatic sensibilities, and enriching your palette.

Odilon Redon: Portrait of Violette Heymann. *Pastel, 72 x 92.5 cm.*
Cleveland, Museum of Art, Hinman B. Hurlibut Collection. Redon was a symbolist painter, and his "finish," like that of the Impressionists, is still vibrant, immersed in plein-air luminosity, and also in a rarefied background that provides an aura of mystery. In this portrait, the flowers, the gray of the background, the purity of the profile, and the mass of hair are the elements of a composition that refers to a precept learned from Corot and intimately internalized by Redon: "Always place uncertainty next to certainty."

"The dominant tendency of color should be to serve expression as much as possible. I place my colors without preconceptions; if instantly and perhaps unconsciously, a color has seduced me or struck me, then, once the painting is completed, I will usually realize that I have respected this color if I have gradually modified and transformed all the colors. The expressive side of colors imposes itself upon me in a purely instinctive way. In order to show a fall landscape, I will not try to recall the particular nuances of that season; instead, I will draw solely on the feelings that autumn has aroused in me; the purity of an icy sky in harsh blue expresses the season as effectively as the tone of the leaves. My sensations can vary depending on the autumn, which can be a warm and mellow continuation of sumer or a rigid period with a cold sky and lemon-yellow trees, that look frozen and already announce the winter.

My choice of colors is not based on any scientific theory; I go by my

H. Matisse; The Dance, 1910. Leningrad, Hermitage (Foto Editions Cercle d'Art) © by Barnes Foundation

The colors in this painting seem to draw their light both from within themselves and from the outer world. This effect is due to the choice and proximity of the three tones, blue, pink, and green. The colors "generate light. Seen in a dim or indirect light, they contain not only the savor and sensitivity of the line, but also light and differences in values obviously corresponding to each color."
The diagrams on the next page demonstrate the importance of the choice of colors by isolating them one by one as colored shapes.

"To Hell with Mistakes!"

Many painters have investigated the practical and theoretical meaning and value of colors. One of the most interesting artists to do so was Henri Matisse, who often gave us lengthy descriptions of his chromatic experiences. He almost seemed to be clarifying them to himself rather than communicating them to others. Thus, in his *Thoughts on Art*, he writes:

"Color demands great precision in the various parts making it up. It also demands that its effect be used as directly and completely as possible. This gives it solidity; vague relationships make for vague and flabby expression. The mute influence of colors is absolutely essential for the colorist; he can obtain the loveliest, most solid, and most immaterial hues without expressing them materially. For instance, you can make pure white lilac, ibis rose, Veronese green, or angelic azure simply by placing white next to its opposites. ...

"In painting, colors exert their power and eloquence only if used in their pure states, if their glaze and purity are unaltered and untouched by any blends contrary to their nature. The blue and the yellow forming a green should be adjacent and not mixed; otherwise you could use green as it is manufactured industrially. The same holds for orange: by mixing red and yellow, you merely get a tone without purity or vibrations. It is

observations, feelings, and sensory experiences. An artist like Signac, who was inspired by certain writings of Delacroix, is concerned with complementary colors, and his theoretical knowledge of this area will impel him to use certain colors here and there. As for me, I simply try to employ the colors that render a sensation. There is a necessary proportion of colors that can modify the shape of a figure or transform my composition. I seek this proportion and I go on working until I have achieved it in all parts of my canvas. Then comes a moment in which I have found the definitive relationships for all the parts; and it would then be impossible for me to make the slightest change in my painting without redoing it entirely.

(Henri Matisse: *Notes of a Painter*, in *La Grande Revue*, 25 December 1908)

obvious that the colors used in a pure state or with gradations of white offer a lot more than visual sensations; they profit from the wealth of the brain of the person who gives them life.

"Colors can be multiplied with gradations of white or by being added to black. What a world of difference between a black tinted with Prussian blue and a black tinted with ultramarine! Black with ultramarine has the heat of tropical nights; black tinged with Prussian blue has the coolness of glaciers!"

Matisse adds that after studying everything necessary for doing a painting, he has to set to work shouting: "And now, the hell with mistakes!" He means that you should let instinct take over.

As for the transparency of colors, once again a sort of instinct guides the hand: "When I began *The Dance* and *The Music*, I had decided to add the colors in surfaces without shading them. I knew that my musical harmony was represented by a green and a blue (depicting the relationship of green pines against the blue sky of the Mediterranean); and, to complete the composition, I added a flesh tone for the figures. The surface amount of the colors struck me as essential. I felt that these colors, applied in any medium—fresco, tempera, watercolor—would render the spirit of my composition. These great changes led me to study each construction element separately: the drawing, the color, the values, the composition, the way in which these elements can converge in a synthesis in which the eloquence of each element is not impaired by the presence of any other element. ... Every generation of artists sees the work of the preceding generation in a different light. The paintings of the Impressionists, which were constructed with pure colors, made the next generation realize that if artists use these colors to describe the objects and colors of nature, then they can have a profound effect on the feelings of the viewer, independent of the objects they are used to describe. Thus, if pure colors are kept simple, they can act upon the emotions all the more strongly. A blue, accompanied by the radiation of its complementaries, acts upon the emotions like a loud stroke of a gong."

Degas

Nudes and ballerinas, figures in motion, "cut off" almost as they are in snapshots, were the pretext for assembling colors with a new freedom. Paul Valéry writes: "Ballerinas, to be sure, but from an extraordinary planet." For Degas, the subject per se is unimportant. He paints the female figure, transforming it by means of light, because, as a painter, he wishes to render movement, lines of force, closeness of hues pulverized by light and enclosed by outlines.... "I'm known as the painter of ballerinas. But people fail to understand that the dancer was merely a pretext for me to paint graceful subjects and depict move-

Edgar Degas: Ballerina with Fan, *1879. Pastel, 45 x 29 cm. U.S.A., private collection*
This drawing emanates a powerful physical sensation, which was felt and always sought by Degas. For him, the figure had to "take," and the balance, a fundamental problem in drawing and sculpture, had to "hold." In this drawing, however, we see the importance of the lines in the floor planks, the foreshortening, and the position of the figure: the base and support, the stage and "weight," the perpendicularity of the figure about to take off, the lightness and transparency of the tutu. Everything is rendered with a non-color, white, barely spotted by the blue ribbon and heightened by the fan and the pink slippers.
The Experience
The "cut" of the framework, with the diagonal floorboards, the figure of the ballerina in the right side of the drawing; the color emerging from the white, with the figure against the light; the ballerina is given bodily weight and her tutu is given lightness by the white.

ments.... Drawing is not form, it is the way we see form.... We have to compose, even when dealing with nature."

In regard to his experiments, he confesses: "One difficulty is light. A sun is an insuperable difficulty. Every man has something terribly dark, dreadfully bitter within him...."

Thus, Degas composed huge charcoal drawings, using successive transfers on top of one another. He imagined and invented original and extraordinarily rich color harmonies, which seemed to announce a new world. "People see the way they want to see, and this falseness is what constitutes art.... We have to cast a spell on truth, make it look like madness."

Edgar Degas: Three Ballerinas in Violet Tutus, *1898. Pastel, 73 x 48 cm.*

Degas's goal is once again his color ("I've spent all my life experimenting"). In this pastel, the violet of the tutus granulates in the dottedness of the light. This is certainly not a pure color, nor is the tone obtained in a simple way. It is based on a thorough investigation, a virtual alchemy that makes the painter's work seem "mysterious." Above all, we see a new way of rendering light and shadow. The illuminated parts are lit up with brief touches of white, yellow, and pink, while the dark parts are depicted with strokes of blue and violet and are rich in reflections that transform the gray and the black into colors.

The Experience

A strong sculptural sense animates the scene; great attention is paid to the volumes, clearly revealing the painter's interest in both painting and sculpture; the "composition" of the colors obtained with a hatchwork of different tones or with the closely knit short strokes—an Impressionist technique.

A Drawing a Day: Sails

Sails, on the beach or at sea, are a fascinating theme if you want to have fun with combinations of colors.

You don't need much imagination. Just observe the thousands of color combinations that enliven the sails bellied with wind on the waves or on boats about to glide away.

These four sketches suggest one approach to the colored world. The world of sails seems to acquire its own equilibrium, its musical harmony in the grand vivacity of colored stripes.

In sketches 1 and 3, we have indicated only an

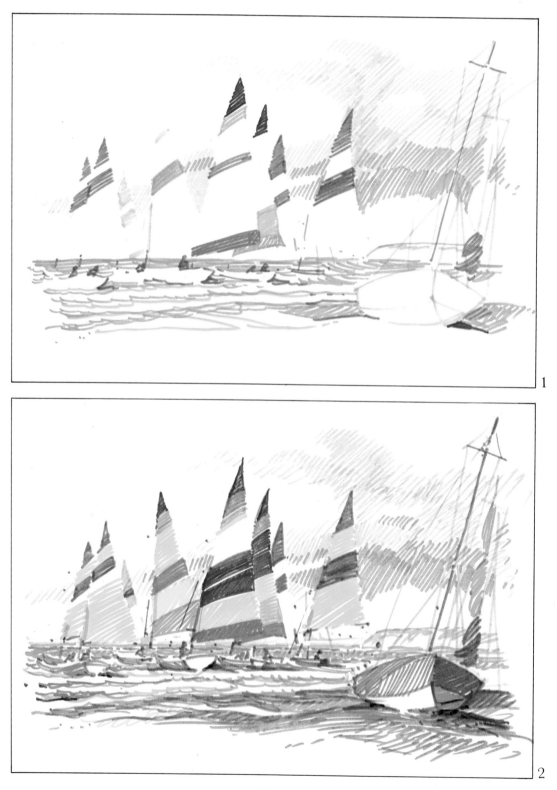

1

2

initial phase of the sketch, limited to the cold tones (blues, greens, grays). In sketches 2 and 4, the image, the impression of the boats about to set sail, is sketched in both cold and hot colors.

In these sketches, the sole intention is obviously to capture the joy, merriment, liveliness, the singing of the hundred colors of the sails against the blue-green ocean waves. And this singing becomes more and more harmonious and vibrant when we succeed in composing non-random combinations of colors.

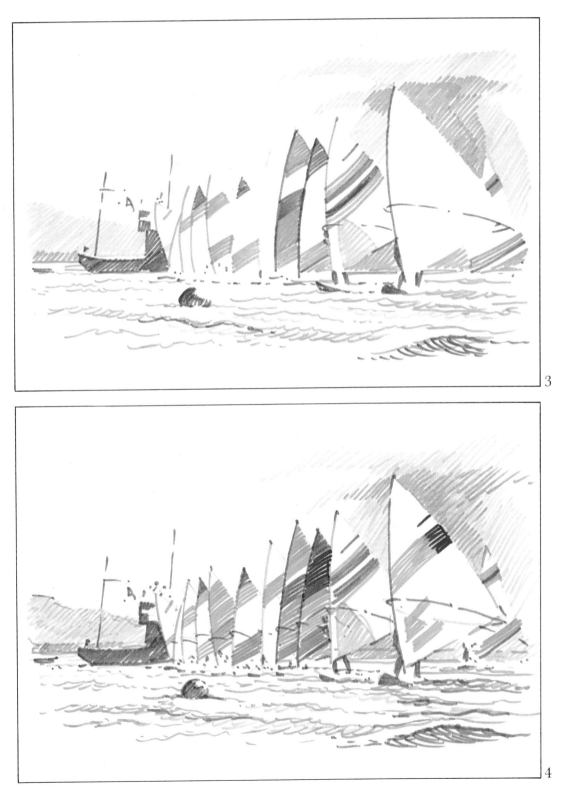

3

4

A Drawing a Day: Brown, Gray, Green

These three drawings in colored chalks offer, as we can see, an entirely different chromatic experience. There is no dazzling sunlight on the open sea, no azure sky framing the lively colors of sails. Instead, the artist interprets the magical and mysterious atmosphere of Venice. A Venice at sundown, with the diffused light enveloping churches and houses. Drawings 1 and 2 show the Chiesa della Salute at two different moments. In the final gleam of daylight, the first drawing stands out in the two basic colors: the brown of the buildings and the green of the lagoon and the sky,

1

2

melting into white, against the gray-ochre of the paper. The second drawing, in the first dimness of night, emphasizes the brown of the architecture, illuminated by artificial light, and the white of the water reflections against the gray-azure background of the paper.

Drawing 3, done with colored pencils, investigates more thoroughly the architecture of the church in morning light. There are three basic colors here: green, ochre, and brown. And even the combination of just three colors contributes to the synthesis of the image.

3

The Colors of the Day

In the surrounding world, as in the paintings that depict and interpret this world, colors have different meanings in the most varied areas: from astrology to precious stones, from heraldry to liturgy. We are so used to colors that we scarcely pay them any heed. But just pause for a moment and try to *see* the colors around you, and you will note that our day is colored.

Think about all the colors you encounter during the day and try to pinpoint them. (When we lack the colors of the day, don't we say, "It's been a dull day"?)

Prepare a small booklet, with one page for every day of the week or at least for every day that interests you. Divide each page with a vertical line. The space on the left is for indicating anything that interests you: a given object, animal, flower, piece of clothing. On the right, indicate the color of each object. Too simple? What good is it?

It is not so easy to pinpoint a color. We are used to saying "red," but there are actually dozens and dozens of red. So, when we call an object "red," we ought to be more precise.

In order to understand that a specific color has a specific hue or tone, value or brightness, and saturation, we have to scrutinize it carefully and compare it with other colors, even watch it shine against its complementary. In your booklet, you can then describe how this color varies next to a different color.

Another enjoyable approach to reading colors is to select a color early in the day, for example "lemon yellow." Then, in the course of the day, look for this same color in the things around you. Try to find it in the plants, objects, surfaces; learn to recognize it and, in your diary, note every object that has this color.

Ultimately, by noticing the colors of things, you will realize that the world is colored—even the night has its colors. And you will understand how important the colors of your day can be.

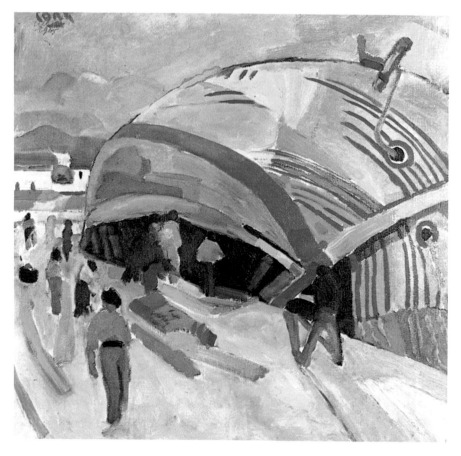

The large tent is merely a pretext for expressing Primo Conti's "colors of the day": against the backdrop of the sky, the lighter blue of the tent, spotted with blue and green and striped with red; all around, the less important spots of the figures animating the scene.

Primo Conti (1900): Dock of Viareggio, *1915. Painting, 60 x 60 cm. Florence, private collection.*

Harmonies and Variations of Colors

Chromatic composition is built on the harmonies and variations of color. Harmony, as we have said, refers to the adjacencies and relationships of colors, from rapport to contrast. Variation, from an analytical and then didactic viewpoint, refers to tonal modifications achieved by the addition of white, black, or other colors, and also the modifications caused by varying the lighting conditions.

Chromatic harmonies are thus obtained by the closeness of two or more colors, while variations are obtained by modifying the value and intensity of a color.

Two-way harmonies are made up of two colors diametrically opposed (i.e., complementaries) in the twelve-part color disk: for instance, red and green, yellow and violet, blue and orange.

A relationship of chromatic harmony is achieved by all the colors that are in a symmetrical position with respect to the center of the chromatic sphere. Thus, yellow corresponds to violet.

Three-way harmonies are made up of three colors corresponding to the vertices of an equilateral triangle within the chromatic circle: for example, blue, yellow, and red.

In order to obtain a three-way harmony, we have to imagine a two-way chromatic harmony and then replace one of the colors with the two colors contiguous to it. For example, the two-way harmony of yellow and violet can become a three-way harmony of yellow, blue-violet, and red-violet.

Four-way harmonies can be obtained in the same fashion. Imagine the four colors corresponding to the vertices of a square inscribed within the chromatic circle: yellow-green, orange, red-violet, blue. Or else think of the corners of a rectangle inscribed in the circle: yellow-green, yellow-orange, blue-violet, red-violet. A four-way harmony can derive from a two-way harmony: select two diametrically opposed (complementary) colors and replace each one with its two flanking colors.

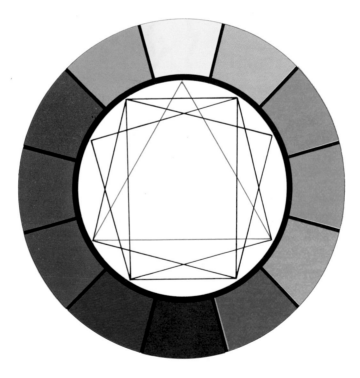

The harmonious colors of the chromatic circle.

Theo van Diesburg (1883-1931): Three Variations, 1920. Paris. Collection Nelly van Doesburg.

Van Doesburg establishes the equilibrium (sought also in architectural compositions) in the color relationships defined by the ratios between quality and quantity.

The knowledge of the values of pure colors and basic colors, and especially the knowledge of their relationships and variations, is fundamental if you intend to draw in color. However, this harmony and this variation are contingent on many factors.

When we use the three pure colors to obtain mixtures, the results are never consistent. For instance, if we combine red and yellow, we don't always get the same orange tone. The result varies greatly because of several factors: the amounts of each color, the presence of white, the size of the overall surface, and so on. We have seen that each color mixture is characterized by three aspects:

1) Hue (chromatic value): violet, for instance, can be more red or more blue; green can be more yellow or more blue.

2) Value (luminosity or brightness): blue, for in-stance, can be light azure or deep blue, and red can be pink or scarlet.

3) Saturation: yellow, for example, can be darkened by gray, made greenish by black, or completely dimmed by white.

To these characteristics we can add the contrast with the complementary (the well-known "contrast of simultaneity") and the quantitative ratio.

All these elements increase our knowledge so that we can use colors in terms of our own aims and goals. We know what we're doing.

The variations of color, as modifications of the basic tone in adjacent tones with the addition of white, black, or other colors, constitute the foundation of many compositions, especially abstract ones. Abstract compositions find harmony and equilibrium in the inter-relationship between

Josef Albers (1888-1976): Study to told, *1960. Oil on masonite. Milan, private collection.*

Albers composes his works as superimpositions of squares in harmonious shades of the same tone.

gradually varied tones. We can also have variations of color in a single subject, or the application of different colors and different chromatic harmonies to the same theme. These approaches constitute one of the most fascinating chapters in the theory and practice of color.

The examples of studies *sur le motif,* i.e., of a single subject, show an artist's intention to deepen the investigation of color and its variations beyond the meaning of the subject per se. The subject is merely a pretext for the experiment. By confronting various chromatic solutions (above all, various lighting conditions) for one and the same theme, we can investigate color all the more thoroughly. For this purpose we have to select a subject and study it in the course of the day, following the changes in light and hence the changes in brightness and intensity. This approach was taken by Monet for his

Cathedrals and by Cézanne for his Mont Sainte-Victoire.

We may view this interpretation of reality as simply an approach and then go on to the harmonies and variations of colors themselves, with no reference to objects. The simplest sequence follows the order of the spectrum, although it can vary depending on the intensity and luminosity of the shades. We can then pass on to more complex variations. The first exercises are variations of a single color by the addition of white, gray, or its complementary (in a series of concentric squares or four triangles within an isosceles triangle that unites the median points of the sides). Next come variations of two or more colors as in the alternating colors of a chessboard.

Monet's Cathedrals

One of the best-known and most important examples of a motif (a subject interpreted from different viewpoints) illuminated by different kinds of light throughout the day is the facade of the Cathedral of Roue with the tower of Saint-Romain. This is the theme in a series of paintings by the French Impressionist Claude Monet. Let us hear what he had to say at the beginning of his extraordinary venture:

"I've settled in an empty apartment facing the cathedral, but I feel a pressing need to begin." Monet wrote these words in 1892. While all his Cathedrals are dated 1894, they were actually painted from February to April during 1892 and 1893.

Monet's correspondence enables us to pinpoint the successive parameters in which he observed and painted the Western facade of the cathedral. They reveal that the artist gradually shifted the subject toward the right. He then changed "windows" as an observation point and recommenced, "without thinking about the cathedrals" and "working on two canvases simultaneously when the sky was gray and overcast" (the canvases of "white harmony" and "blue-and-gold harmony").

In Monet's letters, we can follow his procedure:

"Every day, I add and catch something that I was unable to see. How difficult this is! But nevertheless, I forge ahead; on some days I still have that beautiful sunshine, and a good number of my canvases will be safe. I'm at the end of my rope, I can't go on ... I've had a nightmarish night: the cathedral was falling on top of me, it looked blue or pink or yellow. ... I'm seeking the impossible ... What a terrible time and what changes! It's so hard to do the cathedral this morning.

"All I can do is get the beauty of the air; the subject is unimportant for me; what I want to depict is that which is between the subject and me."

But, in redoing his work, Monet seemed to plunge into despair: "I'm totally discouraged and unhappy with what I've done. I've tried to do too much and now I've wrecked what was done right. ...I'm thinking of dropping everything, I don't want to show my canvases, I don't even want to see them for a while...."

Monet was so committed to investigating the variations of light that he adjusted his meal schedule to the illumination of the cathedral facade and the state of his work: "If I want to work, I have to lead a calm, regular life. Thank you...for understanding that, before anything else, I exist for my Cathedrals."

He confided his troubles to a friend: "I struggle and work...leaving and then going back to my canvases little by little as time passes; this is something that wears you down and exhausts you. ...I am staying on here, but this doesn't mean that I'm almost done with my Cathedrals. Good God! I can only repeat: the further I advance, the more I suffer in depicting what I feel, and I say that any man who claims he's finished a painting is tremendously arrogant! Finished means complete, perfect, and I drudge and drudge without making progress, groping along, and without accomplishing very much, yet I'm exhausted." Ultimately, some light at the end of the tunnel: "At last I'm resting, I've worked harder than ever ...but today I am less dissatisfied than last year, and I believe that some of my Cathedrals are passable."

Monet completed his Cathedrals in his studio, perhaps using a photograph (one was found among his papers after his death).

We have listened to Monet at work, day after day, seeking the variations of light and color on the facade of a cathedral. This was no longer merely a painting fact, a chromatic problem, but a question of the relationship between the artist and reality—a space/time experience that fascinated and absorbed him. Let us now listen to a witness, a friend of the painter's: Pissarro. After visiting an exhibition of twenty versions of Monet's Cathedrals at the Durand-Ruel Gallery, Pissarro wrote to his son:

"I would be unhappy if you couldn't get here

C. Monet: The Cathedral of Rouen, the Portal, Morning Sun, Blue Harmony, *1893. Canvas, 91 x 63 cm. Paris, Louvre.*

Claude Monet: The Cathedral of Rouen, in Full Sunlight, *1894. 110 x 73 cm. Paris, Louvre.*

before Monet's show closes. His Cathedrals are going to be scattered all over the place, and they ought to be seen together. There's been a lot of arguing among the young here and also among Monet's admirers. I'm absolutely wild about his extraordinary achievement.... The Cathedrals are the subject of lively discussions and they are praised by Degas, myself, Renoir, and others. I would so much like you to see them all together, since I find that they have the superb unity that I have looked for so intently. I consider this show so important that I came here just to see it."

Monet's Cathedrals proved to be one of the keenest and most penetrating theoretical and practical investigations by a painter in the variations of color and in the passage of light across the stones of a building. He succeeded in making his depictions vivid and palpitating, and he impressively rendered a mysterious life, almost breath itself.

Variations on a Theme

Rembrandt: The Quartered Ox, *1655. Painting, 94 x 67 cm. Paris, Louvre.*

Honoré Daumier (1808-1879): The Butcher, *ca. 1857/58. Charcoal, pen and black ink, watercolor, 333 x 242 mm.*
Cambridge, Mass. Harvard University Fogg Art Museum, Grenville L. Winthrop Legacy

Rembrandt draws and paints the variations of light and color in several versions of the same subject: an ox carcass hanging spreadeagle. In its dramatic intensity, this picture seems to express a great deal more than a simple still life. The main feature is the light that flows over the flesh, pulling out volume from the depth and color from the darkness. The color is based on a single tone: Yellow, orange, and red light and the greenish-blue shadows against the ochre earth.

The Experience
The strange and special fascination of the subject: this still life takes up the theme of the ephemeral, putting it on a dramatic level; the palette of the great masters seemingly was restricted to a few shades in these chromatic compositions, whose meaning is to be found in their colors.

Daumier's critique focuses also on the problem of meat. The flayed carcass seems to interest him for entirely different reasons. This watercolor stands out because of its sobriety of tones, which are orchestrated chiefly on gray. This gives the picture a dramatic urgency. Once again, Daumier proves that he bears witness to his era. His critique does not need any special effects. He requires only a highly skillful line and a few tones of dim red.

The Experience
Gray, a non-color turns out to be capable of suggesting a multiplicity of palpitating tones, especially in the relationship with the red tones. A drawing can be colored without using all the colors of the palette. You need the tones of only two interrelated colors to render atmosphere and meaning.

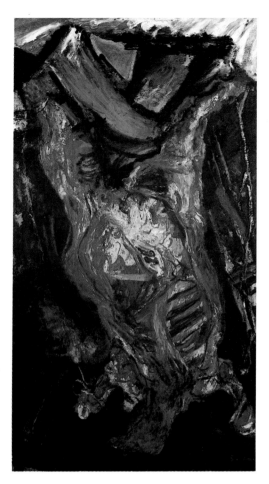

Chaim Soutine (1894-1943) The Flayed Ox, *1925. Painting, 114 x 202 cm. Grenoble, Musée de Peinture et de Sculpture*

Francis Bacon (1909): Second version of Painting 1946, *1971. Painting, 198 x 147.5 cm. Cologne, Wallraf-Richartz-Museum, Sammlung Ludwig*

In his Expressionist vision, Soutine, confronting the quarter of a carcass in his studio, was fascinated by the weight of the reds, the violent color effects of the flesh and the blood. He was so absorbed that he stayed in his studio for four days, working uninterruptedly day and night. He asked his friends to bring him fresh blood to sprinkle on the carcass and revive the tones that he furiously captured on canvas. In his obsessive quest for color variations, he did several paintings, ultimately reaching the outer limit of pigment-charged brushstrokes and material.

The Experience
The meaning of this work resides not only in its colors and their tones, but also in the expressionistic brushstroke. It would be interesting to pinpoint the various reds the artist used.

The carcass of an ox cannot help but fascinate a painter like Francis Bacon. This subject has been interpreted and seen afresh by many artists; but never before was it consumed by its own intense and internal drama. Bacon combs through contemporary society, gleaning images of solitude and individual drama. He enters into the symbol of shattered strength, of a useless carcass, of the existential void. These experiences are captured in gray-violet tones.

The Experience
A highly expressive way of showing the artist's existential quest. In his skillful technique, he manages to render the dramatic atmosphere with an economy of lines and tones.

A Drawing a Day: Variations of a Face

The four pastels of the boy's head are variations on a single theme.

The first drawing is a preparation for the second, an intermediate phase of its development. We need not emphasize the composition with the face (shown almost in its entirety) in the right half of the surface and the artist's goal to suggest the completion of the image.

In the second drawing, the colors are superimposed on one another and blended for the features of the face. A grainy line suffices for the hand, the arm, and the locks of hair.

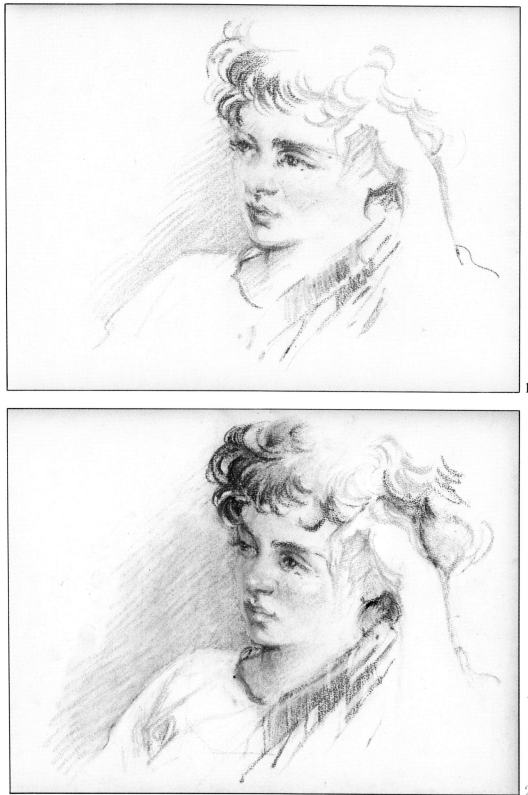

1

2

The third drawing shows a variation, especially in the background tone. While the first drawing has an ochre background (a tone that almost melts into the shadowy part of the face), here the background is dark, with gray, violet, and sienna tones, bringing out the face more sharply.

The fourth sketch exploits the relationship, or rather the contrast, between the orange pastel and the bluish paper, in order to suggest the use of colored paper for bringing out complementary tones.

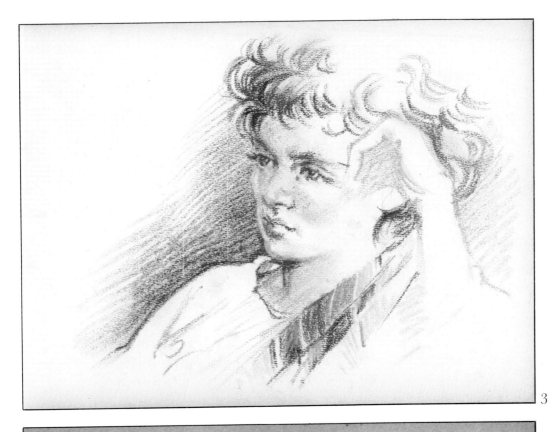

3

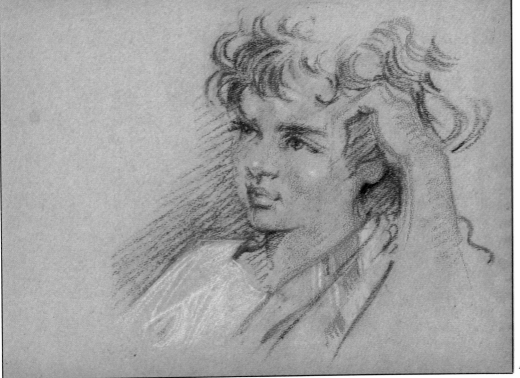

4

A Drawing a Day: Variations on a Shipwreck

What we see here is a boat, cracked in half, foundering near a shore. This curious subject is a pretext for a series of watercolor "variations" done at different moments throughout a day.

The first sketch shows the wreck in daylight. In the foreground, there is a bush on the shore; the skyline is one third up the paper; and the subject is at the right or, rather, in the bottom right quadrant.

The second drawing takes place at sundown in the rosy atmosphere that precedes twilight; details are less visible, the outline is hazy.

1

2

The third sketch captures the atmosphere of twilight, the green-yellow light that precedes the tones of evening and the darkness of night. The reddish outline of the wrecked boat stands out against a pale-green sky that is veined with azure.

The fourth drawing, sketched during the shadowy onset of evening, is based on blue and gray tones that envelope the entire view, a prelude to the darkness of night.

Naturally, a series of such variations can be done on any subject that interests you in the course of the day. It is useful to observe the changing relationship between foreground and background.

3

4

The World in Terms of Painting: Seeing Colors

We have frequently repeated, especially at the start of our graphic experiments, the following: before drawing, you have to see. Now, when we talk about color and drawing in color, it would be logical to realize the following. If a painter interprets nature or the images of his imagination in terms of color, he must also learn to see in terms of color. You cannot just stop at reading, discovering, and seeing the shape of what you want to draw. Beyond the outline, the profile, and the chiaroscuro, you have to observe and see the colors. This new approach to reality has interesting consequences, which can help you to understand the background of visual discoveries. Sometimes, especially at night, when you leave a theater or movie house and you look at the buildings of your city against the sky, you seem to be viewing them in a new light. They are free of traffic now and without the confusion of everyday life and habit. You discover their shapes as if you were seeing them for the first time.

Well, we have done the same thing in regard to colors and we can do it again.

Many people have had a similar experience.

After visiting a museum or art gallery they go back out into the street. The buildings and the people, the traffic, the stores, the signs—everything looks transformed and transfigured.

After seeing so many painted images of reality, and thinking of them as being the reality itself, we suddenly face the real world again—and it is no longer changed into lines and colors. We then spontaneously try to invert the situation, we attempt to see the world, the reality of the street and the people, in terms of paintings. For an instant, we see things with a painter's eye, spontaneously or thinking about them. That is, we try to catalogue, separate, even pinpoint the various subjects and elements that we, as artists, can render with colors on canvas. A tent becomes a red triangle, a shadow a violet splotch. And if you squint, you can pick out a blue kerchief among the yellows and pinks of the houses.

A fascinating experience—and one that all of us can and should try to have whenever possible. Once again, we have to free ourselves from habitual ways of dealing with a subject, we have to cast off the normal meanings of things and seek only the shapes and colors projected on the paper. Ultimately, we have to learn how to see in colors.

Mondrian's landscape is an extraordinary example of a vision of reality transformed by an artist. The meadow, the sky, and the cloud are shapes and colors in an abstract composition. Note the adjacency of the blue, the green, the orange and, above all, the way the blue of the sky intervenes in the orange of the cloud and the green of the meadow.

Piet Mondrian: Landscape with Red Cloud, *1907. Oil on wood, 75 x 64 cm. The Hague, Gemeentemuseum.*

Chromatic Harmony

The Harmony of Nature

When two or more chromatic perceptions arouse a pleasing sensation, we have a chromatic harmony. The concept of harmony is bound up with the pleasantness of the chromatic relationship per se, aside from the effect produced by individual components. Naturally, there are subjective and personal harmonies. But there are also precise harmonious ratios between colors, e.g., the shades or complementaries of any given color. In fact, determining harmonious color combinations seems more important than a subjective preference for a color. If we "feel" that a color is pleasing, then this feeling will be even greater when this color is in a ratio to or combination with other colors.

Is there, then, such a thing as a pleasant or unpleasant color per se?

Red and blue are generally agreeable, while yellow and orange are less so. But even in different examples of the same shade, the degree of pleasantness rises with the increase in saturation and luminosity of the color. In only a few cases

Gaspar van Wittel (Gaspare Vanvitelli): Roman View with Santo Stefano Rotondo. *Pen with watercolors in green clay and bistre mixed with red pencil, 127 x 308 mm. Rhode Island, private collection*

Gaspare Vanvitelli works in the spirit of Claude Lorrain, painting vistas characterized by a distant point of view, a vast framework, and an elogated shape.
One theme, the church of Santo Sefano Rotondo seen among the pines, was treated repeatedly by the vedutisti, *as one of the most typical landscapes of Rome.*
The drawing is orchestrated on its two chief tones: the green of the trees and bushes and the brown of the buildings and the shade.
For all practical purposes, the scene is staged as in a theater with the two trunks and the foliage of the pines in the foreground, the horizontal strip in shadow behind them, and the church in warm tones against the light backdrop of the sky.
This is a precise drawing; but more than anything, the atmosphere and the sky of Rome, created by wash-like use of watercolor, seems to attain color and depth, despite the fact that the artist has used few tones—just two as in this case.

The Experience
The traditional structure (a rather low horizon, a foreground and a background); simplicity of tones, practically just two, green and brown; richness and harmony of the effects, obtained by the close relationship and superimposition (transparency) of the colors.

does a shaded color have a pleasant effect. This is the case with red, which, if ignited, is exciting and pleasurable; but even if it is lightened into pink, it still remains agreeable.

In regard to combinations of colors, the finest harmony comes from a ratio of strong and weak tones rather than medium ones. This holds even for colors in our clothes; for instance, the combination of shades in a tie with those in a shirt and a jacket or scarf with a blouse. We already know about the harmony of colors in the chromatic circle when linked by a triangle, a square, or a rectangle.

However, we ought to bear in mind that a strong contrast in value or saturation is disturbing because it produces a feeling of disruption and confusion. The best conditions even for complementary colors are present when they are neither saturated nor too bright.

Logically, a balanced harmony also depends on the quantity, the surface area of the color. A wider area of a weakly saturated or not too luminous

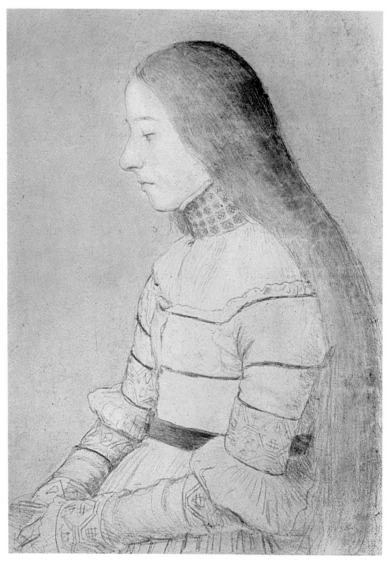

Hans Holbein the Younger: Portrait of Anna, Daughter of Jacob-Meyer. *Black pencil and colored pencils on white paper tinted green, 391 x 275 mm. Basel, Kupferstichkabinett*

An example of colored pencils on white paper, as used by an artist like Holbein. The light tone of the background brings out the whiteness of Anna Meyer's profile, which is barely touched by the pink pencil. Her face is framed by her hair and the high collar of her dress. The pallor of her frock is brought out and emphasized by the adornments and the maroon belt. The warm, gold of the hair stands out against everything else, and the mass of the hair completes the composition of this portrait.

The Experience
The white emerges from and is heightened by the other delicate tones; the basic elements here are: the background tone, the flesh tone, the hair, the lines of the garment.

direction or another, pulling up one weight here and one there, one up and one down, one first and then another, thus determining all the phenomena that occur in space and time."
(Goethe: Preface to *The Theory of Colors*)

shade can balance a smaller, but more saturated or more luminous part.

Thus, we can obtain color harmony if we vary the shade (hue), intensity (value), and saturation of a color by adding white or black, lightening it or darkening it. In other words, colors in the same family, variations of a single tone, can be easily blended and just as easily harmonized.

Basically, all this seems quite natural, because a fundamental chromatic harmony exists in nature.

Just look around, observe the colors about you. Note the hundred shades of green in a forest, from the moss to the foliage, the hundred tones in the sky at sundown, from all the nuances of red to all the nuances of violet. Then, at twilight, watch the violet-green-azure light dimming into the blue of the night. You will feel the profound and mysterious harmony of nature. And we look to nature in order to create our own harmonies, whether in painting or in fashion.

Armando Spadini (1883-1925): Head of Pasqualina. *Colored pencils, black pencil, and chalk on greenish paper, 176 x 110 mm. Rome, private collection.*

The chalk tones on the greenish paper—the orange frock and the blond hair—are the same tones that Spadini uses to draw the features of the little girl's face. Like all his paintings, this portrait is "affectionate." It is based on the harmony of green, orange, and brown. The nuances of the face bring out the only points in which the artist uses a darker pencil: the eyes, the nostrils, the shadow of the nose, and the mouth. The transparency of the greenish paper, under the white and pink chalk, adds light and delicacy to the flesh tone.

The Experience
The importance of the colored paper: the same drawing against a different background would communicate something entirely different; the method of pinpointing the facial details in a few brown strokes; a rapid technique, in which the chalk maintains the freshness of the tones.

—107—

The Colors of Animals

In the inexhaustible spectacle of colors in nature, a major role is certainly played by the hues of animals. We can see the infinite wealth of tones, the characteristics that distinguish sex or age, the agreement and harmony in our environment, the ability of colors to change with the seasons and the surrounding conditions. Color is not only an attribute of a given animal, it is an intrinsic and fundamental element in life and in nature. Just think of the function of color in flowers: their hues attract birds and insects, promoting pollination and reproduction. This shows us how important colors are in nature. And don't forget the colors of birds, and insects, and butterflies; their tones exert a sexual appeal. And then there are species that have a different color and shape for each sex.

Some animals, like chameleons, for reasons of protection or aggression, can change shape and/or color to blend into their environment. Polar bears are white, desert animals are yellowish or reddish like sand, meadow or forest creatures are green. Variegated or spotted animals live in forests among the stripes and dappling of sunlight and shadow.

Franz Marc (1880-1916): Red Roe Bucks, II, *1912. Oil on canvas, 100 x 70 cm. Munich, Neue Staatsgalerie (foto Blauel)*

Marc studied and drew animals, a leitmotif in his painting until he turned to Abstractionism. He wanted to "reveal the essence of things beyond their outer appearance." He sought form, and found the freedom of color—non-naturalistic painterly color—that enabled him to create his stupendous animals. Not a cat, but the cat, not a roe buck, but the the roe buck. "I began a large painting with three horses in a landscape and coloring going from one extreme to the other. The horses are in a triangle. The pure cinnaber ground next to a pure cobalt blue, deep green, and carmine red; the horse from yellowish brown to violet. The terrain is powerfully modeled: entire sections, for instance a bush, in the purest azure. All the shapes are tremendously clear and strong, so that the colors can dominate."
Thus pure color and pure shape have won out.
This diagram demonstrates the linear composition that is emphasized and dominated by the color.

Théodore Géricault: Horses Battling, *ca. 1820. Watercolor on pencil, 216 x 295 mm.*
Cleveland, Ohio, The Cleveland Museum of Art, Charles W. Harkness Fund

Géricault liked to paint horses as symbols of vital energy and sculptural perfection. He caught them when they were galloping, but suggested their motion, as latent energy, even in stables. His snapshot visions of them galloping in flight, were fifty years ahead of the versions of Manet and Degas, who were likewise fascinated by horses. Géricault combined Nordic and Latin styles. "You can achieve beauty in art only through confrontation. Each school has its character. If you managed to blend all these qualities, might you not reach perfection? However, this would require endless efforts and great love."

While color may be vital to animals, their hues have always interested painters. And not just their colors, but also their elegant forms, their symbolic meanings, and their social roles in various eras. For all these reasons, the study of animals was a basic phase in the history of drawing. Gentile da Fabriano and Pisanello, Leonardo da Vinci and Dürer loved and drew animals from both an aesthetic and a scientific viewpoint.

After Da Vinci's horses and Dürer's rhinoceros, we find Pontormo's dogs, Andrea del Sarto's monkeys, Rubens's lions, Rembrandt's elephants, Stefano della Bella's steeds, Delacroix's tigers, Géricault's horses. Géricault understood animals, with their shapes and colors, as a microcosm expressing the true splendor of nature. On the other hand, Toulouse-Lautrec interpreted the relationship between men and animals in the very special world of the circus. This world, which seemed to expand ad infinitum, inspired a series of studies and drawings by Chagall, Mirò, Léger, and Picasso. These artists were fascinated by the special kinship between animals and people in a circus, the particular kind of work, exercise, and spectacle, the richness and festiveness of shapes and colors under the big top.

The Colors of Plants

Plants have so many colors, so many different hues, which, like those of animals, change with the seasons and the environment. When we think of the colors of plants, we recall the splendor of flowers. However, the most prevalent plant color is green in all its gradations. This color, as we know, is due to chlorophyll, which turns green under the impact of light, enabling a plant to go through the process of photosynthesis—fundamental for the oxygenation of the air we breathe. Nevertheless, there are also blue, yellow, violet, and red plants. Their colors are due to the presence of pigments, so-called chromoplasts, which make many flowers and fruits yellow or red-orange.

Another kind of pigment, the so-called anthocyanin, causes many of the more brilliant floral hues, from blue to violet and red. Anthocyanins are also responsible for the brilliant red of the Virginia creeper in autumn.

On the other hand, the white or black that we sometimes find in plants is due to certain physical phenomena rather than coloring agents. Thus, the white in many flowers, such as the lily or the white water lily, is due mainly to the fact that their colorless surfaces and air-filled tissues reflect rather than absorb light.

Along with the presence of one or two pigments, there are other factors and structures that act physically to create beauty in plants. For instance, the silvery green of so many variegated leaves (the variegation is due to the presence of air layers that separate the colorless epidermis of the tissue layers). Or the velvety feel of the petals (due to the domelike shape of the epidermal cells).

Beyond their scientific reasons and interest, the colors of plants have always fascinated painters in all eras, in drawings and paintings of landscapes or still lifes. The landscapes depict a painter's

Odilon Redon: Vase of Flowers, *ca. 1914. Pastel, 72 x 54 cm. New York, Museum of Modern Art*

An art critic attacked Redon for being "black" with "visions of horror." The painter retorted: "I am not a prisoner, my soul is not black, I bless life which makes me love the sun, the flowers, and all the splendors of the world around me." And these flowers, inspired by Corot, seem to confirm the artist's desire for chromatic happiness slightly dimmed by melancholy, "a rich, deep surging that reveals breadth and vastness."

world by way of an interpretation of nature, while still lifes show the beauty of nature as well as the ephemeralness of flowers and fruits.

Thus, every landscape, every vista uses tones, atmosphere, techniques to reflect the ideas of an artist and an era. In previous volumes we have studied Dürer's watercolors, which seem immersed in profound silence, Altdorfer's bright colors, Bruegel's powerful depictions of the Alps, Rembrandt's sketches, Chinese and Japanese paintings suffused with distant fogs, Turner's pure tones, Cézanne's blues. It is not so much the colors of the plants that triumph as the colors of light and atmosphere, with compositions transfigured into suggestive sensations.

Along with the depiction of the landscape, the still life developed later on. These renderings of flowers, fruits, or animals were meant to decorate and embellish interiors, but also, as we have said, to recall the vanity and brevity of life. This new genre, evolving in the sixteenth century, made rapid headway. It was also favored by the great artists, who appreciated the relaxation of still-life paintings, far from the problems of style, approach, and commitment. After the influence of Chinese and Japanese art and the geometric handbooks that regulated shapes and proportions, the nineteenth century turned to flowers and fruits, thanks to a new delight in color and a new pleasure in privacy. And artists, like the Fauves and the Expressionists, who sought their truth in color, viewed the language of flowers as a way of expressing the joy of colored light, a direct kinship with the world of nature.

Thus, the hues of plants, the tones of leaves, flowers, and fruits, when transferred to canvas or paper by pencils and brushes, were transformed into the image of an artist's own world. Becoming abstract images of what was or could be, they seemed to express something more intimate and more profound, beyond man and time.

George Hoefnagel (1542-1600): Vase of Flowers Surrounded by Insects, *1594. Watercolor on tissue paper, 161 x 120 mm. Oxford, Ashmolean Museum*

During the sixteenth century, many artists concentrated on flowers and animals; they were interested in details, and they loved decoration and harmonious compositions. Above all, they delighted in symbolism, the triumph of the colors of petals, and butterfly wings as allegories of life and death. A fine example of this trend is Hoefnagel's watercolor, which, in its perfect construction, reveals his talent for engravings and miniatures.

A Drawing a Day: Vanity.

This drawing suggests the image of several sprigs of flowers in a vase. The chromatic composition is based on the yellow and reds sprinkled with white and contrasting with the green tones of the leaves. The subject is particularly interesting because of the rich and sinuous shapes.

Drawing no. 1 depicts an intermediate phase in the development of the drawing; it is done directly with colored chalks. Naturally, the proper chalk is used for each of the varied objects: light green for the sprigs and leaves, yellow and white, with carmine red, for the flowers.

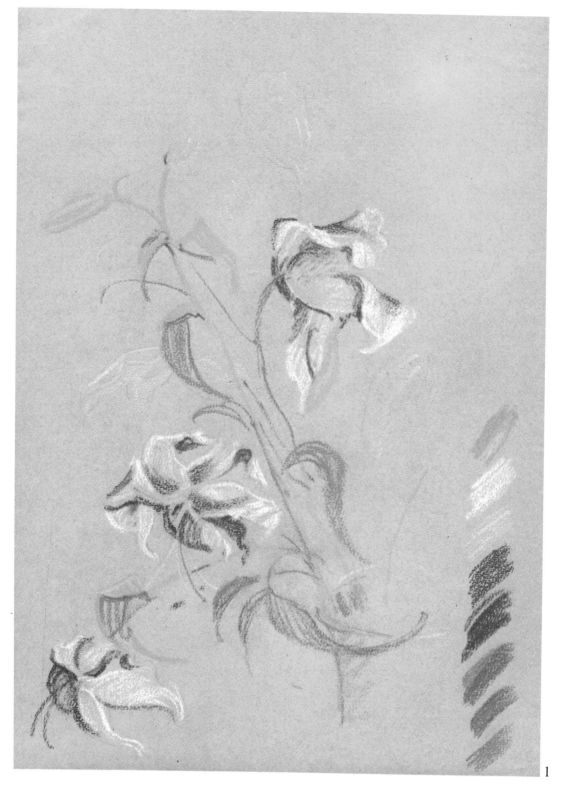

1

Drawing no. 2 shows the finished pastel on gray-green paper, which most effectively brings out the colors, especially white. Obviously, the drawing could be developed further, with finer precision in the details, shapes, light, and shadow, above all in the particularly interesting reflections of the white petals.

This drawing is simply a study, but the idea, the suggestion of human vanity is present in the rendering of the flowers several days after they are picked and just before they whither.

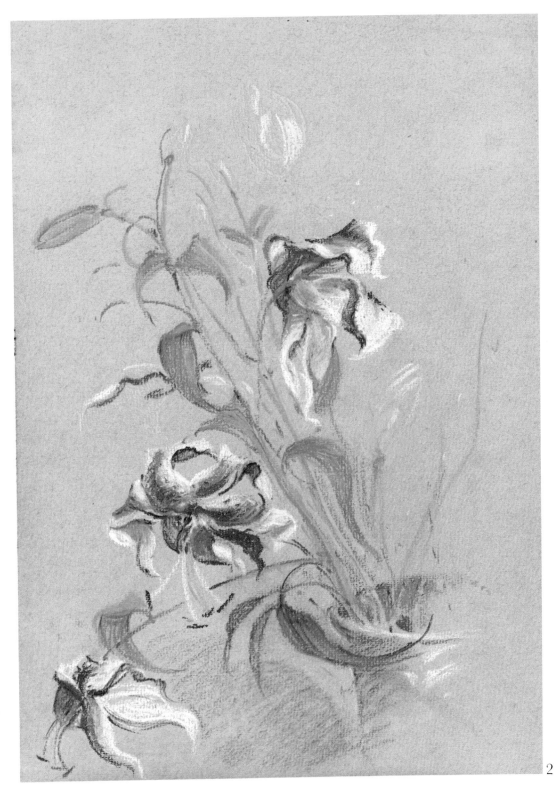

2

A Drawing a Day: The Lion and the Lioness

The circus, as we have said, has always been a fascinating subject for drawings. In the nineteenth century, the circus world, teeming with colors, dancers, acrobats, animals, inspired painters like Toulouse-Lautrec (who gave it publicity with his famous posters), Chagall, Mirò, Léger, and the great Picasso, who was moved by the melancholy of the harlequins.

It would therefore seem logical to go and draw among the cages of a circus, one of the many we can find in our cities.

Drawing no. 2 shows the inside of the lion cage:

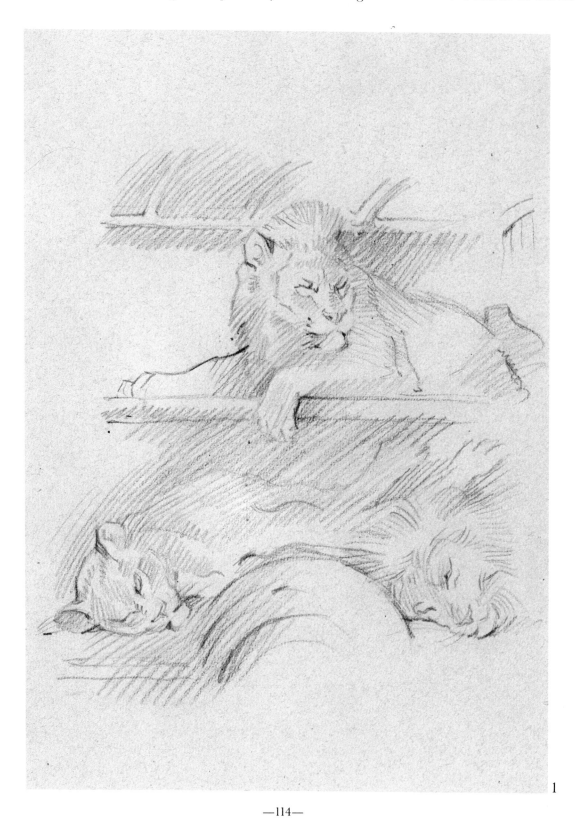

1

two lions and a lioness. It could be titled *Jealousy* or *Drama of Jealousy*. The lion on the higher shelf watches all atremble as the other lion and the lioness play around below him. He will probably tear up his rival in the end. The drawing is organized around the horizontal division halfway up and the semicircular element below. The chromatic composition (as is demonstrated even more clearly in drawing no. 1) is based on the contrast between fundamental colors: the (tawny) orange of the animals and the violet (bluish) of the surroundings. These are complementary colors.

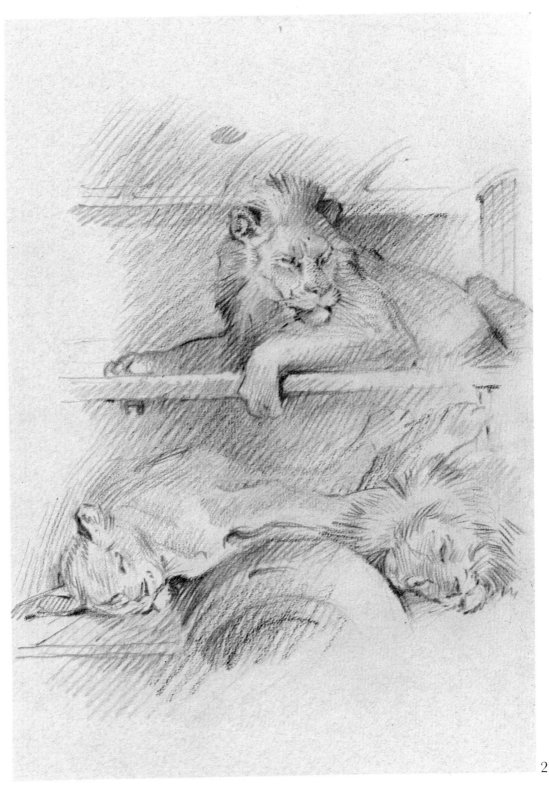

2

The Process of Painting

How do we deal with colors in a painting?

In his *Journals*, Delacroix advises: "It would be a good thing to establish at the very beginning the scale of values in a painting with a clear idea about an object, in which the tone and the value are taken precisely from real life: a handkerchief, a cloth, etc. Avoid black: obtain dark tones with pure and transparent tones, or lake or cobalt or yellow lake or natural or burned sienna....

"The colorist, it seems, does not care about the low, the—so to speak—earthly part of painting; a good drawing is far more beautiful when it is accompanied by a disagreeable color; color serves only to distract the attention, which must focus on more sublime qualities beyond its illusory beauty. One might call it the abstract side of painting, the essential object of which is the outline: it makes other essential parts of painting secondary, independent of color, such as the expression, the proper distribution of the chiaroscuro, and the composition itself."

Elsewhere, Delacroix goes on: "The most universal rule is always to have the foundations of a clear shading (except for flesh tones, of course), but calculated in such a way that the brown parts, as in clothes, beard, hair, stand out in brown in order to put the foreground objects in relief."

On another page, Delacroix goes into the merit of the subject, the landscape and, in particular, the ocean:

"The painters of seascapes do not depict the sea effectively. One could apply the same critique to them as to landscape painters. They demonstrate too much knowledge, they do portraits of waves, just as the paysagistes do portraits of trees, terrains, mountains, and so on. They do not care enough about the fantastic effect, they forget that the multitude of overly precise details, even if they are true to life, distract from the main spectacle, which is immensity and profundity, and which art should make us feel."

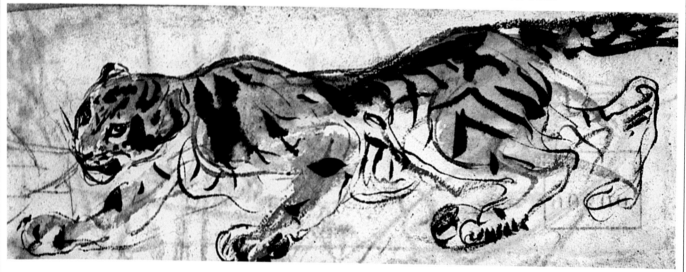

Eugène Delacroix: Tiger Walking toward the Left, *ca. 1831. Pen and ink with watercolor and pastel, 60 x 160 mm. Bayonne, Musée Bonnat*

A watercolor spotted with large brushstrokes and sketched with a brush line; soft and repeated in the color, the outline suggests movement, while simultaneously rendering the character of the feline, the tawniness of the coat, and the black stripes.

The Experience
By drawing with a brush, the artist can achieve special effects in both the lines and the spots; the color splotches, placed upon the barely indicated black contours, make the feline seem palpitating and ready to pounce.

Subjective Harmonies

Subjective color and objective color both exist, and they are both crucial for the perception of colors. Beyond reality, that is, beyond the true color of an object, the observer perceives that object in a personal way, in terms of what he expects and wishes to see.

These are psychological effects that play a part in reading a color beyond the actual visual sensations. Every object is dealt with in terms of past experiences, memorized information; and thus, any strong, abnormal divergency is repressed. There is something like a conflict between the real vision of reality, as it is and appears, and memory, or rather the knowledge of this reality as our experience suggests it ought to be.

However, this is just one of the factors contributing to the subjective and personal perception of color. The chromatic perception can also be linked to other sensory stimuli, for example the contrast between cold and hot. Thus, an environment in which we feel warmth looks more "red"

Paul Klee: Cackle-Demonic, *1916. Watercolor on canvas, 180 x 250 mm.*
Berne, Kunstmuseum, Paul Klee Stiftung

The delight in colors, the composition of unusually dark and mysterious tones and half-vegetable, half-animal shapes recalling and revealing a sort of magic bird, characterize this Klee drawing and make it unique. Do the triangular shapes become infinite iridescencies and reflections of the feathers on this magic bird, or are they mysterious suggestions of a chromatic composition, a new, unsettling poetic theme?

The Experience
The composition is based on the closeness and disintegration of square shapes that become triangles, rhombuses, and triangles again. There are only two circular forms here—a dark, almost black one against a violet background, and a yellow one, like an eye with a black pupil; the rather dark colors are heightened by the few areas of yellow next to blue.

Frank Kupka (1871-1957): Study for Vertical Planes III,
1912-13. Gouache on paper, 350 x 500 mm.
Paris, Musée d'Art Moderne, Centre National d'Art et de Culture
G. Pompidou

*Kupka, known as a figurative painter, showed a painting in Paris
in 1910, Centre Beaubourg entitled* Scale in Yellow. *Its theme
was its color, and it affirmed the subjective and objective value of
color and the striving of abstract painters to bring the language
of colors to the same direct expressivity as the language of musical
notes.*

than it really is. Likewise, a winter landscape
looks more blue.

Among other color-induced phenomena, we
have seen progressive movement suggested by
warm tones and recessive movement suggested by
cool tones. A blue object can look farther away
than it really is—an illusion due to our habit of
seeing distant objects as blue, i.e., filtered by the
atmosphere.

All these psychological effects are inconsistent
with facts, but they have great suggestive power.

However, aside from these suggestive features
of color and its perception, each individual has
his own color sensitivity.

This sensitivity is hard to define. Yet it can be
found in all painters and sculptors who express
themselves successfully, since artistic expression is
possible only with a definite sensitivity. I would
therefore say that the word *sensitivity,* when refer-
ring to line and color, has a meaning that makes it
part of the vocabulary of artists; and it is applicable
to the elements of execution.

We speak of a sensitive stroke or outline with
quiverings of light and atmosphere. An artist can
be more sensitive to line or to color: we know the
difference between the Florentine school, which
emphasized drawing, and the Venetian school,
which delighted in color tones. If an artist is more
sensitive to color than to the outlines of shapes, he
will dwell more on the chromatic composition, the
contrasts, relationships, combinations, and har-
monies of color.

Beyond color sensitivity, which certainly
characterizes some personalities, personal expe-
rience still remains fundamental, especially for
refining the individual's color sensitivity.

The possibilities of combinations and rela-
tionships are endless. But we have to know how to
select and discover those closest to our own sen-
sibilities, our own intuition and awareness. We
have to be able to express in colors what we see,
think, and feel.

·A painterly composition shows the colors of
single objects in light and shadow, the reflections
and transitions. But there are also the reflections

Theo van Doesburg: Studies and Colors for an architectural design by Theo van Doesburg in 1922, C. van Eesteren and T. G. Rietveld, 1925.
Private collection

Theo van Doesburg obtains abstract form by gradually simplifying the natural motif and applying his chromatic sensitivity to architecture. His architectural studies thus became abstract compositions, expressing a way of feeling and seeing, which gave life to the group known as De Stijl.

and mutual effects between adjacent objects, in other words, tones of which all the parts are immersed in the same light, acting together to create an overall effect. You therefore have to seek out one color and make it dominant, and then find the proper ratios for the intensity and luminosity of the subordinate tones, perhaps even sacrificing them to the overall balance, which is more important. Here, knowledge and experience are not enough. Instinct and sensitivity have to help in guiding us through the field of pure creation.

Matisse said: "The distributive pattern of the colors should demonstrate that the construction of a painting involves no less logic than the construction of a house. Don't worry about your own personality. Either you have it or you don't. If you do have it, it will mark the work of its own accord, despite everything."

Thus, it's not enough to know the primary, secondary, and tertiary colors in the order and relationships of the chromatic scale. To get the most out of them, we have to understand the characteristics of the chromatic values. But to employ them in terms of our own personalities, we have to experiment with our chromatic sensitivity. You have to see in color, painting in terms of your "filter," seeking your own color. You have to get beyond the chromatic reality, synthesizing it and integrating it by means of color.

Hidden Images

Color-blind people can see colors, but they cannot make out the various tones clearly and precisely. Thus, they confuse red and orange with yellow and green.

To understand this problem, we should read the theories of Thomas Young, an English doctor and physicist. In examining the retina, Young discovered an endless number of three types of particles: red, yellow, and blue. Modern science has identified these particles as the retina's receptors of color: three types of cones sensitive to yellow, green, or blue light. Color-blind people, who do not see real colors, lack some of these cones and cannot identify specific parts of the spectrum; or else they lack all visual pigments. Thus, if they lack the cones sensitive to green, then their "blue" and their "red" cones take on the job of perceiving green, and these people then see green light in terms of blue and red. How can these defects be tracked down?

We can identify them by means of a series of tests. One of the most famous is the so-called Ishihara Test, which consists of discerning a figure or a letter jumbled into a mass of spots having various shapes and colors. This test was named after the Japanese physician who devised it in order to identify visual defects, especially protanopia (blindness to red) and deuteranopia (blindness to green). The observer is shown a rectangle made up of a mass of small circles of different shapes and colors (three or four shades of green and three or four shades of red-orange). These circles are arranged in such a way that a person with normal vision can recognize a female figure wearing a red hat and a green dress. If a person is unable to distinguish between red and green, then he obviously cannot make out the woman against the background. Another test has a hidden image of a shovel and a fork, made up of small red spots against a background of gray spots. Using this test, we can identify anyone suffering from color blindness.

The ability to see and distinguish colors correctly is fundamental in a society like ours, in which everything is colored and in which colors play a major part in messages and signals. Just think of street signs, maps, or walls, clothing and food. The objects surrounding us are tied up with their characteristic colors, which identify them and determine specific actions on our part. In fruit, for instance, the color indicates taste—and we know how unappetizing a green steak would be! Thus, when the Dadaist painter Man Ray wanted to turn a long French bread into an artistic object, he painted it blue, thereby altering or, better, nullifying its significance.

A color-blind person is unable to distinguish between green and red tones, which have the same density here. He will see this drawing as an indistinct series of variously colored dots and fail to discern the human shape concealed here.

Suggestive Images

In his book *The Art of Color*, the German painter Itten talks about his teaching experiments with subjective color harmonies. He had each of his students paint the color harmonies that he or she found pleasing and agreeable. Then he placed them on the floor and examined them. "Each student had painted several harmonies on his paper, in terms of his own sensitivity. Yet all these works were extremely different from one another. We were amazed to see that each student had a different idea about color harmonies. Impulsively, I picked up one of these sheets and asked a female student: 'Did you paint these harmonies?'

" 'Yes,'" she replied.

"I picked up another, a third, a fourth, and I always identified the student who had done it."

Itten concludes his lesson: "Each of your harmonious compositions expresses only your own subjective sensibility. These are subjective colors."

However, the most interesting and most curious aspect of this experiment, according to Itten, was that the predilection for and choice of colors and harmonies were linked not only to the individual's character, but also to his physical features.

It might be easy to assume, with Itten, that people with a light skin, blond hair, and blue eyes prefer pure colors, pale shades, and harmonies of pure colors, while people with dark skin, black hair and eyes, would select dark shades, with strong, dark color harmonies.

It is thus interesting, even from a psychological viewpoint, to note the colors preferred by a given individual. Observe, above all, whether his or her preferences are consistent, that is, whether there is really such a thing as a "subjective color."

It is especially interesting, indeed fundamental, to try and know yourself, to find your own chromatic harmony. After all, your chromatic personality, for your drawings and your colors, can actually develop on the basis of your attitudes.

We have already said that knowledge of the formal and chromatic laws is crucial, especially for colors, theories, and practical applications of tone, brightness, and saturation. But it is even more important to be able to apply this knowledge in terms of your personality, according to the chromatic harmonies that impel you to make a color dominant and to find the correct ratios of quantity and quality for subordinate colors, even sacrificing them, when necessary, in order to obtain a synthesis, equilibrium, and harmony.

Johannes Itten (1888-1967): Variation II, *1957. Tempera, 78 x 100 cm. Zurich, private collection*

Itten developed his painting on the same basic theories as his teaching methods at the Bauhaus. He composed refined geometries with chromatic modulations and variations. In this tempera, a sort of huge checkerboard, Itten aligns and superimposes yellow, orange, pink, and red squares on other squares in cool tones—green, azure, blue, violet. The result is a calibrated color mosaic. The composition offers a living application of his principles and theories of color, virtually an example of the exercises he did with his students.

The Experience

Any allusion to reality is remote from a conception of art based solely on the relationship and harmony of colors; it is easy to imagine a different checkerboard, similar to this one, but made up of squares arranged to suggest theoretical knowledge, practical experience, and chromatic sensibility.

To Each His Color

Henri de Toulouse-Lautrec: Sleeping Woman. *Red pencil on blue paper, 375 x 480 mm.*
Rotterdam, Boymans-van Beuningen Museum
This drawing, a study for a lithograph, becomes a work in its own right, especially because of the red tone of the pencil on the azure paper. Aside from the luminosity of the sensitive line, which is repeated, gone over, and nuanced, the effect of quivering and contrast is almost unreal.

The Experience
The simplicity of the stroke, the leanness of the drawing; the contrast between the pencil and the paper transforms this drawing.

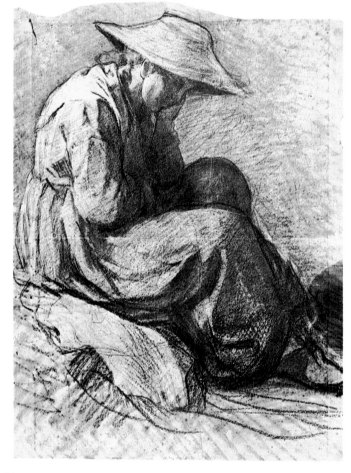

Antonio Fontanesi (1881-1882): Seated Girl. *Charcoal and yellow chalk, 418 x 314 mm.*
Milan, Civiche Raccolte d'Arte del Castello Sforcesco
A study for the painting Solitude *and an example of a monochrome, which becomes a colored drawing thanks to the relationships and the blending of the charcoal and the yellow chalk. The layout is powerful: the light comes from the left, leaving the face and the front of the figure shadowy. On the hat and the shoulders, the light is almost white; on the dress, it is a faint green, with the yellow tone blended with black. The figure, blocked into a position of absorption, is made sculptural by the luminosity of the color.*

The Experience
The choice of light, the layout and framework of the figure in the rectangle of the paper; the monochromatic drawing and the sculptural synthesis obtained by the blend of black and yellow.

Egon Schiele (1890-1918):
The Lovers, 1913. Pencil,
tempera, and oil, 320 x 480
mm.
Torino, Galleria Galatea

Schiele often paints in muddy, burned, sometimes strident tones, leaving large blank spaces with vague, broken outlines. He writes: "I think of hotter colors, which melt, spread, break, intensify. Sienna in layers as hills with green and gray stars and suddently next to a blue, a white, a bluish white." Thus, his paintings enriched this drawing, which is based on a darting, cutting line, with the same drama and despair.

The Experience
The blocky composition of the two figures fused by the line and the color; the powerful expressionistic tension created by the cut of the pictures edges, the broken, concave line, the strokes and spots of color, the blank space around the vibrant bodies.

Giovanni Boldini (1841-1931):
Couple in a Landscape
Pastel, 560 x 730 mm.
Milan, private collection

An early idea for the painting The Idyll. But the vagueness of the drawing, the color strokes, the pastel, which stripes, blends, consumes itself, becoming light and shadow—all these things effectively render the atmosphere, which envelopes the figures of the man and the woman—create an overlapping between the figures and space, between the figures and motion.

The Experience
A drawing done in pastels for a quest, not for shape but for the third and fourth dimension (volume and movement); pastel used like a brush, with large hatchwork, superimpositions, and nuances obtained with the fingers; colors superimposed for special shades and dynamic impressions.

Learn the Names of the Colors

We all think we know the colors and their names. But actually we know only some of the nomenclature. To define colors, we often use the names of objects or materials, animals, or flowers. We talk about yellow-orange or chrome yellow, cherry red or fiery red. We also speak of tortoise gray, canary yellow, cyclamen red. In short, in order to indicate colors, we usually refer to familiar things or elements. Many hues, however, have curious names, more complicated ones that we do not always know.

The color samples illustrated here are merely an infinitesimal part of the thousands of possible shades and tones that we can find around us and create ourselves by blending the basic colors with one another and with white, black, or gray.

There are many attempts at and approaches to classifying the colors. All these methods are based

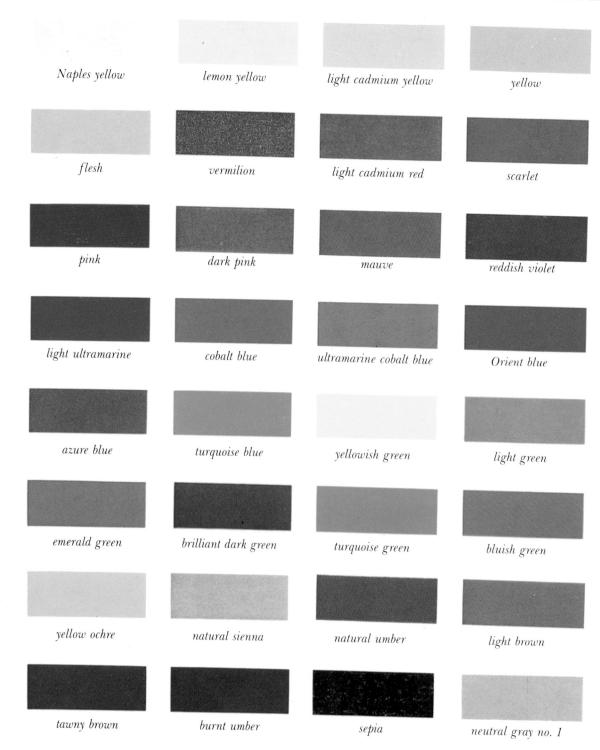

Naples yellow lemon yellow light cadmium yellow yellow

flesh vermilion light cadmium red scarlet

pink dark pink mauve reddish violet

light ultramarine cobalt blue ultramarine cobalt blue Orient blue

azure blue turquoise blue yellowish green light green

emerald green brilliant dark green turquoise green bluish green

yellow ochre natural sienna natural umber light brown

tawny brown burnt umber sepia neutral gray no. 1

on three characteristics: hue or tone, value or luminosity, and saturation. The search for a universal color terminology, for a standardization of color names in terms of their characteristics has not yet led to any unified result. Ultimately, there are a great many additional factors distinguishing colors that are identical in hue, value, and saturation: for instance, we also have to consider the surface on which the color is placed, the quality of the pigment, its opacity, just to name a few.

For this reason, the most common methods of color classification are: (1) colorimetry, which involves precise measurements based on colored filters that examine and define the proportions of colors in blends; (2) spectophotometry, which deals with the color spectrum by using special electronic apparatuses.

dark cadmium yellow	*dark yellow*	*cadmium orange*	*orange*
dark cadmium red	*carmine*	*Bordeaux red*	*Talens pink*
lilac	*violet*	*bluish violet*	*dark ultramarine*
cerulean blue	*cerulean blue (Italo)*	*Prussian blue*	*light blue (cyanide)*
intense green	*medium green*	*Veronese green*	*dark green*
pine green	*moss green*	*chrome oxide green*	*olive green*
dark brown	*English red*	*burnt sienna*	*Indian red*
neutral gray no. 2	*neutral gray no. 3*	*neutral gray no. 4*	*neutral gray no. 5*

A Drawing a Day

In our discussion of color, we do not claim to have dealt with all the problems, but we did try to stress certain major themes: tone, luminosity, saturation, chromatic harmonies, contrasts, chromatic sensibility, and the role of the individual person-

ality. The drawings on these two pages illustrate certain aspects of a pastel depicting a scene of the outskirts of Rome: a gas drum on a bend in the Tevere river.

In drawing no. 1, the image is rendered purely in gray. But given the wealth of shades, the effects of the atmosphere, depth, and "color," gray is

1

sufficient—which confirms the chromatic qualities of a non-color.

Drawing no. 2, on the other hand, is done in colored pastels, especially yellow, ochre, sienna, green, azure, blue, violet, but without black or gray.

In drawing no. 3, black and gray are added to drawing no. 2; the result is livelier, the contrasts are more obvious and more suggestive.

Drawing no. 4, finally, is the same as drawing no. 3, but it is done on straw-colored paper. This gives more body and depth to the vista, brings out the tones more effectively, particularly white and the blends using white.

3

4

The Colors of the Wind

You have all admired the combinations of colors on sails. Why not try to "project" a color composition on an almost triangular shape—the form of a sail? The samples here offer suggestions for pairs of complementaries and color harmonies—but the possibilities are infinite!

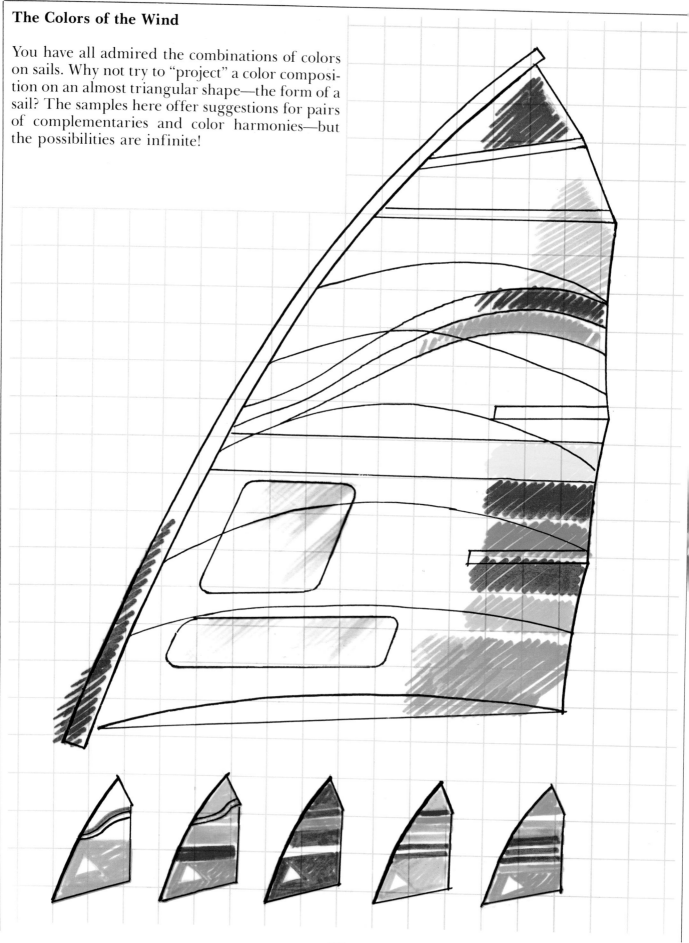

QUICK SKETCHES

Sketches are quick, rapid drawings done in a few strokes, sometimes with a few chiaroscuro spots. The goal of a sketch is to fix an image: either a real image, a curious or interesting impression of real life; or a mental image, a thought or fancy suggested by the imagination. As a mnemonic note, so to speak, the sketch is at the beginning of the artist's creative process. In this way, it differs from a real preliminary drawing, which gives us an overall, though incomplete version of a work of art that must still be realized—a painting, sculpture, or architectural project.

A sketch is a more direct expression of the artist's thought. It is virtually a "drawn thought," and the swiftness and essentiality of the strokes or spots are justified by the need to transfer a seen or thought image immediately from the mind to a sheet of paper. This is why sketches are generally smaller and are usually done in a notebook. A preliminary drawing, in contrast, can also be done on a larger sheet of paper. Typical of the sketch is not only the rapid stroke, but also the overlapping and interweaving of the lines. This latter trait attests to the artist's search for several simultaneous solutions for the same image. Because of its incompleteness and formal fluidity, the sketch is particularly expressive of the artist's personality. It is his "visiting card," an extraordinary link between his vision and reality, or between his invention and the ultimate realization of the work of art.

Paul Cézanne.

1. Five Figures. *Pencil, 148 x 184 mm.*
2. Canoe Race. *Pencil, 103 x 170 mm.*
3. Four Men Sitting Under a Tree. *Pencil, 103 x 168 mm.*
4. Sloping Hills with Houses and Trees. *Pencil, 313 x 473 mm.*

(All four drawings are in Basel, Kunstmuseum, Kupferstichkabinett)

Ideas and Patterns

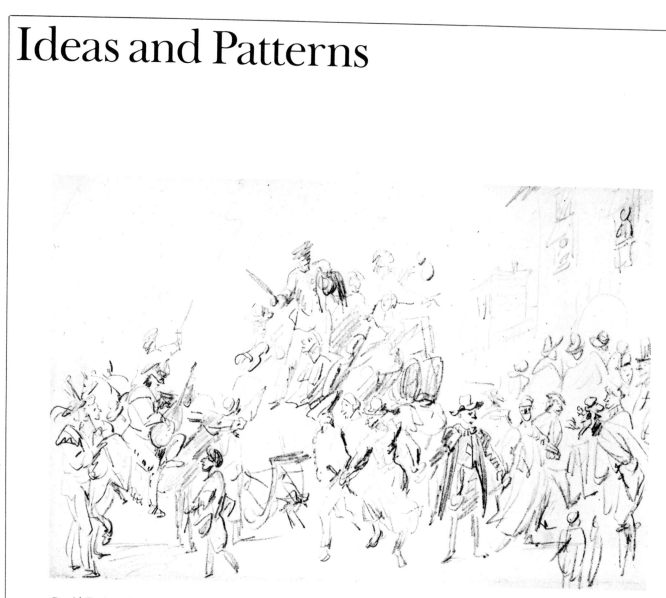

David Teniers the Younger (1610-1690): Carnival. *Drypoint, 197 x 306 mm. Berlin, Staatliche Museen, Preussischer Kulturbesitz, Kupferstichkabinett*
A sketch that looks as if it were taken from real life. Actually, the artist had never been to Italy, and he depended on his own imagination and perhaps on paintings by other artists. In any case, this sketch is intriguing and diverting. A tiny number of pencil strokes render the costumes, the crowd and, above all, the merriment of the Italian mardi gras.

When we speak of a sketch, preliminary drawing, first idea, or immediate image, we instantly wonder how the sketch is tied to the final work. On the other hand, does it have its own value as the primary expression of an inner vision suggested by reality or the imagination? It is fascinating to discover that Leonardo da Vinci attributed a definitive expressive value to the concept of "sketch." According to da Vinci, the point of departure is the analytical search, the graphic and compositional study, and the sketch represents not the moment of departure but the moment of arrival. In his *Treatise on Painting*, da Vinci points out that the artist should not outline his figures in sharp strokes or define their precise relationships. Instead, he should sense, and let the viewer sense, the figurative image in the seeming vaguess of the sketch and the spots. "Oh, composer of stories, do not draw these stories with finished lineaments, or you will endure what is endured by so many different painters, who want even the slightest charcoal stroke to be valid."

Da Vinci calls upon you to *see* the subject attentively before drawing it, to construct the image

and then sketch it with an expressive line and a chiaroscuro that suggest light and shadow, making them quiver in the immediacy of intuition.

He also affirms the value of the sketch per se, as a more direct and more immediate manifestation of "drawing."

We also ought to explain the contemporary predilection for sketches. So many critics refuse to place the sketch below the final version of a work, and the modern sensibility tends to like the unfinished. This taste goes even further, I think. It involves one of the most important features of drawing: the ability to suggest, to leave the image uncompleted and let the viewer fill it in himself. Furthermore, when we look at a sketch, or even a more developed drawing, for instance one showing a person's head, we never think for even an instant that the body is missing, that it is cut out or that in reality it has no colors. In a drawing, evoked by the magic of the pencil, we accept the head, albeit isolated, as part of an imaginary whole. Often guided by the artist, we can picture that whole, just as we can picture colors instead of white and black—here too, we are frequently helped by the artist's chiaroscuro. Remember what the art historian Heinrich Wölfflin (1864-1945) wrote: "When doing a sketch, the painter casts down the first fire of his thought; he abandons himself to himself, showing himself what that thought is." We might also think of a more lucid concept, as discussed by Ernst Gombrich in *Art and Illusion:* "With even greater acumen and penetration, a great French critic, Count De Caylus, tried to define the reasons why he preferred a quick, unfinished sketch, a simple reference to a completed image: it is always more flattering to feel that you are inside secret things."

A sketch expresses your innermost self, the deepest secret of your drawing. By sketching, we can capture and realize the following:

1) The first ideas for drawing a landscape, a figure, a portrait, an object, for illustrating a story, designing a stage set, a construction, or simply a program

2) Studies of nudes, of human or animal anatomy, from life or so-called "flawed" statues

3) Jottings of real-life, visions of the world, of plants and animals, studies of flowers and trees, country walks

4) Curious experiences, behaviors, particular moments and impressions, on the street, at the circus, in discotheques, and so on

A sketch is thus the essence of drawing, and what seemed like the simplest form becomes the most difficult, and certainly the most diverting.

For this reason, you should always have a pocket notebook and a pencil to jot down ideas and impressions. Delacroix commented: "The most spontaneous expression of artistic understanding is to be found in sketches. They express what is essential for the artist, they indicate what he is thinking."

Rembrandt: Woman Walking Downstairs with a Child in Her Arms, *ca. 1636. Pen and brown ink, brown wash; 187 x 132 mm. New York, Pierpont Morgan Library*

Rembrandt likes to fix his ideas in sketches that catch a figure in a snapshot blocked in by pen and ink as rapidly as a thought. Occasionally, we are given an opportunity to verify the extraordinary correspondence between ideas and sketches.

Eugène Delacroix: A Square in Sevilla. *Watercolor on graphite strokes, 97 x 151 mm. Paris, Louvre. Cabinet des Dessins*

Delacroix's sketch, done directly with a brush, reveals his desire to translate the tonal contrast between the foliage of the trees and the uniformity of the surrounding light, the façades, and the ground. Although rich in color, the sketch is based on an interplay of blue-green tones; even in the door on the right, the red tint is merely hinted at.

Let's Learn How to Sketch

Let's learn how to sketch, to draw quickly, with a few strokes. Note the following:
1) Have a clear idea of what you want to draw whether you are working from real life or using your imagination. Naturally, the idea often becomes clear while you're drawing. But the idea is never born with the drawing, and the drawing does not clarify the idea to yourself or to anyone else.
2) Be very familiar with the medium you're using so that you focus on what you're drawing and not on how you're drawing.
3) "See" synthetically (as we have often repeated, by squinting). Then draw synthetically, only whatever is essential to expressing and interpreting your vision or your idea.

The subjects are infinite, whether they emerge from your mind or from the surrounding world. Try to pinpoint a common motif: a landscape, a figure, a portrait, an object.

Sketching a Landscape

What are the most immediate difficulties when we find a landscape that we like and that we wish to sketch?
1) Before anything else, we have to define the framework, that is, the limits of the view. It is always hard to decide where to begin and where to end a landscape drawing when we are confronted with the vastness of nature. To make things easier, choose a reference point, (an object, a foreground) that closes off one side of the framework. Furthermore, this foreground or (frequently shaded) object will help to suggest depth by functioning as a support element for opening up the vista.
2) Establish the correct position of the horizon, which should generally be rather low so that it leaves a large space for the sky and, with the foreshortening, suggests the depth of the landscape. The horizon can even be on the bottom of the paper, unless the vantage point is high, for instance on a hill.

Sketching a Figure

If you want to capture a figure quickly, especially in a spontaneous moment rather than in a pose, a pencil sketch is the best approach. It is just right for the immediacy and swiftness of execution, enabling you to catch a movement and momentary action.

You have to know your medium, the possibilities of the pencil strokes, the sensitive lines and chiaroscuro, to suggest anything that is not sharply indicated. Beyond your medium, however, you have to be familiar with other devices. Even though a sketch is an immediate, if not instinctive approach, you have to know all the elements that make it effective and suggestive if you want your work to be essential and not a summary.

You have to bear the following in mind:

1) The layout, that is, the position of the figure in the blank space of the paper rectangle. It is not always, perhaps even seldom, necessary to place the figure in the center of the sheet. Its position and hence the empty spaces left around it are all part of the composition, helping to suggest the space in which the figure remains or moves; sometimes, these elements suggest the completion by the viewer.
2) The proportion of the various elements of the figure itself. The fundamental ratios are those of the head, arms, trunk, and legs to the body.

What are the secrets of a good figure sketch?
1) Establish the totality, so that the paper shows everything you want to draw, and you're not forced to sacrifice anything because the drawing is too large.
2) Collect the essential data and select what you want to bring out: the conduct, face, or position of the figure, its eyes, mouth, hair style. Often, the totality remains sketchy and suggestive, while details may be sharper.
3) If the sketch is preliminary to a larger and more complete drawing, find the references among the various elements of the figure: To do this, you should not only focus on the proportions (for example, between the head and the body), but also try to see the position of each element with respect to the others. For instance, in terms of the shoulder lines, the angle of the head, the direction of the arms, the position of the hands, and so forth. The more intricate these relationships, the more precise the sketch of the figure.

4) Finally, as we know, you can draw only after observing. And even if you act rapidly, try to observe the plumbline of the figure, its true or natural stance, the vertical line on which it leans, be it the left or right leg, or in any case the line of the trunk and the arch of the back. This is part of a geometric schematization that guides the layout and remains fundamental to a rapid sketch, even if this "diagram" is not expressed graphically.

Edouard Manet: Isabelle Lemonnier, *ca. 1880. Watercolor, 201 x 124 mm. Paris, Louvre, Cabinet des Dessins*

This watercolor drawing of Isabelle Lemonnier is sketched in quick brushstrokes of brown and blue on cream-colored paper, which is brought out by a few dark-brown touches. The details of the face reveal the possibilities of a sketch, pinpointed in the spots of the eyes and nostrils, in the pink of the cheeks and the ear, and in the tone of the hair.

Henri de Toulouse-Lautrec: Studies of heads of femmes de maison. *For Toulouse-Lautrec, a drawing is a continuation of the simplest acts of everyday life. When he saw a face that interested him, he would draw it, or rather, he saw it by drawing it. He thought, pictured, saw, and felt with a pencil or pastel in his hand. His sketches became the mirror of his daily life.*

The Sketch of a Portrait

The same problems and resolutions are involved in a portrait sketch, and they may be even more pronounced than in a figure sketch. During the Renaissance, the crossframe was used precisely because artists wanted their preliminary sketches for portraits to be quicker and simpler. And we know about the instrument that Dürer proposed: a box with a cover that, when opened, contained the crossframe grid. He depicted it in his engraving *The Portraitist.* We will reserve the use of the crossframe for preliminary sketches of a portrait and see what devices are useful for a sketch.

1) The position of the totality (head or bust) within the paper rectangle suggests the continuation of the figure and the proportions. The immediacy of the sketch allows us to confront the height of the forehead with that of the nose, the space between the eye line and mouth line with the space between the mouth line and chin line.

2) The shape and the chiaroscuro can be suggested only by the sensitivity of the line, which can develop in spots: monochrome spots (the shades obtained by the flat use of a stick of graphite or hatchings of short strokes) or colored spots (pastels, chalks, watercolors, applied in short touches).

3) The expression or characterization of the person can be achieved in various ways. It is hard to explain these methods: they are impalpable and linked to the individual sensibility, which can capture and then render the sitter's personality. Perhaps we should select the preferable elements for a sketch: the profile, the eyes, the mouth, and sometimes the hands—that is, the elements that best characterize the person. In any event, because of its immediacy, its synthesis of suggestions, a sketch is often the best medium for expressing this characterization.

Paul Cézanne:

1. Still Life with Candle. *Pencil, 125 x 196 mm.*
2. Still Life with Carafe. *Pencil, 199 x 120 mm.*
(Both drawings are in Basel, Kunstmuseum,
Kupferstichkabinett)

1

2

In his quest for the shapes of the natural cone, cylinder, and
sphere, Cézanne was particularly interested in still lifes,
which offered him a chance to find these volumes.

However, the sketches of still lifes with a candle and
a carafe were animated by the sensitive lines in a
barely indicated, highly atmospheric chiaroscuro.

Sketching an Object

When you draw an object (a still life or an element in a still life), you will probably have fewer problems than when drawing a landscape, a figure, or a portrait.

A sketch *seems* to require less exactness than a drawing, which should frequently be on the same level of generalization beyond the genre, i.e., beyond the subject. Unlike a landscape vista, the object remains motionless, in the same light conditions, for a long time; and it is immediately defined by the rectangle of the paper.

What is necessary for sketching an object quickly and correctly?

1) The most important thing, as usual, is the use of correct proportions between height and width and between the dimensions of the parts of the object.

You must therefore define the carefully viewed shape, even as an outline cut out against the background or rather as the outline of the background cut out by the figure. This as we have repeatedly pointed out, will break your habitual familiarity with the object.

2) The color and the chiaroscuro, present in every kind of sketch, can be rendered only by a sensitive stroke, a swift indication of nuance and shading (or hatched lines) or colored spots (chalks, watercolors).

But even in a very faint chiaroscuro, as in a sketch, we should not forget that a cast shadow is darker than intrinsic shade, which is lightened by reflections.

Here, obviously, the sensitivity in the lines, which are more or less grainy, more or less emphatic, makes for a depiction that is more suggestive than complete.

A Day in the Life of a Master: The Sketches of Toulouse-Lautrec

Is there anyone who hasn't kept a diary at some point or at least tried to keep one?

When Toulouse-Lautrec, the famous painter of the Moulin Rouge, was still a child, he illustrated his letters with delightful doodles. At the age of sixteen, he wrote and illustrated the story of his trip to Nice—not only for himself but also for the amusement of his cousin Madeleine Tapié.

In Paris, Toulouse-Lautrec then exploited his ability as an illustrator, or rather as a narrator with pictures, in his paintings and also in his advertising and journalistic work. He prepared his famous lithographs for posters announcing spectacles, and he supplied pictures for song lyrics and illustrated Paris life mainly in two

Henri de Toulouse-Lautrec:

1. Little Girl. Le Mirliton, *Feb. 1887.*
2. Omnibus Trace-Horse. Paris Illustré, *7 July 1888.*
3. Gin Cocktail. Le Courrier Français, *26 September 1886.*
4. The Last Goodbye. Le Mirliton, *March 1887.*
5. The Last Drop. Le Mirliton, *January 1887.*

newspapers: *Le Mirliton*, which was put out by his friend Aristide Bruant, and *Paris-Illustré*, which was edited by his old schoolmate Maurice Joyant.

Endowed with an extraordinary flair for observing and remembering and with an exceptional talent for illustrating, Toulouse-Lautrec wandered through Paris, capturing the images of daily and nightly life, in the streets and cafés, in the churches and nightclubs. His illustrations, printed in large editions, sometimes have little value. And yet the priceless paintings that are the glory of museums and large collections were often merely sketches for journalistic works.

The few sketches shown here are examples of Toulouse-Lautrec's drawn visions, and they can inspire us to draw our own visions.

6. The Laundress. Paris Illustré, *7 July 1888*.
7. Outer Circle. Le Courrier Français, *2 June 1889*
8. The Day of the First Communion. Paris Illustré, *7 July 1888*.
9. Riders to the Bois. Paris Illustré, *7 July 1888*.
10. Moulin de la Galette. Le Courrier Français, *19 May 1889*.
11. Ball. Echo de Paris, *25 December 1892*.
12. Circle on the Head. Le Courrier Français, *21 April 1889*.

A Drawing a Day: The Drawing Diary

Rather than calling this "a drawing a day," we ought to speak of "drawings of the day." This is not just an exercise, but a source of pleasure; we can enjoy the possibility of jotting down our thoughts and impressions. Take a notebook, and, on its small pages, record the moments that you want to remember, by sketching them. Basically you will be keeping an illustrated diary.

You can take notes when something happens or you experience something interesting; and you can then develop these drawings at home. Or else, as the day passes, you can simply observe situa-

tions, houses, places, landscapes, lights, colors, and bring them back in your notebook. Not just real images, of course, but also dreams and fantasies. In the sketches of these two pages, I have tried to suggest—rather impersonally—several possibilities, merely to give you an idea, not to serve as models for copies. Draw the moments of awakening, the view from your window in the morning, your work environment, the work itself, the monuments you see in the street, your trip home, your family, your children, the hours of relaxation, a TV show, and finally—all your dreams, as you soar away on the wings of your imagination.

Before Sketching

Even if a sketch represents the first stage of a drawing, we can nevertheless imagine an initial phase and a developmental phase. Above all, as I have done in the example on this page, we can picture and indicate the things that lead up to the drawing. We can show our search for and defini-tion of the relationships between the various parts. For instance, in the sketch published here, the heights of the various buildings and houses. We also have to show how we arrive at the shape of the sky (cut out by the building outlines) as well as the boundaries of the subject, the position of the horizon, and the layout.

Anatomical Studies

The study of the nude and life drawing, i.e., anatomical drawing, have always been the most important exercises for the beginner. Why is this so?

The reason, I believe, is as follows. If a person wants to see and know the secret of proportions and beauty in order to see and understand drawing, he must find all this in the human figure, in the specification of proportions, the harmony of the body parts, the equilibrium of movement.

An artist must also study anatomy. Not only the exterior form of the human body, but also its musculature and bone structure. He has to investigate the mysteries of the nervous system, the veins and arteries, he must try to understand the way the heart and the brain function, he must plumb the depth of a machine that is the very thing that allows him to explore in the first place.

Thus, a nude study, the lovely drawing of man tensing his muscles or a woman flowing in the harmony of her grace, are the prime movement of a more thorough study that goes beyond mere, though interesting, scientific research. This is the most direct method for approaching the mystery of life. And logically, every artist tests his mettle by dealing with the shapes and secrets of the human figure—the most complete and most stimulating model he can find. The nude is at the basis of the model drawings that art students are asked to copy. The pedagogical function of nude studies and drawings (before the more difficult drawing from life) is emphasized by L. Scaramuccia: "Before drawing nudes in a public academy, study the drawings of nudes done by an excellent master; you will thus learn how to draw correctly."

Let us dwell on his recommendation. Before the problems involved in drawing a live human figure, we encounter certain difficulties with a nude model. If you wish to deal with the main problem of drawing from life, you have to study anatomy and the human figure in general, even using "models," including those published in these pages. This is a highly useful exercise, despite its intrinsic limitations. After all, if it is true, as Berenson writes, that the nude has always

Renzo Vespignani: Study for the Eye, *1968. Mixed media, 100 x 70 cm.*

In this work, the study of an eye goes beyond mere anatomical depiction; it ends up as an open window to an inner world.

been "the main preoccupation of the art of visual representation…then it is also true that every artist visualizes it in his own terms as spontaneously as he uses his native language."

Just think of how the depiction of the human figure evolved through the various schools of art, from the murals of ancient Egypt to Botticelli's profiles, Michelangelo's potent strength, Rubens's radiance, Modigliani's sensuality, or Picasso's decomposition. Each approach has been an expression of the artist and his time.

What are the greatest difficulties in drawing a human figure?

More than anything, the proportions. You can render the correct proportions of the parts of the body by referring not so much to a basic unit (generally, the length of the head) as to the ratios between the parts. That is, in order to draw the proportions of a figure correctly, you have to continually compare the dimensions of each part with those of the other parts, so that you have something like a chain of interrelationships. These connections are not just in terms of measurements, but also in terms of position. That is, you have to see the position of each arm with respect to the other, the height of a hand in the

Andrea del Sarto: Studies of Hands and Feet. *Red pencil. Paris, Louvre, Cabinet des Dessins*

This page of studies is an elegant example of the investigations into details of the nude, as conducted by many artists of the Renaissance. It recalls the pages of "models" that were to be copied by their students.

chosen arrangement with respect to the other hand, and so forth.

The angles of the axes of the various parts of the figure are also a problem. Even in a standing figure, you have a vertical axis and then several more or less sloping axes. Just recall the classical position of the standing model, leaning on one leg: his head, his torso, the other leg, and the arms are each more or less at an angle to the vertical axis. In order to work out each angle correctly, you have to refer to the vertical and horizontal axes, which you can establish by holding your pencil in the right positions.

Another major difficulty in nude drawings is the shape of each body part. Their rendering is certainly facilitated by the correct representation of the ratios and angles. However, you must work toward a synthesis. Don't forget Leonardo da Vinci's "bag of nuts" and don't try to draw everything you see with the same values in shape and chiaroscuro. Instead, squint and peer at your subject from a distance. Then draw the essential shape and chiaroscuro synthetically. Ultimately, less is more: it's better to draw too little than too much.

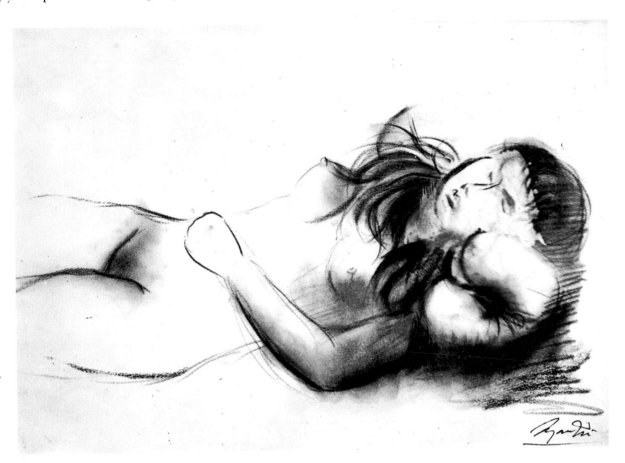

Giacomo Manzù: Woman Reclining, *1967. Charcoal, 356 x 515 mm. Ardea, Collection of Friends of Manzù*

This rapid sketch preserves the freshness of improvisation, but it also has the weight of a sculptor's study.

L. Giambattista Tiepolo: Apollo in His Chariot. *Black pencil, pen, and brown wash, 243 x 241 mm. New York, Metropolitan Museum of Art*

Modifying the Positions

You should also try to modify the positions of the parts of a body you are drawing. Check out these drawings by the masters. Tiepolo, for instance (no. 1), shows Apollo in his chariot; the view from below, in foreshortening, is typical of this Italian artist.

As we know, the motion of the human figure is characterized by the reciprocal positions of the arms and legs: when the right arm moves forward, the left arm moves back; when the right leg moves in, the shoulder rotates toward the arm, and so on. Diagrams 2 and 3 show the figure's attitude (in the same profile as the original drawing) and propose an imaginary motion, with the chariot seen from the back and the front.

Likewise, diagrams 5 and 7 alter the position and movement of the figures depicted in the original sketches, 4 and 6.

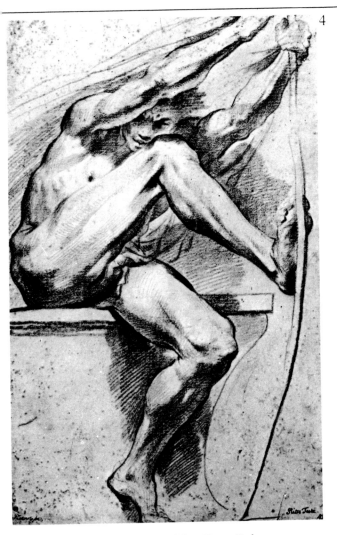

4. *Pietro Testa:* Seated Nude with a Bow. *Red
pencil, 420 x 259 mm. Stockholm, Nationalmuseum*

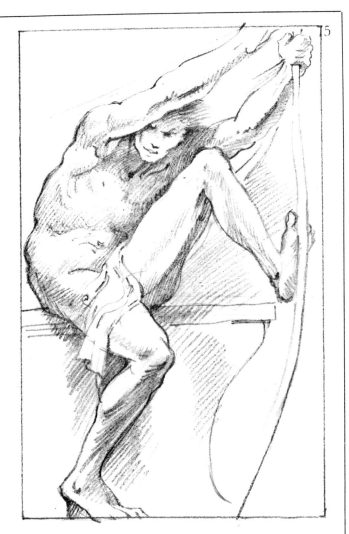

6. *Carlo Maratta (1625-1713):* Study for a Male Figure.
Charcoal, chalk; 472 x 329 mm.
Paris, Louvre, Cabinet des Dessins

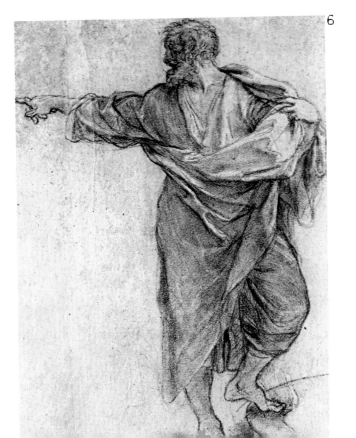

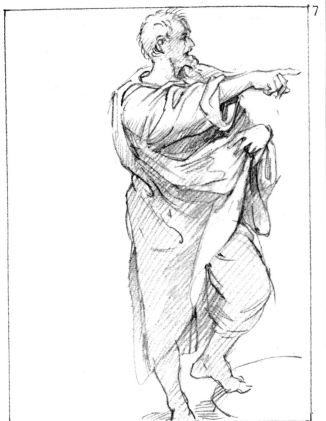

Copying the Masters

Grids and words are superimposed on the diagrams in the anatomical drawings from Diderot's and Alembert's *Encyclopedia*. These superimpositions are meant to bring out the definitions and proportions of the bones and muscles in order to make the copying exercise easier.

Drawing from life is the best kind of training if you want to know the pleasures and problems of drawing. And if you want to become familiar with anatomy, the skeletal system, and the structure of the musculature, copying the masters is the most logical and immediate approach.

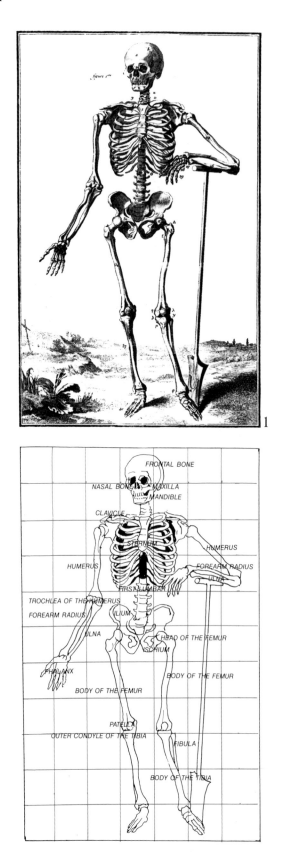

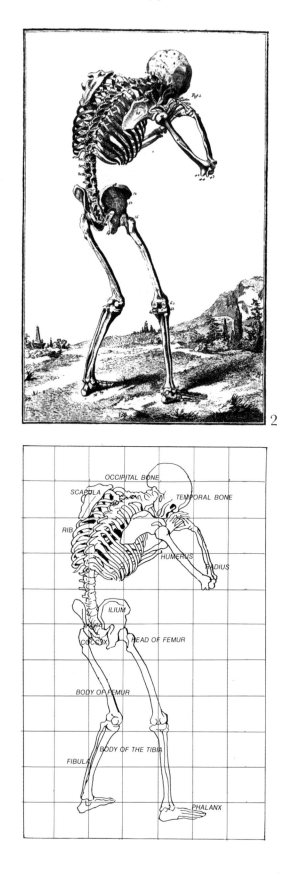

1. 2. 3. 4. Four anatomical drawings from The Encyclopedia, *edited by Diderot and d'Alembert, 1751-1772.*

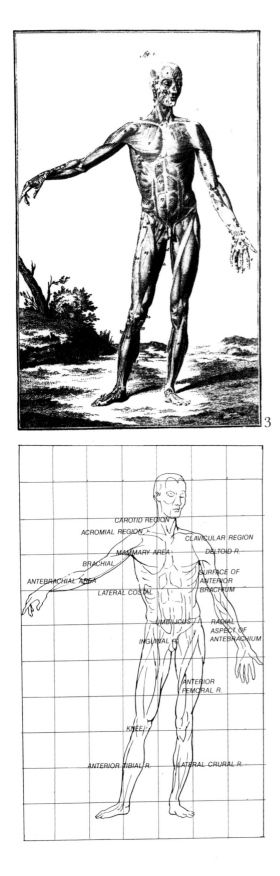

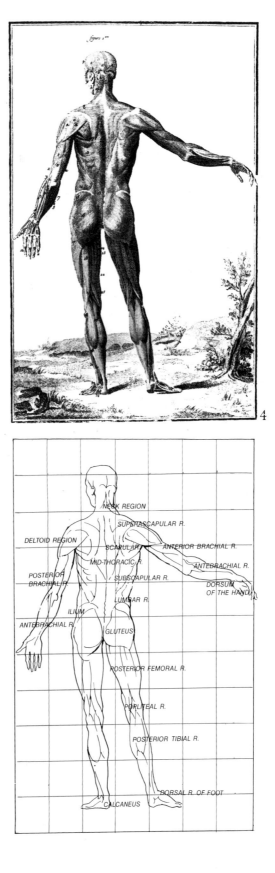

3

4

CAROTID REGION
ACROMIAL REGION
CLAVICULAR REGION
MAMMARY AREA
DELTOID R.
BRACHIAL
ANTEBRACHIAL AREA
SURFACE OF
ANTERIOR
BRACHIUM
LATERAL COSTAL
UMBILICUS
RADIAL
ASPECT OF
ANTEBRACHIUM
INGUINAL R.
ANTERIOR
FEMORAL R.
KNEE
ANTERIOR TIBIAL R.
LATERAL CRURAL R.

NECK REGION
SUPRASCAPULAR R.
DELTOID REGION
SCAPULAR
ANTERIOR BRACHIAL R.
MID-THORACIC R.
ANTEBRACHIAL R.
POSTERIOR
BRACHIAL R.
SUBSCAPULAR R.
DORSUM
OF THE HAND
LUMBAR R.
ILIUM
ANTEBRACHIAL R.
GLUTEUS
POSTERIOR FEMORAL R.
POPLITEAL R.
POSTERIOR TIBIAL R.
DORSAL R. OF FOOT
CALCANEUS

"In painting, artists use lines in several ways, especially to outline figures, ensuring that these are well drawn and done accurately and in correct proportion; the shadows and lights add utmost relief to the lines of the face being drawn, so that the face is utterly good and perfect. As a result, if you want to handle these lines properly, and if you are guided by practice and judgment, you will achieve excellence in each of these arts. If you want to learn how to express yourself by drawing the concepts of the mind and anything else, you have to follow that path, because you must accustom your hand; and in order to become more intelligent in the arts, you have to practice depicting figures in relief or marble, or stone, on in plaster shaped on a living face or on some beautiful ancient statue, or reliefs of models made of clay or nudes or rags covering the back, serving as garments or clothes; for, since all these things are immobile and without emotions, they are very easy; they stand still for a

Leonardo da Vinci: The Proportions of the Horse. *Silverpoint on prepared blue paper. f. 12319. Windsor, Royal Library*
Superimposed on the profile of the horse is a grid based on a module worked out by da Vinci. He bases it on the length of the horse's head. For a deeper rendering of the measurements, the artist measured the height of the diagram on half the module in order to obtain a grid of rectangles; with the base of each rectangle equal to the horse's head and the height equal to half.

The Proportions of the Horse

Leonardo da Vinci confronts the spectacle of nature in order to see and investigate it with his drawings. He tries to discover the mechanism of development, the key to its interpretation, in order to establish a universal law. Flowers and trees, rivers and mountains, men and animals are the subjects of his sketches. These are never mute images. They document a profound and precise research, down to the least detail. A fine example is the drawing of the horse, shown here, in which da Vinci tries to find the exact proportions. His field of knowledge widened. He was no longer interested in human beings alone—with their proportions, their "module" (represented by the dimensions of the head, which determines the sizes of the other parts of the body). Da Vinci also sought the measures and proportions of animals, which are always a fascinating subject for artists. Da Vinci displayed his talent in an equestrian statue, the famous monument to Francesco Sforza. The artist did a giant model, but it was destroyed by the projectiles of French catapults. Da Vinci could not help but deal naturally with the proportions of the horse, the most common animal in artistic iconography and the one he loved and depicted more than any other creature. Dozens and dozens of drawings confirm his interest and passion, culminating toward the end of the fifteenth century in the drawings for the equestrian monument.

person who draws and does not go into living, moving things. When you have had thorough practice and gained a sure hand in drawing such things, you can start to draw natural things. Practice correctly and with assurance, working hard and diligently, because the things that come from nature are truly those that do credit to the artist who has toiled away at them. Along with a certain grace and vividness, they have the gentle, simple, and easy quality that is intrinsic to nature, and that can be learned perfectly from her things and never from the things of art. And bear well in mind that the practice gained in years of drawing is, as I have said above, the true light of drawing, making artists excellent. Now that we have discussed this sufficiently, we should concern ourselves with the nature of painting.

(from Vasari: *Lives.* "On Painting")

At the court of Francesco Sforza, Leonardo da Vinci explored these animals more thoroughly in a series of jottings, measures, proportionings, which formed the basis of a book on the anatomy and motion of horses. This book disappeared, but it was mentioned by Vasari in his *Life of Leonardo:* "A small wax model, considered perfect, has vanished [probably a model for the monument] together with a book on the anatomy of horses which he did for his investigations."

In drawing proportions, da Vinci, though arriving at a modular abstraction, never loses sight of reality. The object of his study and his conclusions is a real animal, a horse that moves, runs, rears. This is no ideal model, but a flesh-and-blood horse, which da Vinci tries to capture in detail and describe in a script running along the back of the horse.

As we know, the module worked out by da Vinci is the length of the head: the unit of measure, which he indicates with the letter *T*, and which he repeats in every note and every calculation, corresponds to the length of the horse's head, measured from the neck to the lower lip. All the other proportions refer to this unit, which is multiplied or divided accordingly.

Thus, da Vinci was simply applying to equine anatomy the principle tested in the era of Vitruvius. According to this rule, the proportions of the human body are all multiples and submultiples of the measure of the head. This mathematical canon guided the artist toward wider horizons in his explorations of the laws governing the universe.

A Drawing a Day: Two Portraits

These eight diagrams illustrate the developmental process in two drawings of children done in black and colored pencils.

The first diagram is a black-and-white sketch. The second shows an intermediate stage in the development: the outline alone, drawn in a sensitive line. The third diagram illustrates the establishment of the layout and the proportions with the help of the axes. The fourth diagram shows the references between the height of the

forehead, the length of the nose, the distance between the eyes, in a system of interrelationships between the various measurements; this is fundamental for a correct construction of the face and features. As you can see, the faces of these children are depicted against the architectural background of a village in an interplay and contrast of light. The surroundings add greater depth to the portrait, creating a specific combination of colors.

The Proportions of the Head

In 1751-1772, Diderot and Alembert published *The Encyclopedia* in Paris. This revolutionary opus signaled the triumph of reason and the start of a new world. Drawing, particularly the drawing of the human figure, is treated according to a methodological vision that allows for pedagogical reasoning. Accordingly, the diagram in the article *Drawing (Dessin)*, dedicated to the oval of the human face, pinpoints three fundamental positions of a human face as viewed from the front, in profile, and in three quarters.

Each position is then examined and drawn from below and from above, without neglecting reference to the original position. Naturally, the proportions of the features are worked out—the distance between the top of the head and the middle of the forehead, between the latter and the line of the eyes, and then the length of the nose, the distance between the nose and the line of the mouth, and finally between the latter and the chin.

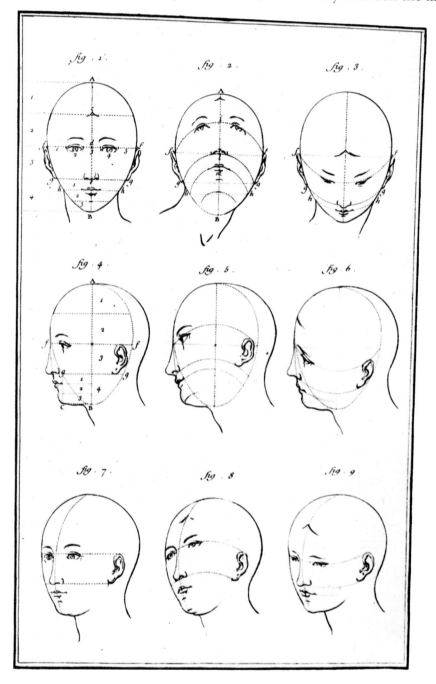

Plate depicting the oval of the face, from The Encyclopedia, *edited by Alembert and Diderot, 1751-1 and Diderot, 1751-1772.*

Jottings from Life

We are often asked whether, and to what extent, it is useful to draw from life, and what the relationship should be between life and art. Life is a unique training-ground for finding proportions, shapes, outlines, light and shadow. Nevertheless, we should not forget that this relationship has greatly changed since the Romantic era. Today, art is no longer viewed as mutation, and drawing from life no longer means exact and perfect reproduction, or illusion of things and figures taken from nature. We now consider art a depiction, interpretation, reinvention of reality as seen by the individual artist (beyond, of course, the large group of non-figurative painters).

According to a famous passage by Plinius, the painter Protogenes, looking at a painting in which he had depicted a dog with foam on its mouth, was unhappy because "it was obvious that the foam was painted rather than emerging from the dog's mouth." Eventually, after repeated attempts to sponge away the colors and redo them, he became so frustrated and infuriated that he hurled the sponge at the painting, striking the dog's mouth. "The sponge struck the colors in such a way as to leave the exact impression that the artist desired." Plinius concludes: "In this painting, chance created nature."

Later, especially in the Renaissance, the study of reality no longer aimed at "redoing nature." Instead, artists tried to locate and define the universal laws regulating nature beyond the object. Along with these laws, which concern perspective and anatomy, physiological and psychological mechanics, we must also consider the individual artist's ability to invent and also to avoid errors and contradictions.

Pisanello: Saint Justine Saving a Unicorn. *Pen and ink. Florence, Uffizi*

Camille Corot: Landscape Sketch. *Ink. Paris, Louvre, Cabinet des Dessins*

Now, however, after the break with tradition by Cubism, Abstractionism, Surrealism, and so many contemporary movements, can we still draw from life, and is it useful to do so?

We can easily answer in the affirmative. Just think of all the movements rooted in the observation of reality or at least affected by the depiction of reality in their expressive modes. And there is no painter who, before depicting his reality, has not first looked at the surrounding reality and drawn according to the rules of tradition.

It is only after knowing reality and then drawing it that we are able to transform it. It is only after learning to see the world around us and then drawing it that we can see and draw the world within us.

Thus, the sketches, the drawings of reality, the jottings that we make during the day by looking around us are the best exercise, the most useful and most immediate, for the beginner. What should we draw?

We have said so repeatedly: we should draw whatever strikes our fancy, whatever interests us, not only for what we see, but for what it makes us think and feel. A drawing of reality is not merely an image of reality, it is also something that forces us to see and think—and ultimately play.

In his *Treatise on Painting,* Leonardo da Vinci suggests: "When you who draw wish to obtain some useful pleasure from your games, you should use things to aid your profession; this includes the good judgment of the eye and the ability to properly gauge the width and length of things. In order to accustom your commitment to such things, draw a straight line on a wall, and then each of you take a thin straw and cut it to what you feel is the length of that line while standing at a distance of ten feet away. Then compare the line with your estimation; the one who comes closest is the winner and receives the prize that you agreed on beforehand. ... Such games can sharpen your visual judgment, which is the principal act of painting."

In other words, drawing reality can teach you to see, gauge, proportion, and think.

Walking Around a Tree

Among the first exercises that we suggested, you will recall, was the idea of drawing a tree. This is useful especially because the structure of a tree is an extraordinary example of balance and proportion in the natural interplay of the trunk, the branches, and the foliage.

The three examples shown here are images of the same tree seen by walking around it in an attempt to discover its shapes, balance, and composition. These drawings were done in graphite and red chalk. Next come three diagrams (4,5,6) of drawing no. 3, indicating various approaches

1

2

to this graphic execution.

The first diagram shows the guidelines and force lines of the tree. We see the various angles of the trunk and the branches with respect to the vertical axis (the dotted line in the lower left of the paper); the axes of these elements are drawn.

The second diagram, in contrast, focuses on establishing the proportions. The simplest method is to show the ratios between the various compositional elements. I have taken the width of the trunk as the point of departure, the module, indicated by segment *a;* using this, I measured the

3

4

distances and the heights of the branches, in a series of relationships, guaranteeing the correct proportions by a reciprocal verification of the elements.

The third diagram takes up the repeated concept of a shape that is easier to pinpoint when we manage to see it in an unaccustomed way—in this case, as the "form of a tree." Instead of seeing it as a foreground element against the background, imagine seeing the shape of the background, or rather the background shapes cut out by the outline of the object—background shapes as independent and therefore easier to bring out.

5

6

Straight Lines and Curves: Toulouse-Lautrec's Animals

Synthesis is, as we have said, fundamental to drawing, particularly in a sketch of animals. Using a synthetic line, the artist tries not only to find the essential line but also to express the characteristics, movements, details of not just this animal, but all animals of this type.

You will greatly enjoy the highly useful and pedagogical experience of seeing the animals that Toulouse-Lautrec sketched for Jules Renard's *Natural Histories.* Note the lines that generate the shape, which, in Toulouse-Lautrec's soft, flowing line, be-

1

comes chiaroscuro and color. Here I have tried to pinpoint the curves and straight lines that contain and guide Toulouse-Lautrec's animal sketches synthetically and with excellent characterization. The results are extremely informative, cheifly in regard to finding the synthesis and interpretation of reality.

1.2. Several of the animals drawn by Toulouse-Lautrec for Jules Renard's Les Histoires naturelles. *1897. Paris, Bibliothèque Nationale*

Seeking Reality:
Toulouse-Lautrec's Circus Drawings

Take a look at Toulouse-Lautrec's circus drawings, the images of arenas and clowns, vivid, true-to-life pictures capturing the atmosphere and the fascination of the Big Top. Who would imagine that these are not reproductions of reality, but memories and fantasies. In the hospital room in which he was recovering, Toulouse-Lautrec used these circus scenes to experience the freedom that was momentarily denied him. If we look closely at these pictures, we see that they have something different. The figures are viewed realistically, but deformed, heightened, intensified: just look at the giant clown with the small top hat. The point of view, likewise, is not that of a normal spectator; we are watching from a high, remote point, as though from a distant, lofty window.

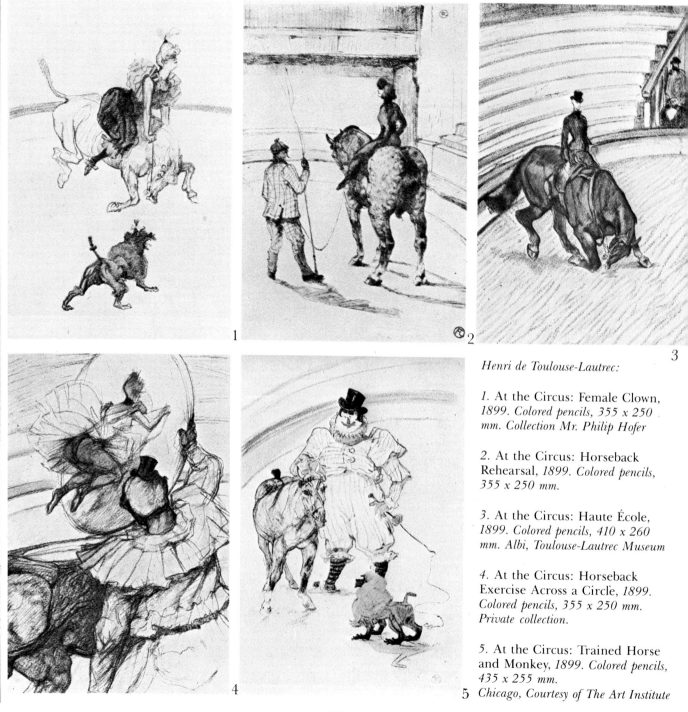

1

2

3

Henri de Toulouse-Lautrec:

1. At the Circus: Female Clown, 1899. Colored pencils, 355 x 250 mm. Collection Mr. Philip Hofer

2. At the Circus: Horseback Rehearsal, 1899. Colored pencils, 355 x 250 mm.

3. At the Circus: Haute École, 1899. Colored pencils, 410 x 260 mm. Albi, Toulouse-Lautrec Museum

4. At the Circus: Horseback Exercise Across a Circle, 1899. Colored pencils, 355 x 250 mm. Private collection.

5. At the Circus: Trained Horse and Monkey, 1899. Colored pencils, 435 x 255 mm.

4

5 *Chicago, Courtesy of The Art Institute*

A Drawing a Day: Circus Elephants

A Drawing a Day: Animals

Drawing animals is as useful and informative as drawing human figures. It helps us to find the proportions, the equilibrium of the composition, and the characterization of the subject. In regard to animals, the characterization is bound up with the artist's ability to synthesize, his capacity f[or] seeing the basic lines that determine the lines of [a] given animal.

In the drawings shown here, especially d[i]agrams 1 and 3 (representing intermediate phas[es] in the development of the sketch), I have tried [to]

1

2

ring out the curved lines that are necessary in a careful study of the shape and volume of a buffalo, a pelican, or a parrot. For the latter, I have drawn two networks, a horizontal and a vertical one, intersected by other segments, to indicate references to the proportions of various elements of the drawing.

With their synthesis and sinuosity, these lines characterize the figures of the animals, making them very elegant.

The diagrams should inspire you to visit zoos and circuses and to study and draw the animals you see there.

3

4

Gustave Courbet: The Confederates at Versailles. *Black pencil on blue paper, 165 x 265 mm. Paris, Louvre, Cabinet des Dessins*

Courbet: Drawing Reality

Courbet's realism is not a copy of reality. Every artist seeks his own internal and external reality, translating it into a personal and original language. There are two basic directions: a tendency toward the depiction of reality and one toward allusive, symbolic, or abstract expression.

Once, a group of artists asked Courbet to open a public studio for painting, and he replied in a long piece. (Courbet had already scandalized Paris by using a live, red and white spotted bull with one horn tied to a ring in the wall as a model in his "school.") In discussing the study of reality, the artist noted:

"I also feel that painting is an essentially concrete art, and that it can simply depict *real* and *existing* things. It is an entirely physical language, and its words are all visible objects; an *abstract,* invisible object that does not exist cannot fall within the dominion of painting. In art, imagination consists of knowing how to find the most complete expression of an existing thing, not in supposing it or creating it. Beauty is in nature and can be found in the most varied guises.... If something is real and visible, then it contains its own artistic expression. We cannot alter it without denaturing and hence weakening it. Beauty in nature is superior to all artistic convictions. Beauty, like truth, is linked to the time we live in and to the individual who is able to perceive it." With this last sentence, Courbet, who thought he had established once and for all the standards of drawing reality, restores to the artist the right and the ability to interpret reality, according to his time and his sensibility. This confirms that in drawing the outer world, one is ultimately drawing one's inner world.

Movement and Behavior

As we have repeatedly said, you have to see before you draw. And I believe that curiosity is what moves us to see and then draw. Curiosity about the surrounding world. Curiosity about the human figure, as well as its movements, expressions, its types. Curiosity about the behavior of animals, the way a cat curls up, the way a horse gallops. Curiosity about the makeup of a tree, about the birth and development of the branches, about the way clouds change in the sky, the motion of waves, the blasting of the wind. You may say that this is what a camera is for. We'll talk about it later in the chapter on photography or rather on drawing and photography. Meanwhile, when we talk about drawing, we mean less a way of depicting, than of seeing, of grasping. We have to understand how that marvelous machine, the human body, functions, or how that perfect construction, the tree, operates, or how the arabesques on the sand of a beach are renewed. You do not just capture a moment or a behavior and depiction. You actually circle around it and penetrate it with your eyes and your sensibilities rather than through the impersonal lens of a camera.

When we are curious about something and try to draw it, our eyes seem virtually to run over the figure, landscape, objects in order to read it and know it. And in drawing it, we tell ourselves and others about it, making it live again in our words, that is in our lines.

Théodore Géricault: Page of studies: Oriental Horsemen, Mamelukes, Kosaks *(from a sketchbook), 1813/14, F. 35 v. Black pencil, 174 x 230 mm. Chicago, Art Institute*

During the very same period that Manet was traveling through Italy, another painter, Edgar Degas, was hard at work in the museums of France. Having just barely begun to study, he wandered through the stupendous collection of the Louvre, viewing the elegant and meager grace of the Quattrocento painters. Then, partly for family reasons, and partly because he wished to visit Tuscany, Degas found himself in the center of Italy, among his artistic forebears Masaccio, Botticelli, Gozzoli, and Ghirlandaio. His worship turned into fury, and a mass of drawings attests to his conscientious studies as he tried to appropriate the beauties and teachings of the art he was obsessed with. Believing that he had found a good life, he sketched (in either Italy or France) one of the most classical paintings imaginable, *Young Spartans Challenging Youths to Wrestle*. He was sincere about this painting when he began, and he continued working on it for a while, ultimately abandoning it with the same sincerity that had inspired him in the first place. A highly educated man, modern in all

For this reason, a sketch, which tends to render the image and meaning of an object or a conduct that interests us, ultimately depicts the very essence of drawing: the ability to catch the instant of a movement or expression, the pleasure of seeing and possessing something that arouses our curiousity.

Your pencil is ready to draw a movement or sensation on the paper. You watch a drawing gradually becoming less one of only technique and more one of a content and feeling, richer and richer, more and more agile, seeing and capturing the impression of an instant, even the drifting of a cloud—just as you want it and feel it.

Edgar Degas: Ballerina Lacing a Slipper, *ca. 1880. Pastel, 460 x 580 mm. USA, private collection*

In his pastels, Degas manages to capture movement. His sketches are like snapshots of actions in significant moments. Upon viewing such immediacy, we spontaneously wonder how long it took Degas to sketch an impression.

aspects of his life, Degas could not be fossilized in a compositional past, which, reconstructed from fragments, can never be what it was. A bothersome game, which can produce excellent people, but never an artist who feels the throbbing of present-day life. Studying more for his own satisfaction than for any need to show his works to an admiring public, Degas was struck by the efforts and the special quality of the motion made by laundresses when ironing and by the pleasing display of light produced by the large amounts of white in their shops. White, open-necked shirts, a bit of collar, reflections from all the surrounding whites, the drawing and coloring of the arms moved by the action of the woman holding the iron—after an initial observation, all these things became a point of departure for a series of profound and beautiful studies, making up the body of his work.

(Diego Martelli: *Writings on Art*)

Auguste Renoir: Sketch for "The Large Bathers,"
1884/85. Canvas, 620 x 950 mm.
Paris, Collection of Paul Pétridès

One particular aspect of behavior is facial expression. As we know, when a child wants to show joy and laughter in a circle representing a face, he shows half-closed eyes and a mouth with its corners going up. On the other hand, when a child wishes to show pain and suffering, he draws lowered eyelashes and a mouth with its corners going down. However, the depiction of facial expression requires a more complex discussion. Expressions can be studied not only in real life, but also on models, such as drawings that show expressions.

The problem of rendering movement has always fascinated artists for it plunges their

Renoir's sketch is one of a series done for the painting The Great Bathers *done in 1887. These studies (along with a series of drawings in graphite and red pencil and two oil sketches) helped the artist fix moments and actions of the female figure, preserving Renoir's typical joy and elegance in the immediacy of the execution.*

matrices into the very essence of depiction: two-dimensional essence, the width and height of the surface. With the discovery of perspective, artists added a third dimension—depth. But how can they express the fourth dimension, time, which also means movement? If an artist draws, he instinctively seeks motion and manages to render it with the simplest means, by repeating lines, shifting them, superimposing outlines, sketching the same subject several times, capturing successive impressions, perhaps even drawing the same subject twice with the legs in two different positions.

There are so many examples of artistic attempts to render motion. Among the sketches that marked a change in the way we see and draw is a work by Géricault showing Oriental horsemen, a perfect example of how to depict motion. He uses a fluidity of several superimposed lines, a multiplicity of viewpoints, and contrapositions in the figures, which seem to mirror and complete one another. Rather than being a series of sketches, this is really one single sketch, for ultimately the images of horsemen flow together into a picture of a single rider in motion. This work has the unique and unmistakable quality of a study done from life. Géricault's line, coinciding with the swiftness of a jotting down of reality, contrasts sharply with the classical rules of composition and idealization.

Furthermore, we note the final stupendous sketch of the wounded horseman, which seems to conclude the series. You can see the details of the face: a kind of pre-literary animated cartoon which also reveals a gradual transformation of the medium—it becomes more and more essential.

Leonardo da Vinci considered drawing a continuation of the eye and the mind. With the line of his pencil, he followed the evolution of a shape, reconstructing it. In many of his sketches he seems to envelope, or rather unroll, the motion of his figures in the warp and woof of his lines. His drawing of a rearing horse is one of numerous examples. Moreover, in investigating the laws of nature, the mechanisms of the human and animal bodies, and the possibilities of flight, da Vinci studied the motion of bird wings. He wanted to construct a machine that would copy this motion and move with the mechanisms of the human body. Drawing, as a cognitive device, became an instrument of his research and planning.

Leonardo da Vinci:
1. Study of motion of water (detail). Windsor 12660 v.
Windsor, Royal Library.
2. Clouds (detail from a page in Various Studies). *Windsor 12283 r. Windsor, Royal Library*
3. Observations of the Flight of Birds (details). Codice Atlantico, 845 r.
Milan, Biblioteca Ambrosiana

Adriaen Brouwer (1605-1638): Page from a Sketchbook.
Pen, brush, bistre; 150 x 210 mm. Besançon, Musée des
Beaux-Arts

An evocative page of jottings that vividly renders the
atmosphere of a tavern: the customer holding the tankard, the
argument, the struggle, and the duel. A few essential pen
strokes, an almost geometric drawing, swift spots of
watercolor and bistre; extreme synthesis and immediacy of
communication in a sketch that manages to capture a visual
instant.

Jean-Antoine Watteau: Page of Studies of Five
Figures. Red pencil, 180 x 198 mm.
Rotterdam, Boymans-van Beuningen Museum.
It would be more accurate to call this a page of
studies of two figures, because only two figures
are depicted here: the very elegant lady on the
left and the soldier shown in four different
positions. We see Watteau's ability to capture
reality, especially in a series of notations of
movements and postures, in order to construct a
gallery of "models" to be used for canvases.

A Drawing a Day:
Capturing the Movements of Dance

It is certainly hard to draw a moving figure. But drawing the movements of a dance (here, done by Japanese and Balinese performers) is a lot easier, because the motions are often repeated and therefore seen several times. In this way, it is less difficult to pinpoint the positions of the figures and catch them in quick jottings. In drawing no. 1, the dancer is captured in one position, and in drawing no. 2 in the next position. Here, however, we see a blue diagram of the first position superimposed on the second. The same process is applied to the dancer in drawings 3 and 4. The other nine drawings pinpoint nine positions in a Japanese dance, which is characterized by a series of separate positions.

1

2

3

4

The Book of Manga by Hokusai

Hokusai is perhaps the most famous Japanese painter. He was born in 1760, and in a lifetime of eighty years he followed various trends, including the Western style, painting landscapes, figures, flowers, animals, fantastic visions, and more.

Among his works, the most celebrated are the thirty-six views of the volcano Fujiyama, which he showed from thirty-six different vantage points, using original points of view. They were then printed as engravings. The best-known is certainly *The Great Wave*. He is also renowned for his book *Hokusai Manga:* fifteen volumes covering all

Katsushika Hokusai: Two Pages of Pen-and-Ink Sketches from one of the fifteen volumes of Hokusai Manga.

the sketches he did during his life. Katushika Hokusai, who used to sign himself as "the old man crazy about drawing," made jottings on the pages of his notebooks describing everything he saw, everything that aroused his interest or curiosity, from the most banal everyday scenes to battles, cloud images, landscapes transmuted into fantastic visions. His extraordinary sketches, which influenced the French impressionists, are a unique and unparalleled testimony to the behavior and curiosities of the Japanese figurative world.

The diagrams of some of the sketches emphasize Hokusai's extraordinary ability to synthesize shapes and volumes with his lines.

A Drawing a Day:
Completing the Characteristic Movements

In this exercise, your task is to complete the figures for these heads drawn by Jacob de Gheyn II. As you can see, diagram no. 2 shows only the figures of a few people, sitting or standing, to suggest possible ways of doing the exercise.

Guided by the example, you can find your own solution. Place a sheet of transparent paper over the plate and complete the other figures. Pay attention to the positions of the heads and shoulders, and also picture the various movements or actions that the barely indicated figures may suggest.

1

I. Jacob de Gheyn II: Pages of Studies: Nine Male Heads, *1604. Pen and brown ink, 362 x 260 mm. Berlin, Staatliche Museen, Kupferstichkabinett*

2

Piazzetta's Character Heads

The artist Piazzeta, famous for his drawings, is also known for his instruction in drawing. Albrizzi said about him: "His only memorable honor was that he was named one of the chief directors of the new Academy of Painting." It was during this period that Piazzetta did his drawings for *Studies of Painting*. Published by Albrizzi in 1760, this volume presented Piazzetta's pedogogical views on drawing.

He is also famous for establishing a form of regular artistic instruction in Venice. Because of the large enrollment, it was based not only on direct teaching, but also, as was usual in the academies, on "models" drawn by the artist. These drawings were available to the students, whose apprenticeship consisted of copying the master's drawings. These "models" were mainly life drawings of male and female nudes, which showed Piazzetta's extraordinary sense of light and modeling, even in original poses. The students also copied his compositions for paintings. His "character heads," although done as autonomous works, were also objects for exercise and copying because of their expressive syntheses and technical mastery. The examples presented here can also be copied by anyone who is first starting to draw.

His pictures show one, two, or three figures from the back and from above. They are caught in various positions (buying or selling a chicken, playing the violin, reading or drawing). And they do not look like real portraits, even though sometimes the same person was drawn several times. The artist's goal was to convey the intensity of the person's concentration. The sense of being caught in a particular moment and the immediacy of the expression and behavior remind us of modern snapshots. These are images "shot from real life," portraits of ordinary people, "character heads," because of the essentiality and characterization of the draftsmanship.

Gian Battista Piazzetta: Portrait of Young Man, *ca. 1730. Charcoal and white chalk on grayish-pink paper, 520 x 398 mm. Venice, Museo Correr.*

Gian Battista Piazzetta: Head of Youth. *Charcoal and white chalk on brown paper, 315 x 299 mm. Oxford, Ashmolean Museum*

Drawing and Photography

In illustrating methods and procedures of drawing, we have often spoken of photography. In other volumes, we compared the camera (a direct descendant of Canaletto's camera obscura) to the mechanism of the human eye, the mechanical lens to the crystalline lens of the eye, the impression of images on film to the retina's registration of images, and so on. Basically, we have tried to explain one in terms of the other.

In reality, however, drawing and photography are two entirely different areas. Aside from any technological or functional precision, the basic distinction is as follows. In photography, a machine, however perfect, is maneuvered by a human being; drawing on the other hand, is the direct expression of the human personality, allowing us to see and redo the images of reality and, above all the images coming from our imagination.

However, there *is* a relationship between the two modes of depiction. It is established the moment the new means of capturing the image appears on the scene, and there is no better relationship, because it instantly produces the contrast between greater possibilities and quantity, especially with the development of a realistic art.

People may wonder if a photograph can compete with art as a means of representation, if it can become an art per se, separate from the pure imitation of objects, transforming mechanics into creation, with the emotional power intrinsic to the imagination and, as such, an individual gift in every person.

When this new medium was born, the French poet Charles Baudelaire (1821-1867) saw the problem as follows: "Assuming that photography can replace art in any of its functions, it would promptly supplant and corrupt it, but only through the natural alliance it would find in the stupidity of the masses. Let photography therefore perform an effective task as an auxiliary of the sciences and the arts—a very humble handmaiden, like printing and stenography, which have neither created nor supplanted literature. Let photography quickly enrich the voyager's log and give his eyes the precision that his memory would lack; let photography adorn the library of the natural scientist, magnify microscopic elements, even supply data for the astronomer's hypotheses; let it thus act as secretary and prompter for the man who has a professional need for absolute material exactitude—all well and good. Let it salvage from oblivion falling ruins, books, prints, and manuscripts that time devours—a task for which it will be thanked and applauded. But if it interferes with the sway of the impalpable and imaginary, with anything that is valuable only because man adds something from his soul, then the results will be disastrous!"

It may be astounding that someone could have made such exact statements about a newborn

Henri Daumier: Nadar Raises Photography to the Level of Art, *1862. Lithograph. Milan, Fototeca Storica Nazionale*

1. *Edouard Manet:* Concert at the Tuileries, 1861. *Sepia and India ink, 180 x 225 mm. Paris, private collection*

2. *The Tuileries in an old photo.*

activity, with its functions and technology as yet to be precisely defined. It took an artist's intuition to inspire such a response!

But is there such a thing as photography as art and an art of photography? Indeed, there is—if "photography of art" means something self-contained, able to supply the viewer with an emotion that it can express independently of any other non-creative goal; and if the "art of photography" tends toward medial ends and continually perfects its methods in order to achieve its many, essentially practical goals.

The ballet *Notes* was staged at the Parisian Théâtre des Champs-Élysées by means of photographs projected as sets. Picasso was amazed: "I would never have dreamed that photography could get this far!"

The usefulness and possibilities of the new medium were no longer debatable. Of greater interest was the relationship that the two images, a photograph and a drawing, have with reality. Thus, during that period, French artists became interested in movement (remember Degas' studies of horses and dancers) and wondered about the "truth" of the lens and of art.

In *Conversations with Rodin,* Gsell asked the French sculptor Auguste Rodin (1840-1917) about the eternal question of the positions of a horse's hooves while it is galloping:

"You have always said that an artist must copy nature with utmost sincerity; but what happens when the interpretation of motion disagrees totally with photography, which is an irrefutable mechanical testimony?"

"The artist," replied Rodin, "is telling the truth, and photography is lying, because time does not stop in reality, and if the artist manages to reproduce the impression of a gesture executed in successive moments, then his work is certainly less conventional than the scientific image in

1. Henri de Toulouse-Lautrec: Cabby. *Cartoon painting, 51 x 80 cm. Lausanne, Maison Edita*

2. Alfred Stieglitz (1864-1946): Terminal, *1893. Photoengraving (courtesy of the Boston Museum of Fine Arts)*

which time is suspended. And this is what condemns any modern artist who reproduces poses from snapshots in order to depict galloping horses. They criticize Géricault...for depicting horses with their bellies on the ground, that is, hurling their legs alternately forward or backward....But I feel that he was right, despite photographic evidence, because he gives us a sense of the race; the totality, although false in its simultaneity is true when the parts are observed successively, and this is the only truth that counts, for this is the truth that we see and that strikes us."

Rodin concludes: "Instinct guides the artist's hand better than any mechanical device."

Let us return to Picasso, whose paintings expressed a warped nature, but who loved photography because of its ability to capture nature as it is, while he demanded creative freedom for painting. Thus, he wrote to a photographer friend:

"Dear Brassar, why weren't you here this morning? I woke up and looked into a mirror: tousled hair and a physiognomy that I had never seen. This should be photographed, I thought!" And he concludes:

"When you see what a photograph can offer, you realize that a painter's commitment can no longer be what it used to be. Why should the artist try to render what a camera lens can capture so effectively? Photography came just in time to free painting from any literary, from any anecdotal functions—from the subject. From now on, certain aspects of the subject belong purely to the world of photography."

There was some danger that, because of its mechanical character, photography might kill poetry; but the very opposite happened: a new poetry emerged from photography.

Photography of Art or Art of Photography

In the earliest years of its development, photography proved to be an extremely useful tool for drawing and painting—chiefly as an instrument of cognition for increasing knowledge about movement. Daguerreotypes, named for their inventor, the French painter and physicist Daguerre, were the first examples of images fixed by the camera obscura. Ruskin used daguerreotypes and drawings to understand and reconstruct history. For such endeavors, the new medium meant an enormous saving of time and a greater facility in working out measures and proportions.

Ruskin collected a series of daguerreotypes of landscapes and buildings in order to analyze and pinpoint, for his own drawings, the gradations of tones and the precision of details. In a letter to his father, he talks about these daguerreotypes: "Palazzos that I have tried to draw...every stone fragment, even the tiniest spot is there... naturally, there are no errors in proportionsThe daguerreotypes taken in sunlight are splendid...whoever acted clumsily and confusedly as I did...when he then sees the things I have tried to do...perfect and impeccable in a matter of minutes, will never again speak ill [of photography].... Amid all the mechanical vileness that this terrible nineteenth century has poured down upon mankind, it has at least given us one antidote: the daguerreotypes."

However, photography is useful not only to "surveyors." "The daguerreotype offers a means of highly useful information to the artist who paints from memory," said Delacroix, who was so excited about the new medium. He appreciated its qualities, but he also knew its limits.

Once, in order to illustrate its qualities, Delacroix attempted a curious experiment with several friends, after having performed it on himself several days earlier: "I showed them several photographs of nude models, some looking miserable, with disproportionate parts and disagreeable effects. Next, I showed them engravings by Marcantonio [Raimondi]. We were repulsed, nay, disgusted by their lack of precision, their manner, their unnaturalness, despite their stylistic qualities, the only ones we can admire, but which we did not admire at this point. Actually, if a genius were to use the daguerreotype as it should be used, it would reach previously unknown heights!" To explain the tricky problems involved,

Theodore Géricault: Mounted Officer, *ca. 1814. Black pencil with watercolors, white highlights; 254 x 215 mm. Paris, Louvre, Cabinet des Dessins*

Delacroix writes: "When a photographer takes a view, you see only a part cut out of the whole; the edge of the picture is as interesting as the center. You can suppose a totality of which you barely see one part, which seems chosen at random. The accessory is as important as the principal. You have to be more indulgent toward a lack of reproduction in a photographic work than in a work of the imagination. The more striking photographs are those in which the imperfections of the procedure used to reproduce as precisely as possible leave some lacuna, some break for the eye, allowing it to focus solely on a small number of objects."

The Symbolist painter Odilon Redon likewise feels that a photographic image cannot transmit truth: "The yearning, perhaps stupidity, the frenzied and feverish passion for success or profit have spoiled the artist, dulling his sensitivity to beauty. He resorts to photography directly and shamefully in order to achieve truth. In good or bad faith, he finds the result satisfying if it gives him nothing but the random ambiguity of raw material. Photography is limited to transmitting a lack of life. The emotion felt at the sight of nature

Edgar Degas: Jockeys in the Rain *(detail), ca. 1881. Pastel,
470 x 650 mm.
Glasgow, Art Gallery and Museum

Auguste Rodin (1840-1917): Two Female Nudes.
*Pencil, brown watercolor tints, on light-gray paper; 305 x
195 mm. Vienna, Graphische Sammlung Albertina*

will always furnish a type of truth, which is authentic in an entirely different way, validated only by nature. The other, the factual truth, is dangerous."

The Surrealists did not care for the mechanical quality of photography. The Cubist painter Albert Gleizes complained: "Photography has completely distorted the idea of form, even the notion of descriptive form as it consolidated after the thirteenth century. The triumph of photography means that the function of seeing has been reduced more and more to what can be caught by the physical eye."

The Futurists also stated that their painting was contrary and superior to photographic images, since "the painter is not limited to what he sees within the frame of a window, as a mere photographer is; instead, he reproduces what he would see if he were to look from every side of the balcony." Balla points out: "With the existence of photography and cinema, painterly reproduction of reality no longer interests or can interest anyone." Boccioni, says: "We have always been repelled and disgusted by even a remote comparison with photography, because it is outside the precincts of art. Photography is valid in one way: it objectively reproduces and imitates, and its perfection liberates the artist from the fetters of the exact reproduction of reality."

There were also votes in favor of photography. Rodin opined: "I believe that photography can create works of art. I consider Steichen [American photographer and painter, 1879-1973] a great artist ... I don't know to what extent he interprets, I don't see anything wrong with that, and I don't think it's important, in regard to the devices he employs to achieve his results, which, however, are obviously photographs." And Matisse stated: "If exercised by a man with taste, photography may appear like art. The photographer has to interfere as little as possible, so as not to lose the objective fascination of photography.... The goal of photography is to register and furnish documents."

This is certainly one of its jobs. But today, photography has become a tool that not only perpetuates and circulates the value of art works in an imaginary museum without walls but also manages to be a permanent source of art, continually seeking the new and the extraordinary.

Photographing in Order to See

There are many ways of seeing, not just looking, but knowing and recognizing something, understanding its makeup, reading its form and proportions, observing its differences from other things—and, I hasten to add, there are many ways of drawing a thing. As we have repeatedly said, drawing ultimately means concretizing our vision on paper—i.e., managing to see, to pinpoint, hence to individualize our subjects in the characteristics that make it what it is and not something else.

With a drawing, we succeed in truly seeing, in freeing ourselves from what we have termed the "habit of the subject." But only with a drawing? We can do the same thing with a camera, if we photograph in a certain way. That is, you have to shoot not just any subject, say, a landscape, a building, a figure within a given framework. Instead, you have to seek specific ideas, specific themes; for instance, contrasts of light and shadow, of levels, curves and straight lines, geometric figures, variations of use. As you walk about with your camera, look around, try to observe the forms of things, beyond their meaning or chiaroscuro—if in any case whatever those forms may be beyond their nature and specific existences. In this way, you will no longer be distracted or confused by your familiarity with the subject, you will no longer see a house, a tree, a stair, a cloud. Instead, you will specify their shapes, their geometric lines, their lights, the relationships between light and dark. You will notice variations of use: something meant for one function will be employed for another; for example, a street, designed for traffic, will be transformed into a baseball diamond, or a park bench, normally used for brief relaxation, will be converted into a comfortable bed.

Your approach is a way of learning how to see with a camera, and it is also a way of photographing concepts rather than things.

1

2

1. 2. *Variations of use*

3. 4. *Lines and geometric shapes*

3 4

5. 6. *Reflections*

7. 8. *Movement*

9. 10. *Contrasts of light and shadow*

When man vanishes from photography, then, for the first time, the expository values states its superiority over the cultural value. The fact of giving this process its own place constitutes the importance of Atget [French photographer, 1856-1927]; at the turn of the century, he captured various aspects of Parisian streets empty of human beings. It was correctly said of him that he photographed streets the way others photograph the scene of a crime. The latter is likewise deserted. It is photographed as evidence. With Atget, photographs turned into documentary evidence of the historical process. This is what constitutes their hidden political character. They demand the reception of a given meaning. A freely roaming contemplative fantasy is not suitable to their nature. They unsettle the observer; he feels that he must seek a particular path in order to reach them. In the nineteenth century, a debate took place between painting and photography in regard to the artistic

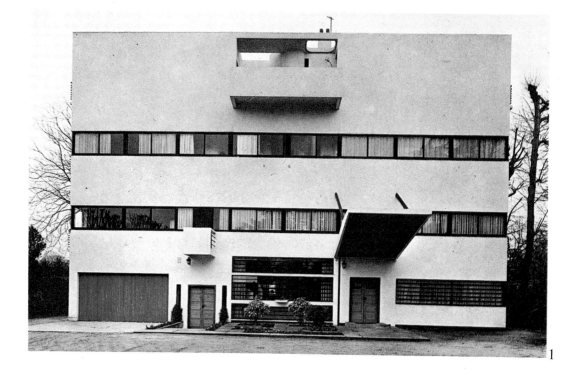

1

A Drawing a Day: Drawing from Photos

Often, even at school, one of our exercises consists of drawing from photos (generally of buildings). Such copying is useful for training the hand, but not the mind, it doesn't help you to find the ways and means of working. This should be the chief goal of drawing. If it is important to acquire a technique and to improve your mastery by continuous application, then it is also vital that you exercise both your hand and your mind; that is, you have to think by drawing or, if you prefer, draw by thinking.

Thought, analysis, and the search for methods can also develop through the process of copying a photograph, or rather, a photographed building. However, in lieu of merely transferring the perspective of what you see reproduced to your paper, you should try to think about the photograph.

1. Le Corbusier: Villa Stein, *1927. Garches.*

value of their respective products; today, this debate seems confused and out of place. But this does not impugn its significance and might even underscore it. This debate was actually the expression of a worldwide historical change, of which neither side was aware. Stripping art of its cultural foundation, the era of its technological reproducibility wiped out its autonomy for all time. However, the resulting change in the function of art, surpassed the visual field of the century. It fled into the twentieth century, which then experienced the development of the cinema. It had taken a great deal of acumen to settle the issue of whether photography was an art, but no one had asked the preliminary question: that is, whether the discovery of photography modified the complex character of art."

(Walter Benjamin: *The Art Work in the Era of Its Technological Reproducibility*

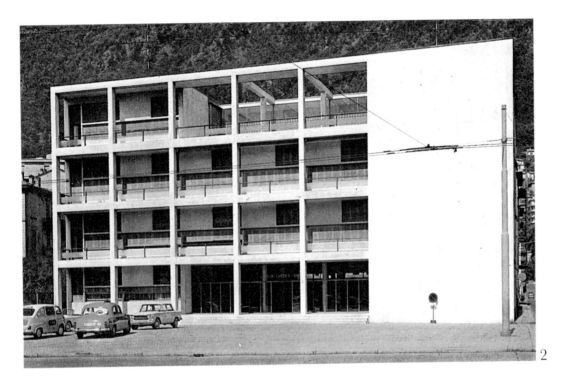

2

Reconstruct views of the building from the photo; that is, draw the facade and the sides as if seen from the front, making sure you find the exact proportions of the width and height. A good example is the exercise illustrated here: the view of Le Corbusier's Villa Stein in Garches, and Terragni's Casa del Fascio in Como.

These views were recovered by a perspective "adjustment" to the faces of the buildings in question. An attempt was made to clarify the relationships and proportions between the various element. This is obvious in the Garches villa: the rectangles of the facade are all proportioned correctly.

Another approach to architectural photography with drawing is the interpretation of volume. Draw only the shadowy areas but not the outlines; let the cast shadows and dark apertures suggest the architecture, the architectural space.

2. *Giuseppe Terragni:* Casa del Fascio, *1932/36. Como*

Snapshot Images of a City

If you walk or take a boat through Venice, use your notebook. Make rapid sketches of the Grand Canal, a view of Venice from the sea, the basilica of San Marco, the island of San Giorgio, the Chiesa della Salute.

These "snapshots" of a tour can also be taken with a camera. The results are different, as we can see by comparing these sketches with the photos. You can also enjoy making quick sketches during your tour and then trying to recreate the same scenes with your camera.

The Grand Canal

Venice Seen from the Sea

Piazza San Marco

The Island of San Giorgio

Chiesa della Salute

Chiesa della Salute

Collage and Photomontage

In the early nineteenth century, a new element joined the Cubist way of seeing and rendering: the use of fragments of real objects and photographs in a painting. Cubism turned the collage into art; however, popular art had already introduced and experimented with the collage.

With the invention of photography, cuts and snippets of photos were mounted, pasted next to drawings, paintings, newsprint shreds, and various objects. Naturally, the Cubists did not use the photographic material or any material for what it was or depicted; its purpose was usually allusive, artistic. Why, said Picasso, should we use a moustache in a collage in order to depict a real moustache? It is the revision, the use of metaphor, the suggestion of a specific object or photographic material, above all its "transformation, that justifies its use in a graphic or painterly composition.

The Futurists and Dadaists likewise used photos in collages to suggest unpredictable contacts, random combinations, irrational images.

For the Dadaists, who challenged official art and society, the collage was the best medium for ridiculing and transforming situations and pople, and turning them topsy-turvy.

The substitution of parts of the figure for others (head, legs, arms, etc.) was one of the most frequent techniques. It was very easy to do, with immediate results of satire and reversal of meaning. Other elements were substituted in collages: the background, things that a figure was holding in his hands, one of the persons in a scene. The aim was always to modify if not to ridicule the meaning and turn it inside out. Figurative elements were joined by typographical elements, letters and typefaces of various kinds and as messages and preliterary cartoons. Obviously, this effort tended to make reality absurd and absurdity real.

Why don't you try to cut out photos or drawings from a magazine or newspaper (but not a book!). Paste them on a sheet of paper in terms of a specific goal: caricature, satire, contradiction, absurdity, challenge. Or else, let your taste be your guide.

1. *Raoul Hausmann (1886-1970):* Tatlin at Home, *1920.- Collage, 28 x 41 cm. Berlin, private collection*

2. *Hannah Hoch (1889-1978): Collage, 1920. 30 x 35 cm. Chicago, private collection*

INDEX